W9-CKQ-640

tips, inspiration and instruction in all mediums

How did you paint that?

100 ways to paint
FLOWERS & GARDENS
VOLUME 1

international
artist

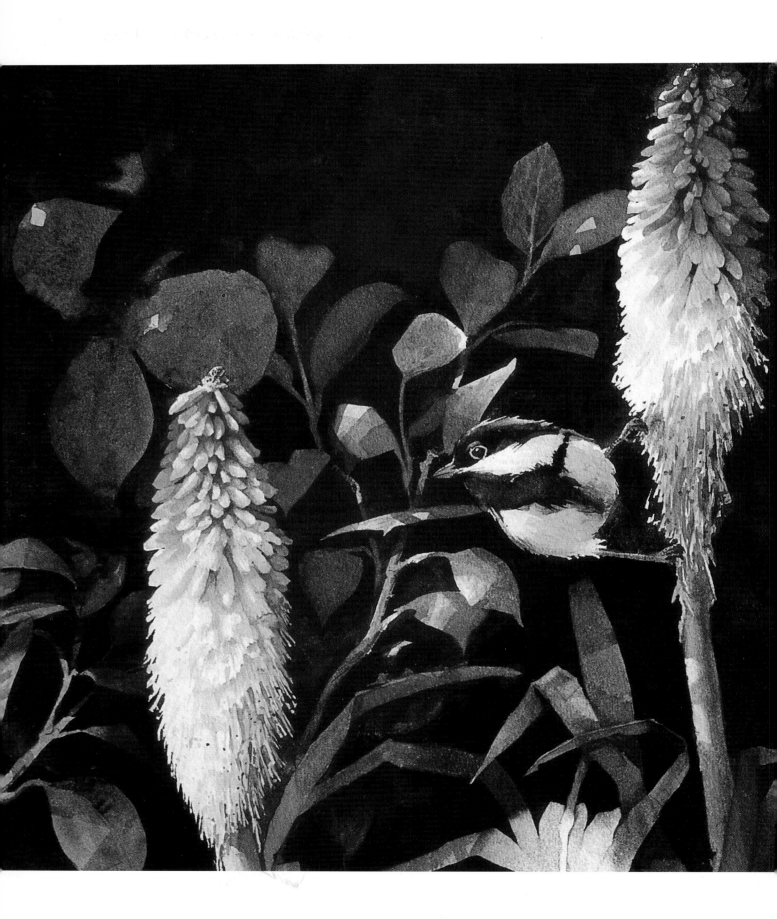

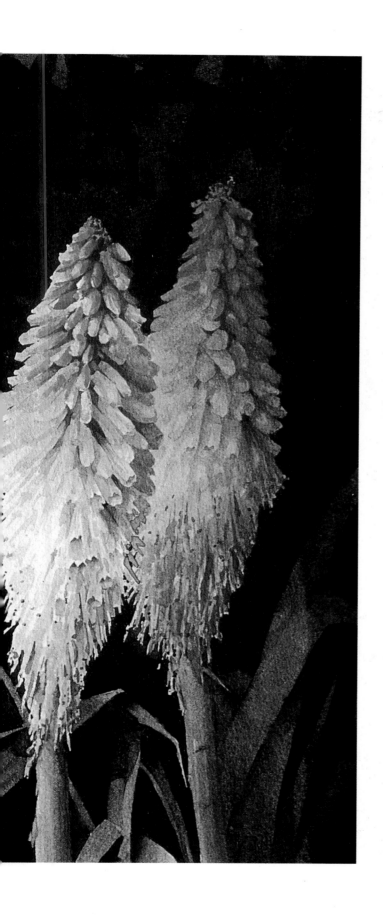

tips, inspiration and instruction in all mediums

How did you paint that?

100 ways to paint

FLOWERS & GARDENS

VOLUME 1

international artist

international
artist

International Artist Publishing, Inc
2775 Old Highway 40
P.O. Box 1450
Verdi, Nevada 89439

Website: www.internationalartist.com

© International Artist 2004

All rights reserved. No part of this publication
may be reproduced, stored in a retrieval
system, or transmitted in any form or by any
means, electronic, mechanical, photocopy,
recording or otherwise without the written
permission of the publishers.

This book may not be lended, resold, hired out
or otherwise disposed of by way of trade in any
form of binding or cover than in which it is
published, without the prior consent of the
publishers.

Edited by Terri Dodd, Jennifer King and Nicole
 Klungle
Designed by Vincent Miller
Typeset by Nicole Klungle and Jennifer King
Editorial Assistance by Tina Tammaro

ISBN 1-929834-44-6

Printed in Hong Kong
First printed in paperback 2004
08 07 06 05 04 6 5 4 3 2 1

Distributed to the trade and art markets
in North America by:
North Light Books,
an imprint of F&W Publications, Inc
4700 East Galbraith Road
Cincinnati, OH 45236
(800) 289-0963

Oil
2, 4, 5, 6, 8, 10, 12, 14, 16, 17, 26, 27,
28, 32, 33, 36, 37, 38, 42, 43, 45, 48,
49, 50, 52, 54, 55, 57, 58, 61, 62, 66,
67, 68, 69, 71, 78, 82, 83, 84, 86, 90,
92, 94, 99, 100

Watercolor
1, 7, 9, 11, 18, 19, 20, 21, 22, 24, 25,
30, 35, 40, 41, 44, 46, 47, 51, 56, 59,
60, 63, 64, 65, 70, 72, 75, 76, 79, 85,
88, 89, 93, 95, 96, 97, 98

Acrylic
3, 13, 23, 29, 31, 34, 73

Pastel
15, 74, 80, 87

Colored pencil
53

Gouache
77

Mixed media
39, 81, 91

Acknowledgments

International Artist Publishing Inc. would like to
thank the master artists whose generosity of spirit
made this book possible.

Lee Alban 14
Kathy Anderson 4
Joan Aochi 6
Susan Ashbrook 13
John Atkinson **92**
Rebecca J Becker 15
William Bensen 16
Betty J Billups 17
Sally Bookman 18
Frederic Briggs 19
Valentina Bright **100**
Rosemary Butterbaugh 21
Pat Camillo 22
Michael Card 23
Carol Carpenter 24
Susan Chaker 25
Sherry Chien 26
Patti Cliffton 8
Peter Collinson **99**
Gene Costanza 27
Joanna Crawford **94**
JD Cummings 28
JP De Vynck **97**
K S Degon **93**
Lyn Diefenbach 86
Kimberly R Dow 29
Louaine Elke 30
Henry Fernandes 31
Mary K Forshagen 32
Sharon Forthofer 33
Rosalind Forster 11
Anna Galea **96**
Stacy Giebler 34
Sherrill Girard 35
Marsha Goodman 12
Andrzej Gosik 88
Sonia Grineva 36
Shizuko Barbara Hanson 3
Ann Hardy 37
Ray Harrington 5
Judy Heyer 38
Marcia Holmes 39
Kelv Holtom 1
Lou Jordan **40**
Shoko Judd 41
Emi Karakan 87
Marla Karimipour **42**
Laurie Kersey **43**
Ruth Eiring King **44**
Patricia Kness **45**

Loren Kovich **46**
Sharon Krapfl **47**
Mary Kay Krell **48**
Robert Kuester **49**
Joyce E Lazzara **50**
David Dodge Lewis **52**
Heidi J Klippert Lindberg **53**
Lucy Mazzaferro **54**
Angus McEwan **95**
Alicia Meheen 7
Bryn Miles 89
Mary Minifie **55**
Joye Moon **56**
Hedi Moran **57**
Gail Morrison **58**
William Mowson **59**
Nancy Nordloh Neville **60**
Annette Novoa **77**
Lainee O'Donnell **91**
Gregory Packard **61**
SeKyoung Park **62**
Heidi Lang Parrinello **63**
Monique Parry **64**
Monika Pate **65**
Virginia Peake **66**
Paul Penczner **51**
John Pototschnik **67**
Diane Rath **68**
Gavin Rendall **85**
Theodor Rieger 10
Mary Rodgers **98**
Bennette A Rowan **71**
William Schneider **69**
Karen Shelton **70**
Lloyd Smith 20
Suzy Smith **72**
Tish Smith **73**
John Stoa **90**
Patricia Taylor **74**
Rene Thibault **75**
Marilyn Timms **76**
Suzanne Valiquette 9
Diane Van Noord **78**
Andrea Vincent **79**
Ann Kelly Walsh **80**
Thomas A Wayne **81**
Qiuzhen Wei 2
Chuck Wood **82**
Hye Seong Yoon **83**
Cindy Harlan Youse 84

With special thanks to Timothy R. Thies,
whose painting appears on the front cover

Message from the Publisher

We have taken the "learn by observing" approach six huge steps further.

Welcome to the latest title in our innovative 6-volume series. Each volume contains 100 different interpretations of the subject by outstanding artists working in the world today — in all mediums.

There are five more Volumes in the series, each tackling a popular subject. Titles you can collect are:

100 ways to paint Still Life & Florals

100 ways to paint People & Figures

100 ways to paint Seascapes, Rivers & Lakes

100 ways to paint Favorite Subjects

100 Ways to paint Landscapes

Turn to page 128 for more details on how you can order each volume.

Studying the work of other artists is one of the best ways to learn, but in this series of Volumes the artists give much more information about a favorite painting. Here's what you can expect from each of the Volumes in the series.

- 100 different artists give 100 different interpretations of the subject category.
- Each one gives tips, instruction and insight.
- The range of paintings shows the variety of effects possible in every medium.
- A list of colors, supports used, brushes and other tools accompanies each picture.

- The artists reveal what they wanted to say when they painted the picture — the meaning behind the painting and its message.
- Each artist explains their inspiration, motivation and the working methodology for their painting.
- Artists say what they think is so special about their painting, telling how and why they arrived at the design, color and techniques in their composition.
- The artists describe the main challenges in painting their picture, and how they solved problems along the way.
- They offer suggestions and exercises that you can try yourself.
- They give their best advice on painting each subject based on their experience.
- Others explain why they work with their chosen medium and why they choose the supports and tools they do.
- The main learning point of each painting is identified in the headline.

Each of the explanations shown in **100 ways to paint Flowers and Gardens** was generously provided by artists who want you to share their joy of painting. Take the time to read each description fully, because you never know which piece of advice will be the turning point in your own career.

Vincent Miller

Vincent Miller
Publisher

I catch the viewer's eye with contrasts in

f you were standing beside Timothy R. Thies, the artist who created this painting, the first thing you would ask is, "Timothy, how did you paint that?" Then a multitude of other questions would follow, fed by your insatiable hunger to know what it is that goes into making a masterpiece like this.

Our series of books is the next best thing to having direct access to exemplary artists like Timothy Thies. And on your behalf we asked them the burning questions that you would ask if you met them face to face.

Here's the kind of information and insight you can expect to find on the following pages from the other generous artists in this book.

my inspiration

I wanted to convey the intimacy of this small backyard, the exquisite early morning light on the window visible through the arched gate, and the glow of the New Dawn roses growing wildly over the fence.

my challenge

It was important to me to capture the brilliant morning sunlight on the window. While painting a color study on site, the light kept moving and changing, so I took a photo for reference and used my on-site study and the photo for reference in my studio.

my design

I placed my lightest lights and darkest darks where the sunlight hits the window. This, along with the placement of the window within the arch of the gate, draws the eye to my chosen focal point. Wherever I wanted to attract the eye, I used exaggerated colors against neutrals, hard edges against soft, and boxy architectural shapes against soft, organic ones.

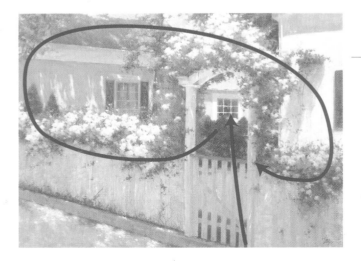

the eye-path

- The viewer's eye enters the painting at the bottom of the gate and is immediately drawn to the lightest light against the darkest dark at the window.
- The eye then travels left along the roses and up across the roofline to the roses on the arch.
- From there, the eye progresses across the roses growing on the arch and down the cool shadow cast on the wall by the red roses.
- The eye then follows the pink roses along the fence and back to the gate.

color, texture, edges, value and shape.

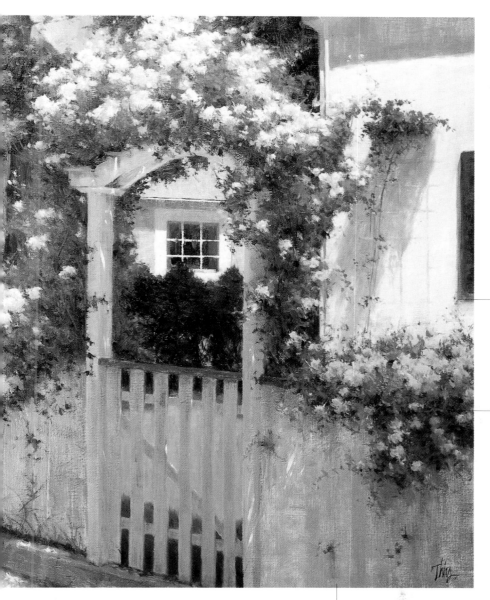

Davis Lane Roses, oil, 30 x 40" (76 x 102cm)

the materials I used

support
primed canvas mounted to foam board

brushes and tools
nos. 6, 8, 10, 12 bristle flats
nos. 2, 4, 10, 12, 44 sables
1", 2½", 4" palette knives

oil colors

Sap Green	Dioxazine Purple
Ultramarine Blue	Permanent Rose
Cobalt Blue Light	Cadmium Scarlet
Cerulean Blue Hue	Cadmium Red
Viridian	Cadmium Yellow Deep
Transparent Oxide Red	Cadmium Yellow Pale
Terra Rosa	Cadmium Lemon
Yellow Ochre	White
Alizarin Crimson	

color plan

The main colors in this painting are pink and green with a supporting cast of neutrals. I paint from life so I can observe the close relationship between warm light and cool shadows found in nature.

my favorite techniques

- I paint a color study on site and take photographs to capture the light and details. I don't use photos for color because my color studies are more accurate.

- I like to create a watercolor effect using oil washes. I always let these initial washes show through the final painting.

- I can create the effect of pastels with drybrushing. I often layer opaque, drybrushed paint over my transparent washes.

- I use soft brushes to create lost edges and palette knives to create hard ones.

- Wherever I want to create emphasis, I use impasto paint.

Timothy R. Thies lives in Idaho, USA.
wwfa@adelphia.net
www.westwindfineart.com

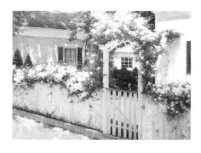

tonal value plan

See how the light values lead your eye through the painting.

acrylic paint

Fast drying, waterproof, long lasting acrylic is an elastic paint that flexes and resists cracking.

Use it straight from the tube for intense color, dilute with water for transparent washes, or mix with an assortment of mediums to create texture. Available in tubes or jars, liquid or impasto, matte or gloss finish.

Binder: Acrylic resin emulsified with water.

Support: Flexible and inflexible, primed or unprimed.

alkyd

Looks similar to oil paints and can be mixed with them. Alkyds resist yellowing and they dry faster than oils.

Support: Prime flexible or inflexible surfaces first with oil or acrylic primer.

Binder: Alcohol and acid oil modified resin.

casein

This old medium, bound with skim milk curds, has mostly been overtaken by acrylic paints. However, casein is still available and many artists swear by it. The medium dries quickly to a velvety matte finish and is water-resistant when dry. It does become brittle, and if you apply too much, it can crack. Like acrylic paint, casein is versatile and can be applied as a thin wash or as an underpainting for oils and oil glazes. When it is varnished it looks like oil paint.

Support: Because casein does not flex like acrylics it is not suitable for canvas. Use watercolor paper or rigid surfaces, primed or unprimed.

egg tempera

This product uses egg yolk in oil emulsion as its binder. It dries quickly, doesn't yellow and can be used just as it is or diluted with water. Egg tempera will crack on canvas so only use rigid supports. Use as underpainting for oils and oil glazes.

gouache

This medium is opaque and can be rewetted and reworked. It comes in vivid colors.

Binder: gum arabic

Support: paper and paper boards. Dilute with water or use neat. Don't apply too thickly or it will crack.

acrylic gouache

This gouache uses water-soluble acrylic resin as the binder. Use it just like gouache, but notice that because it is water-resistant you can layer to intensify color.

oil

The classic painting medium. You can achieve everything from luminous glazes to opaque impasto. As the paintings from the Old Masters show, oil paintings can crack, yellow and darken with age. Oil paint dries slowly on its own, or the

bud or soft brush. Hard pastels enable finer detail to be added as the work progresses or as a primary drawing medium for planning sketches and outdoor studies. Pastel pencils can be used for drawing and for extra fine detail on your pastel painting.

You can combine pastel with acrylic, gouache and watercolor. As long as the surface upon which you are working has a "tooth" (a textured surface that provides grip), then it is suitable for pastel.

Support: There is a variety of papers available in different grades and textures. Some have a different texture on each side. These days you can buy sandpaper type surfaces either already colored or you can prime them yourself with a colored pastel primer. Some artists prepaint watercolor paper with a wash and apply pastel over that.

water-thinned oil

A recent development. Looks like oil paint but cleans up in water instead of solvent. Dries like traditional oil. Use straight or modify with traditional oils and oil painting medium. Transparent or impasto.

Support: Flexible and inflexible canvas or wood.

watercolor

Ancient medium. Pigments are very finely ground so that when the watercolor paint is mixed with water the paint goes on evenly. Some pigments do retain a grainy appearance, but this can be used to advantage. Provided you let previous washes dry, you can apply other washes (glazes) on top without disturbing the color beneath. Know that watercolor dries lighter than it looks.

Watercolor is diluted with different ratios of pigment to water to achieve thin, transparent glazes or rich, pigment filled accents of color. Watercolor pigments can be divided into transparent, semi-transparent and opaque. It is important to know which colors are opaque, because it is difficult to regain transparency once it is lost. Watercolor can be lifted out with a sponge, a damp brush or tissue.

Support: There are many different grade watercolor papers available from very rough, dimply surfaces to smooth and shiny. Different effects are achieved with each. Although a traditional method is to allow the white of the paper to show through, there are also colored watercolor papers available that allow warm or cool effects.

process can be accelerated using drying medium. There are many mediums that facilitate oil painting, including low odor types. Turps is widely used to thin oil paint in the early layers. Oils can be applied transparently in glazes or as thick impasto. You can blend totally or take advantage of brush marks, depending on your intention. Oil can be used on both flexible and inflexible surfaces. Prime these first with oil or acrylic primers. Many artists underpaint using flexible acrylic paint and then apply oil paint in layers. You can work oils all in one go (the alla prima method), or allow previous layers to dry before overpainting. Once the painting is finished allow as much time as possible before varnishing.

Binder: linseed, poppy, safflower, sunflower oil.
Support: Flexible and inflexible canvas or wood.

oil stick

This relatively new medium is artist quality oil paint in stick form. Dries faster than tube oils. Oil sticks allow calligraphic effects and they can be mixed with traditional oils and oil medium. Oil stick work can be varnished.

pastel

Use soft pastels to cover large areas of a painting. Use the side of the pastel to rapidly cover an area, either thickly or in a thin restrained manner. You can blend pastel with a finger, cotton

Find-it-Faster Directory
Color coded numbers let you quickly find the paintings you like,
all the methods and materials used and how each artist painted them

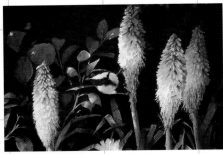

1 **Kelv Holtom**
Red Hot Meal
11¾ x 17¼" (30 x 44cm)
WATERCOLOR

Color

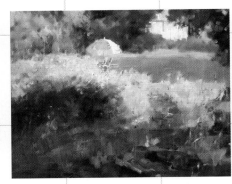

2 **Qiuzhen Wei**
Summer in Backyard
16 x 20" (41 x 51cm)
OIL

Contrast

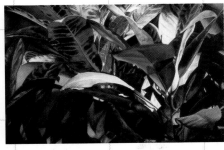

3 **Shizuko Barbara Hanson**
Tropical Patterns
22 x 33" (56 x 84cm)
ACRYLIC

Design

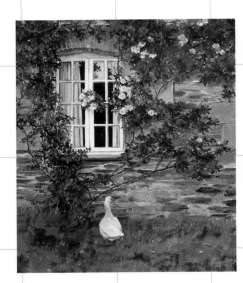

4 **Kathy Anderson**
Cornwall Roses
36 x 30" (91 x 76cm)
OIL

Color

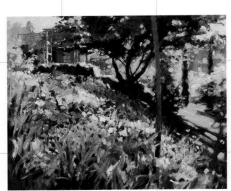

5 **Ray Harrington**
Spring at Chalumeau
20 x 24" (51 x 61cm)
OIL

Design

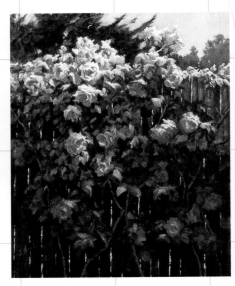

6 **Joan Aochi**
Spring Abundance
24 x 20" (61 x 51cm)
OIL

Lighting

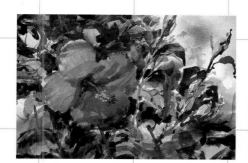

7

Alicia Meheen
Hibiscus
14 x 20½" (36 x 52cm)
WATERCOLOR

Technique

8

Patti Cliffton
Poppies
12 x 16" (30 x 41cm)
OIL

Technique

9

Suzanne Valiquette
Ombre et Lumiere
19 x 26" (48 x 66cm)
WATERCOLOR

Design

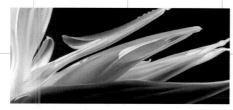

10

Theodor Rieger
Bird of Paradise
16 x 36" (41 x 91cm)
OIL

Shape

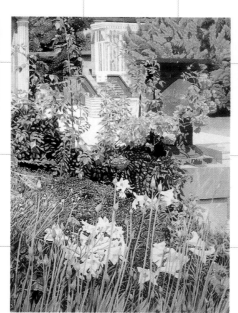

11

Rosalind Forster
Herbaceous Border, Chatsworth Garden
21¾ x 15¾" (55 x 40cm)
WATERCOLOR

Tonal

12

Marsha Goodman
The Homestead #2
16 x 24" (41 x 61cm)
OIL

Color and contrast

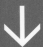

Find-it-Faster Directory

Color coded numbers let you quickly find the paintings you like,
all the methods and materials used and how each artist painted them

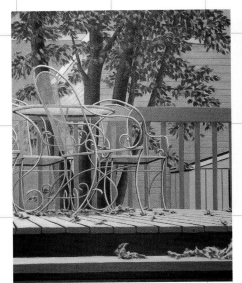

13 **Susan Ashbrook**
Outer Sanctum
20 x 16" (51 x 41cm)
ACRYLIC

Mood

14 **Lee Alban**
The Ball Jar
23 x 20" (58 x 51cm)
OIL

Setup

15 **Rebecca J Becker**
Bayou State Garden
12 x 12" (30 x 30cm)
PASTEL

Drama

16 **William Bensen**
Once upon a Time
20 x 24" (51 x 61cm)
OIL

Color temperature

17 **Betty J Billups**
Oranges & Peonies
20 x 16" (51 x 41cm)
OIL

Complementary color

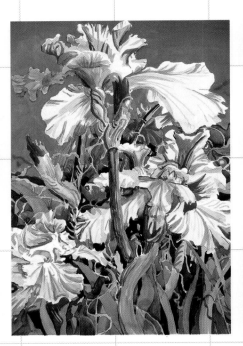

18 **Sally Bookman**
Iris Pizzazz
30 x 22" (76 x 56cm)
WATERCOLOR

Negative shape

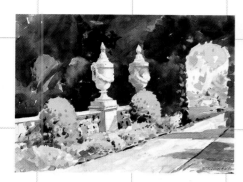

19 Frederic Briggs
Hillwood Garden
15 x 20" (38 x 51cm)
WATERCOLOR

Contrast

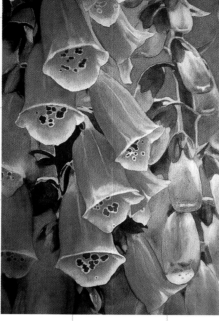

20 Lloyd Smith
Foxglove
16 x 11" (41 x 28cm)
WATERCOLOR

Color

21 Rosemary Butterbaugh
Home from the Market
17 x 22" (43 x 56cm)
WATERCOLOR

Viewpoint

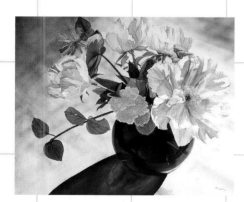

23 Michael Card
Love at Home
20 x 47" (51 x 119cm)
ACRYLIC

Color

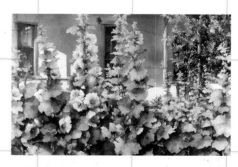

24 Carol Carpenter
Baca House Portal
22 x 30" (56 x 76cm)
WATERCOLOR

Value and texture

22 Pat Camillo
Inner Glow
28 x 35" (71 x 89cm)
WATERCOLOR

Color

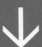

Find-it-Faster Directory

Color coded numbers let you quickly find the paintings you like,
all the methods and materials used and how each artist painted them

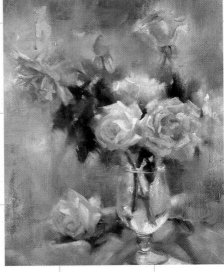

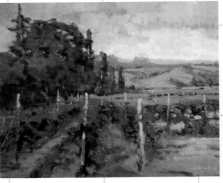

27 Gene Costanza
In the Vineyard
20 x 24" (51 x 61cm)
OIL

Design

26 Sherry Chien
Corner Fragrances
18 x 14" (46 x 36cm)
OIL

Mood

25 Susan Chaker
Perfection
30 x 22" (76 x 56cm)
WATERCOLOR

Design

29 Kimberly R Dow
Rose Arbor
16 x 20" (41 x 51cm)
ACRYLIC

Shape

30 Louaine Elke
Poppies, Pods & Weeds
22 x 30" (56 x 76cm)
WATERCOLOR

Design

28 JD Cummings
Sunflower Power
48 x 36" (122 x 91cm)
OIL

Dramatic lighting

You'll find all the information you want about how each painting was created by turning to the tab number indicated, in sequence from 1 to 100

31 Henry Fernandes
Flower Power
36 x 48" (91 x 122cm)
ACRYLIC

Technique

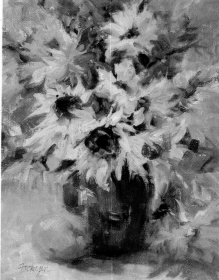

32 Mary K Forshagen
Sunflowers
16 x 12" (41 x 30cm)
OIL

Brushstrokes

33 Sharon Forthofer
Bloomin' Perfect
20 x 30" (51 x 76cm)
OIL

Design

34 Stacy Giebler
Peach Rose
36 x 24" (91 x 61cm)
ACRYLIC

Color contrast

35 Sherrill Girard
Peony's Waltz
15 x 22" (38 x 56cm)
WATERCOLOR

Depth

36 Sonia Grineva
Flowers in a Salviati Vase
36 x 40" (91 x 102cm)
OIL

Movement

Find-it-Faster Directory

Color coded numbers let you quickly find the paintings you like,
all the methods and materials used and how each artist painted them

37 Ann Hardy
Samovar & Lilies
24 x 30" (61 x 76cm)
OIL

Placement

38 Judy Heyer
Say It with Flowers
18 x 14" (46 x 36cm)
OIL

Value contrast

39 Marcia Holmes
Vintage Bouquet
36 x 24" (91 x 61cm)
MIXED MEDIA

Color

40 Lou Jordan
The Blue Hills
22 x 30" (56 x 76cm)
WATERCOLOR

Atmosphere

41 Shoko Judd
Smiling Peony
18 x 23½" (46 x 59cm)
WATERCOLOR

Color

42 Marla Karimipour
Fatima
24 x 30" (61 x 76cm)
OIL

Design

You'll find all the information you want about how each painting was created by turning to the tab number indicated, in sequence from 1 to 100

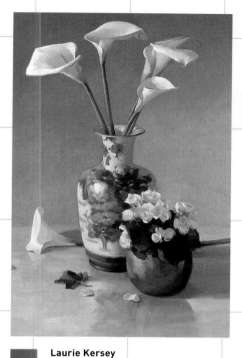

43 **Laurie Kersey**
Callas & Begonia
30 x 20" (76 x 51cm)
OIL

Color harmony

44 **Ruth Eiring King**
Buckets of Blooms II
14 x 21" (35 x 53cm)
WATERCOLOR

Texture

45 **Patricia Kness**
Sunflower on Chair
24 x 18" (61 x 46cm)
OIL

Brushwork

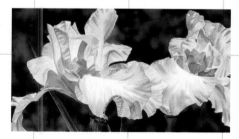

46 **Loren Kovich**
Grandpa's Iris
15 x 22" (38 x 56cm)
WATERCOLOR

Value contrast

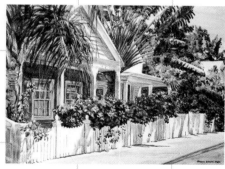

47 **Sharon Krapfl**
Key West
13½ x 17½" (34 x 44cm)
WATERCOLOR

Color

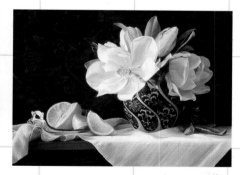

48 **Mary Kay Krell**
Evening Magnolias
18 x 24" (46 x 61cm)
OIL

Light and color

Find-it-Faster Directory

Color coded numbers let you quickly find the paintings you like,
all the methods and materials used and how each artist painted them

49 Robert Kuester
The Love Birds
20 x 16" (51 x 41cm)
OIL

Design

50 Joyce E Lazzara
Nicolai
18 x 18" (46 x 46cm)
OIL

Contrast

51 Paul Penczner
Cotton and Sunflowers
40 x 30" (102 x 76cm)
WATERCOLOR

Color

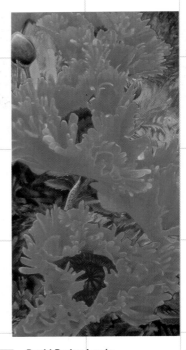

52 David Dodge Lewis
Poppies
48 x 25" (122 x 63cm)
OIL

Design

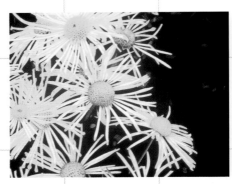

53 Heidi J Klippert Lindberg
Sunbursts
16 x 20" (41 x 51cm)
COLORED PENCIL

Movement

54 Lucy Mazzaferro
Complements
30 x 24" (76 x 61cm)
OIL

Unity

55 Mary Minifie
The White Vase
36 x 26" (91 x 66cm)
OIL

Line and color

56 Joye Moon
Garden of Isola Bella
10½" x 6½" (26 x 16cm)
WATERCOLOR

Viewpoint

57 Hedi Moran
Backlit Roses
12 x 9" (30 x 23cm)
OIL

Technique

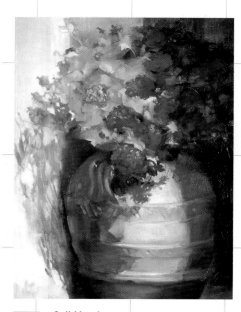

58 Gail Morrison
Villa Geranium
30 x 24" (76 x 61cm)
OIL

Color

59 William Mowson
Longer Days II
15 x 22" (38 x 56cm)
WATERCOLOR

Mood

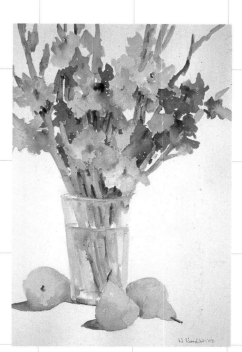

60 Nancy Nordloh Neville
Glads and Pears
24 x 17" (61 x 43cm)
WATERCOLOR

Balance

Find-it-Faster Directory

Color coded numbers let you quickly find the paintings you like,
all the methods and materials used and how each artist painted them

61 Gregory Packard
Still Life with Roses
24 x 24" (61 x 61cm)
OIL

Complementary color

62 SeKyoung Park
Morning Garden
30 x 24" (76 x 61cm)
OIL

Technique

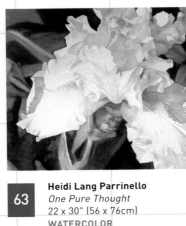

63 Heidi Lang Parrinello
One Pure Thought
22 x 30" (56 x 76cm)
WATERCOLOR

Contrast

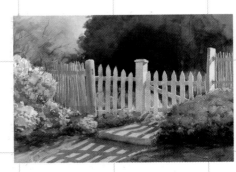

64 Monique Parry
Secret Garden
22 x 30" (56 x 76cm)
WATERCOLOR

Design

65 Monika Pate
Tomatoes
28 x 20" (71 x 51cm)
WATERCOLOR

Color

66 Virginia Peake
Luscious Whites
24 x 20" (61 x 51cm)
OIL

Color

You'll find all the information you want about how each painting was created by turning to the tab number indicated, in sequence from 1 to 100

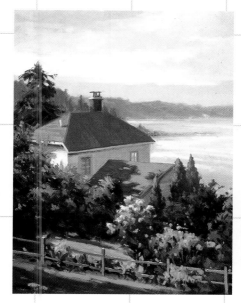

67
John Pototschnik
Overlooking the Sound
18 x 14" (46 x 36cm)
OIL

Design

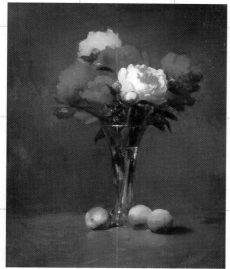

68
Diane Rath
Peonies & Peaches
24 x 20" (61 x 51cm)
OIL

Color temperature

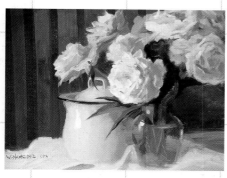

69
William Schneider
Pink Peonies
14 x 18" (36 x 46cm)
OIL

Edge control

70
Karen Shelton
Fresh from the Garden
16 x 22" (41 x 56cm)
WATERCOLOR

Backlighting

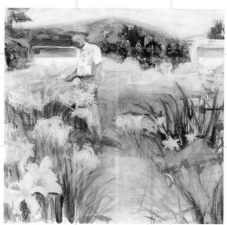

71
Bennette A Rowan
Day Lily Man
30 x 30" (76 x 76cm)
OIL

Color

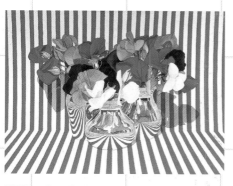

72
Suzy Smith
Sweetpeas with Red Stripes
23 x 28" (58 x 71cm)
WATERCOLOR

Shape and volume

Find-it-Faster Directory

Color coded numbers let you quickly find the paintings you like,
all the methods and materials used and how each artist painted them

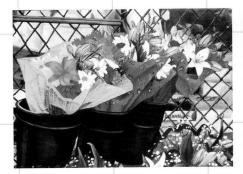

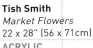

73 **Tish Smith**
Market Flowers
22 x 28" (56 x 71cm)
ACRYLIC

Realism

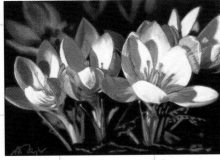

74 **Patricia Taylor**
Crocuses
7¾ x 10½" (19 x 26cm)
PASTEL

Edge control

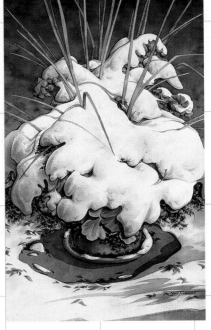

75 **Rene Thibault**
Flowers with Early Snow
20 x 12" (51 x 30cm)
WATERCOLOR

Variety of shapes

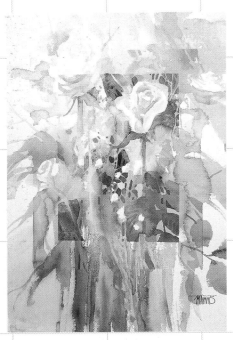

76 **Marilyn Timms**
White Roses I
22 x 15" (56 x 38cm)
WATERCOLOR

Layered design

77 **Annette Novoa**
In Motion II
15 x 15" (38 x 38cm)
GOUACHE

Movement

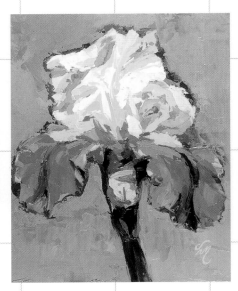

78 **Diane Van Noord**
Iris
10 x 8" (25 x 20cm)
OIL

Paint application

You'll find all the information you want about how each painting was created by turning to the tab number indicated, in sequence from 1 to 100

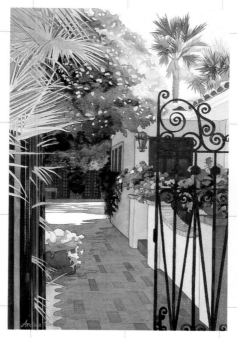

79
Andrea Vincent
Villa Royale Welcome
22 x 15" (56 x 38cm)
WATERCOLOR

Design and color

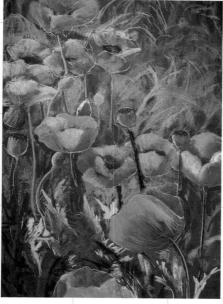

80
Ann Kelly Walsh
Poppy Drift
27 x 19" (69 x 48cm)
PASTEL

Color

81
Thomas A Wayne
Rock Garden
22 x 30" (56 x 76cm)
MIXED MEDIA

Color and line

82
Chuck Wood
Imagine What's in Store
39 x 48" (99 x 122cm)
OIL

Technique

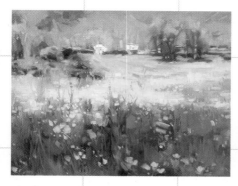

83
Hye Seong Yoon
Spring
14 x 18" (36 x 46cm)
OIL

Simplicity

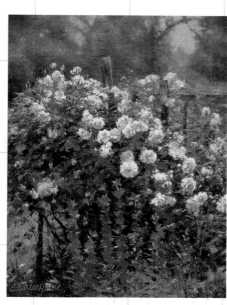

84
Cindy Harlan Youse
Ramblin' Roses
18 x 14" (46 x 36cm)
OIL

Paint application

Find-it-Faster Directory
Color coded numbers let you quickly find the paintings you like,
all the methods and materials used and how each artist painted them

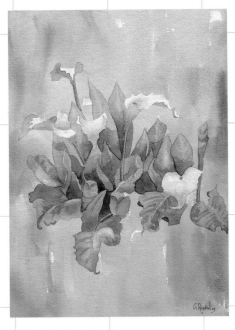

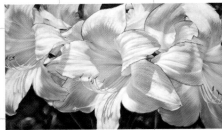

 Lyn Diefenbach
Ruffled Joy
35½ x 59" (90 x 150cm)
OIL

Color

87 **Emi Karakan**
Pond of Tranquility
21 x 27½" (53 x 70cm)
PASTEL

Mood

85 **Gavin Rendall**
Lilies from North Island, NZ
14 x 10" (36 x 25cm)
WATERCOLOR

Technique

88 **Andrzej Gosik**
Magic Gate
33½ x 45" (85 x 114cm)
WATERCOLOR

Light

89 **Bryn Miles**
Lilac
12 x 10" (30 x 25cm)
WATERCOLOR

Design

90 **John Stoa**
Daffodils
22 x 18" (56 x 46cm)
OIL

Style

You'll find all the information you want about how each painting was created by turning to the tab number indicated, in sequence from 1 to 100

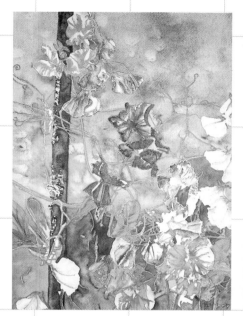

91 **Lainee O'Donnell**
Iced Gems
19 x 13" (48 x 34cm)
MIXED MEDIA

Technique

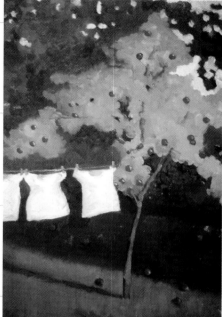

92 **John Atkinson**
Linen Line
18 x 14" (46 x 36cm)
OIL

Contrast

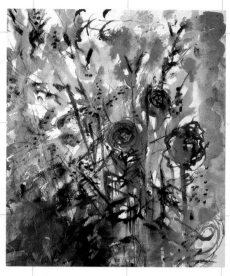

93 **KS Degon**
Wild Flowers
20 x 16" (51 x 41cm)
WATERCOLOR

Technique

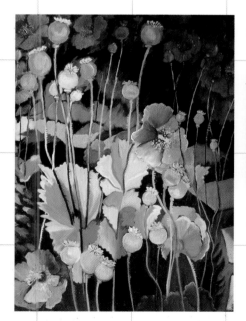

94 **Joanna Crawford**
The Blue Poppy
20 x 16" (51 x 41cm)
OIL

Color

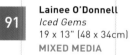

95 **Angus McEwan**
Eye of Flora
41 x 48" (105 x 122cm)
WATERCOLOR/PENCIL

Design

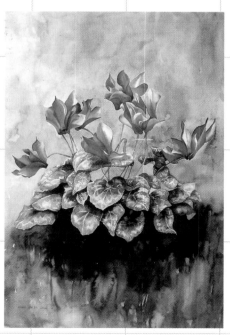

96 **Anna Galea**
Cyclamen
26 x 18" (66 x 46cm)
WATERCOLOR

Emphasis

Find-it-Faster Directory

Color coded numbers let you quickly find the paintings you like,
all the methods and materials used and how each artist painted them

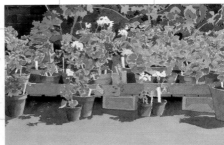

98 **Mary Rodgers**
Ready for Bedding
12½ x 18½" (32 x 47cm)
WATERCOLOR

Design

You'll find all the information
you want about how each
painting was created by turning
to the tab number indicated,
in sequence from 1 to 100

97 **JP De Vynck**
Elizabeth's Garden
26 x 22" (65 x 55cm)
WATERCOLOR

Focal point

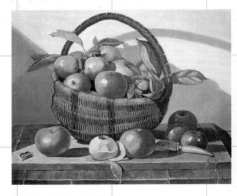

99 **Peter Collinson**
Garden Apple Basket
20 x 24" (51 x 61cm)
OIL

Design

100 **Valentina Bright**
Passion
59 x 47" (150 x 119cm)
OIL

Color

I spotlighted the naturally vibrant colors of the flowers.

Red Hot Meal, watercolor, 11¾ x 17¼" (30 x 44cm)

my inspiration

My painting resulted from a coincidence. On a coffee break, I took a walk in the garden and spotted these spectacular red hot pokers with a tit resting on the blooms. The flowers were located in a semi-shaded area beneath the overhanging branches of a nearby tree. The moment of inspiration came when, for just a few minutes, the bright sunshine filtered through the leaves, illuminating the flowers and bird like a spotlight. The brilliance of the sunlight intensified the vibrant colors against the very dark backdrop. The painting just presented itself to me.

my design strategy

I wanted the viewer to be struck by the flowers first because of their size and vivid contrast with the rest of the painting. Then they discover of the bird, which adds a story to the focal point.

Kelv Holtom lives in Coventry, England → kelvholtom@hotmail.com

Positioning the bird as high as possible on the central flower prevented the impression that the other flowers were slipping off the bottom. For balance, I lowered the flower on the left and placed the ones on the right off-center. For depth, I put the flower nearest the edge into the shadow.

my work process

• I used enlarged photocopies of my reference photographs to establish the design.

• Once satisfied, I covered the back of the photocopies with 2B pencil, then drew lightly over the image onto stretched, acid-free watercolor paper.

• Next, to lessen the starkness of the white paper, I washed over the entire sheet, wet-into-wet, using a large brush and weak mixes of the lighter yellows, greens and reds. I left

some lighter areas and blotted out others with tissue.

• After the paper dried, I used various round brushes to apply stronger washes in some areas and more definite brushwork on the flowers and bird.

• I used a pencil to more clearly define form in the background.

• Finally, I washed in some of the darkest areas to establish the middle tones; then worked the tonal range from light to dark.

the materials I used

support
140lb (300gsm) NOT paper

brushes
⅝" flat wash
no. 8 filbert
various rounds

pencils
2B, 4B

watercolors

	Burnt Sienna	Burnt Umber	Cobalt Blue	Sap Green	
Vermilion					Olive Green
Yellow Ochre					Neutral Tint
Cadmium Yellow					Ivory Black
Lemon Yellow					

I depicted fleeting sunlight by stressing the contrast between light and dark colors.

Summer in the Backyard, oil, 16 x 20" (41 x 51cm)

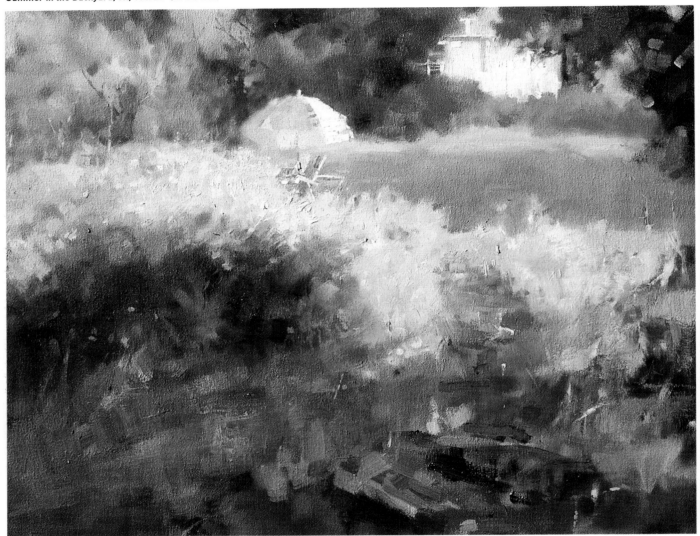

my inspiration

In my search for sunlight, I find that it is both close at hand and remote. It has been there for millions of years, yet at the same time, it is new. It shines brightly but disappears in a twinkling, and although it has vanished, it will come back. In my painting, I tried to keep the early summer sunlight in my backyard with my brush.

my design strategy

The bright parasol, the focal point, catches the eye because it is so different from the shapes and colors around it. The shrubs in front, the shadowy part of the foreground, bend gently and contain several elf-like, dancing light spots for balance. Behind the

parasol are some dark, tranquil trees. A path leads from the bottom of the painting to the parasol. The entire painting is an integration of repose and motion.

my work process

- I painted from life without any preliminary sketches or color studies.
- First, using Burnt Umber mixed with turpentine, I drew the contours of objects and the boundaries of the bright and dark parts.
- Next, I blocked-in with more colors and heavier paints mixed with a 60:40 ratio of turpentine and linseed oil, paying attention to the contrast and tonal values.

- I used thick paints for the places around the parasol, creating more detail.
- With a fan brush, I painted the dark part quickly, deliberately creating the effect of obscurity

so that this dark area would be subjugated to the bright ones.
- After that, I contrasted the bright areas with the dark, creating the sense of motion and repose.

the materials I used

support
stretched canvas

brushes
fan brush

house paintbrush

medium
turpentine and linseed oil in a 60:40 ratio

oil colors

LEMON YELLOW · YELLOW OXIDE · CADMIUM ORANGE · BURNT SIENNA

BURNT UMBER · BRILLIANT YELLOW GREEN · PERMANENT GREEN LIGHT · PHTHALO GREEN

CERULEAN BLUE · ULTRAMARINE BLUE

Quizhen Wei lives in California, USA → quizhenweig30@msn.com

My computer came in handy as a color and design tool.

Tropical Patterns, acrylic, 22 x 33" (56 x 84cm)

my inspiration

While on vacation in Hawaii, my husband and I stayed at a lovely resort with an interior garden. There I saw a cluster of crotons bathed in a stream of light coming from the slatted rafters overhead. That light revealed beautiful colors and enchanting tropical patterns.

my design strategy

I wanted to stress color, contrast, and variation. Using my computer to alter the reference photos I took on site, I recreated the vibrant colors and the lights and darks to evoke a sense of drama. I was intrigued by the flowing lines of the plants and how they suggested movement. Because there were so many leaves of the same type, I painted repeating patterns of similar shapes.

my work process

- Using my computer, I cropped my main reference photo so that the focus — the dramatic light — was in the lower right corner. Then I heightened the colors in all the photos until they matched my memory.

- Next I deleted the glare in the main photo and cut and pasted the background from another, changing its colors from green to blue-purple.

- Then I sketched the design, transferred it to canvas, and began painting.

- While I painted, I referred to both original and computer-altered photos. Using artistic license, I made certain colors more vibrant and deleted tedious detail from the leaves.

important tip

There are those who insist artists should always paint outdoors. Yet outdoor painting isn't always possible. If I hadn't taken these photos, this painting would never have happened.

the materials I used

support
stretched canvas

brushes
nos. 2, 4, 6, 10 brights and filberts

medium
acrylic glazes

acrylic colors

Shizuko Barbara Hanson lives in Colorado, USA → hshanson@worldnet.att.net

I found the right colors for the roses by adding shades to my palette.

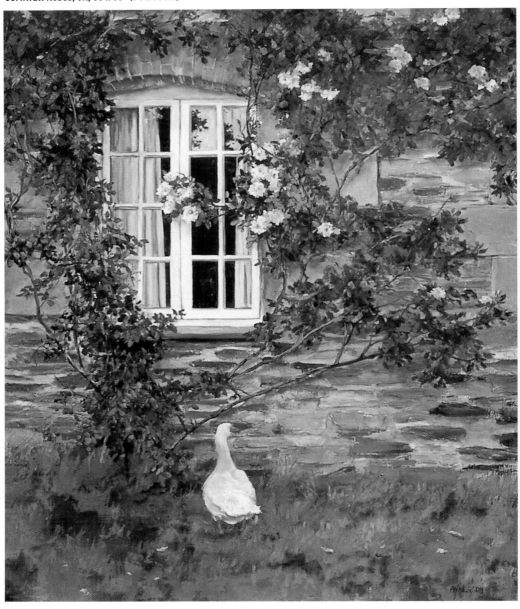

Cornwall Roses, oil, 36 x 30" (91 x 76cm)

my inspiration

While studying mural design in Cornwall, I stayed in this lovely cottage where the ducks would greet us every morning. This duck was my favorite because he seemed to be waiting for us to let him in. He was an appropriate addition to the roses and stone cottages that I love to paint.

my design strategy

I began with the window, then went on to the garden. My main challenge was the design of the foliage and the unification of the palette. To direct the viewer's eye around the painting, I realistically designed the growth of the climbing roses and reworked the greens in the leaves and grass many times, using combinations of Viridian for the blue-green rose leaves and Sap Green for the grass. Although the colors and texture of the stone needed no embellishing, the roses, spindly canes, and foliage did. In the first stage of this painting, I had used a deep red for the roses, replicating the few actual flowers still in bloom. When finished, I realized the deep reds did not blend with the tonal value of the painting as a whole. Away went the red and in came many shades of white and pink until I knew that it was right!

my preparation process

- I painted in the studio from photos.
- I began with a wash of Transparent Oxide Red over the whole canvas.
- Then I lifted out the lights with a paper towel and a brush.
- Now I was ready to paint.

my advice to you

I can't imagine painting believable gardens without a passionate love and intimate knowledge of flowers from years of experience gardening and painting. I don't recommend painting flowers from photos until you have painted them from life many times. Buy a bouquet of roses and spend hours painting just one. Notice that white flowers aren't white, pink aren't pink, and so on. And spend a lot of time just painting greens.

the materials I used

support
canvas

brushes and tools
mongoose brights and filberts

nos. 2, 4 synthetic rounds

palette knife

medium
5 parts turpentine, 1 part stand oil, and 1 part Damar

oil colors

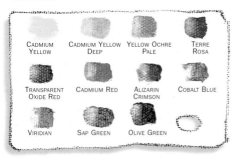

CADMIUM YELLOW | CADMIUM YELLOW DEEP | YELLOW OCHRE PALE | TERRE ROSA

TRANSPARENT OXIDE RED | CADMIUM RED | ALIZARIN CRIMSON | COBALT BLUE

VIRIDIAN | SAP GREEN | OLIVE GREEN

Kathy Anderson lives in Connecticut, USA → www.kathyandersonstudio.com

Diagonal shadows and glowing colors dramatized a placid scene.

Spring at Chalumeau, oil, 20 x 24" (51 x 61cm)

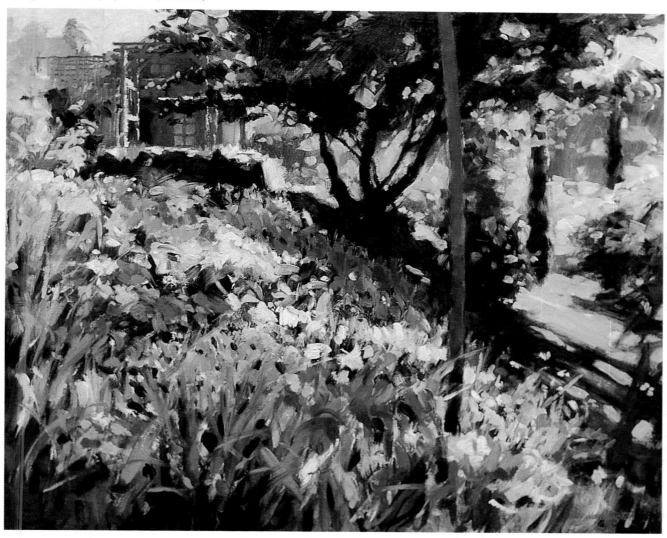

my inspiration

This painting shows my own garden at the height of spring. The strong backlight made the blossoms and leaves glow like a stained-glass window, and the contrasting shadows made the colors even more intense.

my design strategy

I used the strong diagonal shadow from the spreading maple tree as my main design structure, in addition to the vertical stem of a young cherry about a third of the way in from the right. The naturally steep slope of the land gave a dynamic feel to the composition, and the placement of the cottage high in the top left corner provided balance. Normally such a strong directional composition would drag the viewer's eye out of the picture, but because of the bright colors, the eye explores and follows the sunlight from front to back, then straight up to the house.

my work process

- I sketched my basic composition directly onto canvas board using a large brush and thin paint.
- Next I blocked in the key shapes, shadows and bright areas.
- Using thicker paint, I built the picture progressively.
- By establishing contrasts between lights and darks, I achieved the particular sunlit glow I was seeking.
- Finally, using artistic license, I fine-tuned to obtain a balance in the distribution of the pure pigments of the blossoms so that they were not repetitive or too concentrated in one area.

the materials I used

support
canvas board

brushes
nos. 2, 4, 6, 8, 10 bristle flats

oil colors

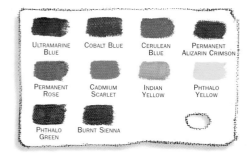

ULTRAMARINE BLUE · COBALT BLUE · CERULEAN BLUE · PERMANENT ALIZARIN CRIMSON · PERMANENT ROSE · CADMIUM SCARLET · INDIAN YELLOW · PHTHALO YELLOW · PHTHALO GREEN · BURNT SIENNA

Ray Harrington lives in New South Wales, Australia → raykat@lisp.com.au

Like a theatrical set designer, I drew attention to my lead characters with light and shadow.

Spring Abundance, oil, 24 x 20" (61 x 51cm)

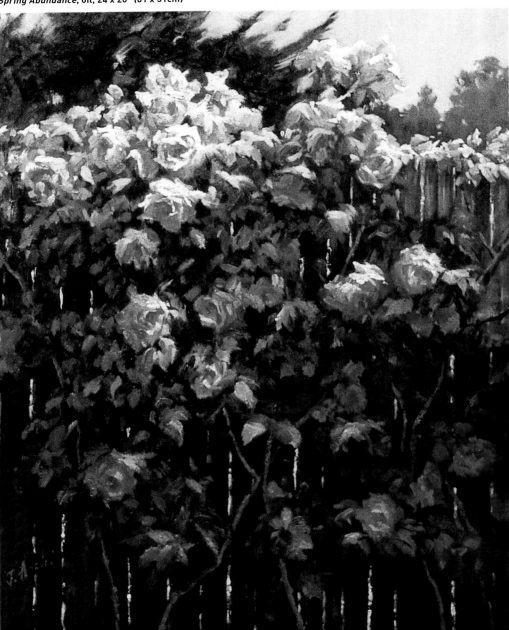

my inspiration

Someone told me once that raising my own roses would not only enhance my painting but would add some fragrance to my work. The climbers I planted in my daughter's garden were showing off brilliant delights. They were so heavenly that I couldn't wait to set up my easel to capture the breathtaking spray of roses!

my design strategy

In theater, for a star to shine, all the supporting actors must work together to enhance the star's strength. I always apply this same theory to my painting. Flowers can't glow without having a rich, dark, shadowy background to balance them.

Because the roses were climbing to the top of the fence, the horizontal and vertical lines were already clearly set. To create an interesting shadow pattern, I simply designed the shaded area of the plants in diagonal shapes to break up some vertical lines of the fence slats. At the same time, I arranged the rose canes at right angles so that they also supported the diagonal pattern. The contrasts in my design were enhanced with opposing color temperatures and complementary colors.

my painting approach

In the early stages of my work, I use very little white or painting medium. Color brings all the excitement into a painting, so I work with color temperature, local values and edges (sharp or lost) to accurately present what I want to express. This is the hardest part and I struggle with it every time I paint, but I love this challenge. I then use transparent colors as much as I can where I need them. I try to make sure the highlights work with the rest of the painting.

something you can try

This painting was done outdoors from life. Not only do the true colors and values present themselves more clearly, but the subject and setting provide wonderful air, sound, aroma and "visual conversation" that will help you understand how to paint.

Joan Aochi lives in California, USA → jaochi1@earthlink.net

the materials I used

support
stretched canvas

brushes and tools
nos. 4, 6, 8, 10 filberts
nos. 8, 10, 12 flats
nos. 6, 8 round sables
palette knife

medium
odorless turpentine
painting medium

oil colors

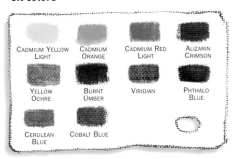

CADMIUM YELLOW LIGHT | CADMIUM ORANGE | CADMIUM RED LIGHT | ALIZARIN CRIMSON

YELLOW OCHRE | BURNT UMBER | VIRIDIAN | PHTHALO BLUE

CERULEAN BLUE | COBALT BLUE

Spontaneous, calligraphic brushstrokes yielded a powerful feeling of vitality.

Hibiscus, watercolor, 14 x 20½" (36 x 52cm)

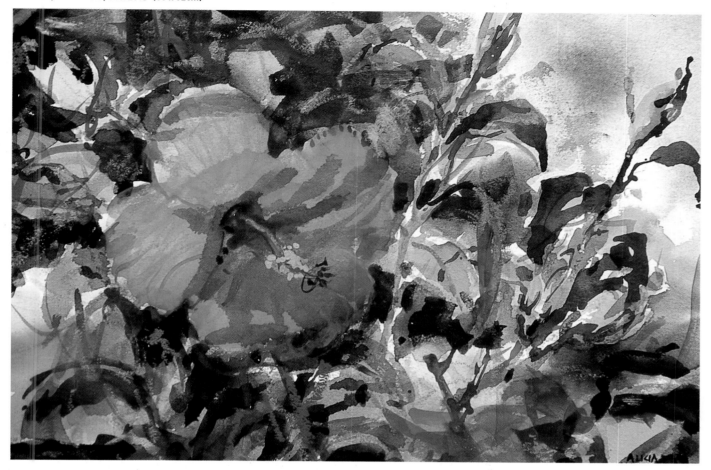

my inspiration

Seated on my folding stool near a large potted hibiscus plant, I became excited by the effects of the bright sun shining from behind the plant. The flowers appeared saturated with vibrant, glowing color, yet at the same time, fragile, translucent shadows showed through. One flower shouted at me, and the challenge was on to present this transient moment.

my work process

- With a 2" wash brush, I wet the watercolor paper and charged in sky color in the upper right. Using an orange colored pencil, I "scribbled" (sketched) until the design began to take form. My strategy was to establish the force of the main flower first and then work for support.

- Still using the wash brush — now saturated with reds, pinks and oranges — I brushed in

flower color in three places. I then added some bright, warm yellow-greens for the foliage. I was painting in the moment as spontaneously as possible while still trying to apply the rules of good painting!

- I paused to take a look. To my dismay, the main flower was not empowered with the vitality I saw. Maybe I could save it! With clear water, a clean brush and absorbent rags, I gently scrubbed the paint off and recharged the area with stronger color. Luck was with me, and I was happy with the richness of the second try.

- Turning to the rest of the painting, I covered some of the original bright greens and defined leaf, bud and stem forms with midvalue greens.

- While the paper was still damp, I painted the shadows shining through the large flower with a dark mix of pigments. More

accents of strong darks made the flower pop out.

- Working over the whole painting, I adjusted relationships and added calligraphic detail. Thick Cadmium Yellow is naturally opaque and worked well for the flower stamen.

- When the painting was dry, I played around with placing some bright spots of color over

the darks with water-soluble oil pastels.

my advice to you

Try sketching with an orange colored pencil. It blends well with watercolor and the painting stays bright, unlike graphite pencil. Build on your own strengths, abilities and passions. This is the road to a signature style.

the materials I used

support
140lb (300gsm) rough paper

watercolors
Raw Sienna
Burnt Sienna
Raw Umber
Burnt Umber
Ultramarine Blue
Phthalo Blue

brushes
2" wash
assorted rounds and flats

Cerulean Blue
Opera
Alizarin Crimson
Cadmium Red Light
Cadmium Yellow Medium
Phthalo Yellow

Alicia Meheen lives in California, USA

Working under natural light forced me to work quickly and spontaneously.

Poppies, oil, 12 x 16" (30 x 41cm)

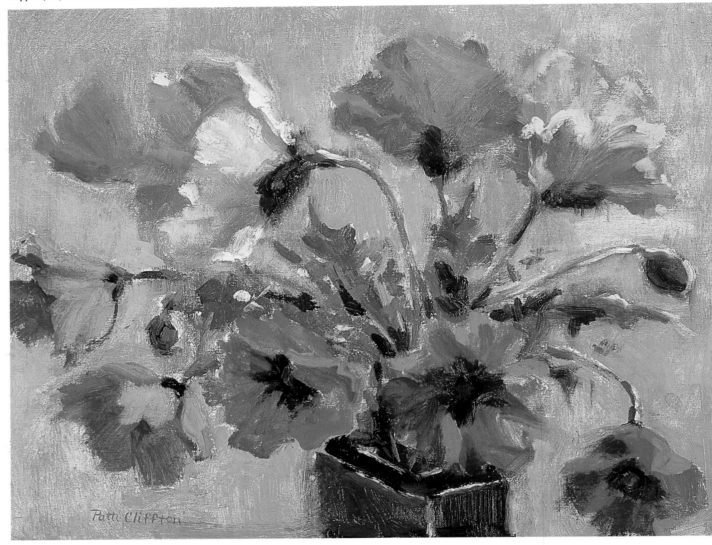

my inspiration

While on a trip to Taos, New Mexico, I noticed a bunch of bright red poppies outside a shop in afternoon sunlight. I was so inspired that I went home and began a series of poppy paintings.

my design strategy

I am intuitive and spontaneous in my painting method. My main concern is to develop a focal point that's properly placed and to use value contrast to draw attention to it. I then look at the shapes of the negative spaces, trying to make them all differ in size. I do not consciously think about the path the eyes will follow.

about the light

I prefer to work from life under a natural light source, especially afternoon side lighting. The forms are easier to see and the shadows more pronounced.

my work process

• With a clear concept in mind, I loosely sketched the elements.

• I freely blocked in the values with thin, transparent washes.

• Switching to oil paints mixed with my own medium, I started putting in all of the intense and dark colors, using no white.

• Gradually, I worked toward the lights, using pure paint.

the materials I used

support
linen panel

brushes
nos. 2 to 10 hog bristle

oil colors

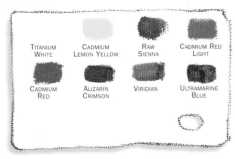

TITANIUM WHITE CADMIUM LEMON YELLOW RAW SIENNA CADMIUM RED LIGHT

CADMIUM RED ALIZARIN CRIMSON VIRIDIAN ULTRAMARINE BLUE

medium
equal parts Damar, linseed oil and turpentine

Patti Cliffton lives in California, USA → www.patticliffton.com

By tightly cropping in on the bold value contrasts of my subject, I projected the impression of bursting energy.

Ombre et Lumiere, watercolor, 19 x 26" (48 x 66cm)

my inspiration

Arriving at my studio one cold January morning, I found myself lacking inspiration. I began to shuffle through old photographs, partly to get some ideas but mostly to cheer me up. Suddenly, a picture of gerberas caught my attention. It wasn't the gerberas themselves but rather the light falling on a bunch of lilies at the back of the picture. It was as though the lilies were fighting their way up so they could get a little bit of sun, too. That was all the inspiration I needed.

my design strategy

I absolutely wanted my drawing to project an image of a bustling mass of flowers. To focus the observer's attention on the flowers and to accentuate the effect of light, I decided to zoom in and make the background dark and abstract. Then, to make it more dramatic, I inserted a large stem across the mass of flowers that anchors the subject. Lily buds and a flower were added in the bottom right corner for balance. They serve as an entry point for the viewer's eye.

my work process

- Once I had decided on the size of the painting, I began a drawing on a graphite sheet, which allowed me to perfect the composition without erasing on the watercolor paper.
- After transferring my finished drawing, I used a drybrush method to block in the flowers, the main stem and the buds. I feel that watercolor's transparency and fluidity best render the lightness and fragility of flowers.

- I then attacked the background in an abstract style, going from very dark on the left side to much lighter at the far right. I mixed different pigments directly on the paper and used my brush to splash a bit of water over it. To give the background depth and balance, I used a brush saturated with pigment to freely draw in the silhouette of a stem and its leaves.

- I put the painting aside to reflect on it. As I'd done throughout the process, I observed it with an overhead mirror and a reducing lens to get a global view of the work. After a few days of careful study, I made various touch ups.

the materials I used

surface
hot-pressed illustration board

watercolors
Paynes Gray
Ultramarine Blue
Sap Green
Rich Green Gold
Carbazole Violet
Geranium Lake

brushes
nos. 10 and 12 synthetic rounds
variety of flats

Rose Madder Quinacridone
Quinacridone Burnt Orange
Quinacridone Gold
Cadmium Orange
Hansa Yellow

Suzanne Valiquette lives in Quebec, Canada → sue.valiquette@sympatico.ca

This high-impact image is the result of dramatic backlighting, tight cropping and attention to detail.

Bird of Paradise, oil, 16 x 36" (41 x 91cm)

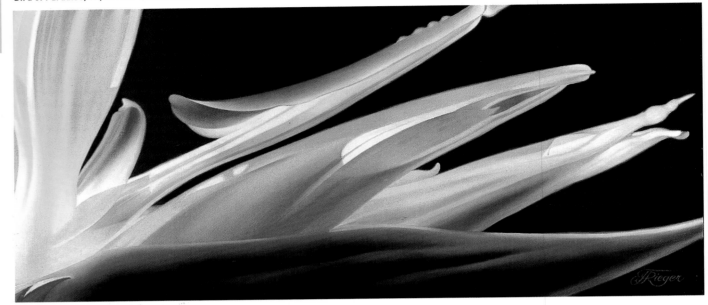

my inspiration

I have always been fascinated with nature's spectacular creations. As I go through life with open eyes, always observing nature, I have found myself concentrating more and more on flowers. When I spend time studying at close range the detail of a bloom, I am transported into another world that is exciting and intriguing. I am in awe of nature's creativity and imagination.

My wife's garden, overflowing with beautiful flowers, and botanical gardens full of exotic tropical flowers are constant sources of inspiration. This bird of paradise fascinated me until the urge to paint it became irresistible. It had such an unusual and striking shape, and I found the colors very exciting, varying from bold to very delicate. The more I studied the flower, the more excited and determined I became to paint it. I usually let my feelings and intuition guide me to my subject matter.

my design strategy

I used to paint flowers in the traditional way with the light source coming from above my left shoulder, but I've since discovered that backlighting creates a much more dramatic effect. To support the high-impact image I had

in mind, I spent a lot of time composing, ending up with a design that bordered on the abstract. I wanted to emphasize the dynamic and powerful shapes of the flower petals as well as the delicate backlit details.

composing with a camera

There are many reasons I prefer to work from slides and then create the paintings in the studio rather than on site: I can work in any season no matter the weather (it's easier to work on a large canvas indoors, out of the wind); I don't have to rush to finish before the flowers wilt; and I can "freeze" the exact time of day, lighting and mood I want.

I compose the image to some degree with my camera. As I shoot the slides, I zoom in and out with the lens and study the flower from every angle. Once I select a composition, I decide how large I want the painting to be and scale up the image to the desired size.

why I chose this medium

Oils best suit my style of painting. I work very meticulously and in great detail. The slow drying time is an advantage for me.

the materials I used

support
stretched canvas

medium
mixture of 80 percent odorless solvent and 20 percent pale drying oil

oil colors

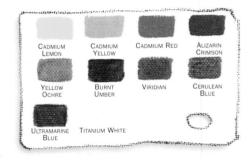

CADMIUM LEMON CADMIUM YELLOW CADMIUM RED ALIZARIN CRIMSON

YELLOW OCHRE BURNT UMBER VIRIDIAN CERULEAN BLUE

ULTRAMARINE BLUE TITANIUM WHITE

brushes
nos. 1, 2, 3, 4 round sables
nos. 1, 2, 3 bristle rounds
nos. 2, 4, 6, 8 filberts
nos. 2, 4, 6, 8 flats
nos. 2, 4, 6, 8 brights

Theodor Rieger lives in Ontario, Canada → theo.reiger@sympatico.ca

To enhance the sense of light in my painting, I incorporated the white of the paper into my design.

Herbaceous Border, Chatsworth Garden, watercolor, 21¾ x 15¾" (55 x 40cm)

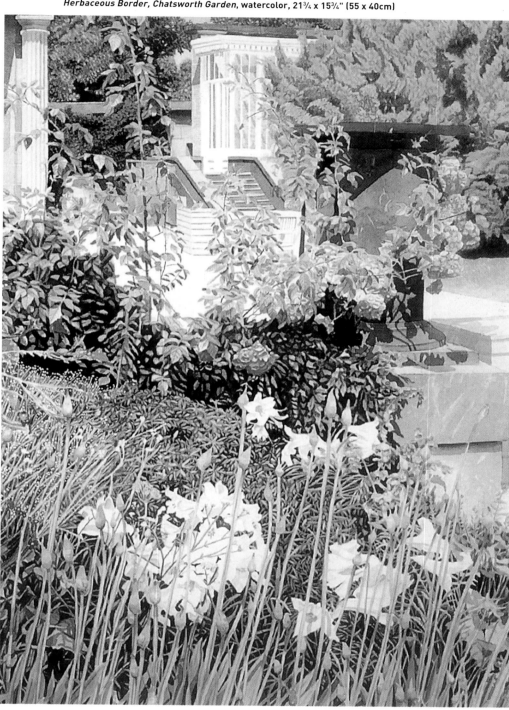

my inspiration

Because I am a passionate gardener and painter, Chatsworth, one of the great historic gardens of Derbyshire, has long been a favorite place. This painting is one of a series depicting the garden. I wanted to capture the beauty of the flowers in their grand setting.

my design strategy

I wanted the flowers in the border to be the main focus of the painting, with the grand architectural details only hinted at in the background. The viewer should feel up close to the flowers.

my work process

- I have often sketched in the garden but wanted to make a more detailed finished painting. Weather and the time required to create such a painting necessitated that most of the work be done in the studio.

- On site, I took carefully composed photographs. However, I also painted color references in watercolor so that I could rely on my personal, signature palette instead of the colors found in the photographs.

- In the studio, I drew lightly and accurately with an HB pencil so that I could later rub out any pencil lines that became intrusive in pale areas. For me, accurate drawing is the key to sorting out the challenging tangle and intricacy of flowers and foliage.

- I painted all of the light tones first, using clear, delicate colors. I then gradually added up to 10 layers to achieve the deeper tonal areas. I used a very absorbent paper so that the layers would create a lovely, velvety effect.

the materials I used

surface
140lb (300gsm) paper

brushes
nos. 0, 1, 2, 4 sables

watercolors
Green Gold
Sap Green
Olive Green
Viridian
Lemon Yellow

Cobalt Blue
Neutral Tint
Raw Sienna
Sepia
Permanent Rose

Rosalind Forster lives in Derbyshire, UK

Vivid color and strong contrast produced a dramatic painting.

The Homestead #2, oil, 16 x 24" (41 x 61cm)

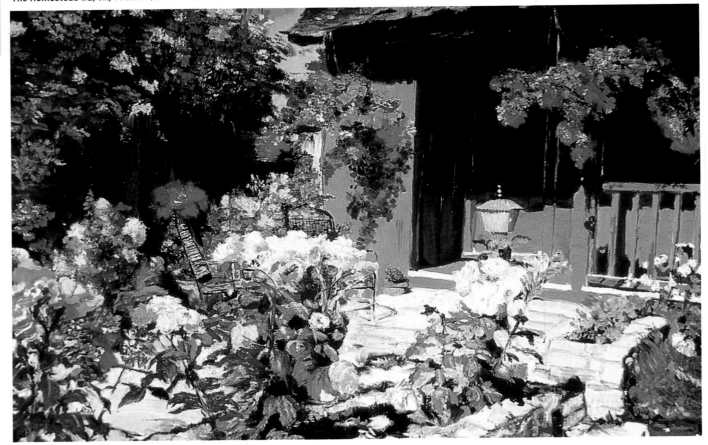

my inspiration

On a visit to Carmel, California during the summer, I stopped at an inn where the foliage was in full bloom. The afternoon sun had produced some compelling contrasts. I was struck by the color and quantity of flowers in front of a variety of interesting structures. I had found my inspiration for a painting that would come alive with color.

my design concept

I approached the canvas with the primary view of the flowers and the striking contrast of the building behind them. The angle of the sun had projected dramatic shadows that were important to convey because they brought the viewer's eye from the left corner, to the steps of the building, then to the sky at the top.

my working process

- I began by sketching the scene in charcoal and spraying it with a fixative.
- Then I blocked in all the values using variations of three colors: Ultramarine Blue, Cadmium Red and Titanium White.
- After photographing the garden, I returned to my studio to do the painting. I relied on photos to help me keep the light consistent.
- I began with primary colors — Prussian Blue, Alizarin Crimson and Cadmium Yellow Pale — and then added colors as they became apparent to me.

try this yourself

Try painting with water-soluble oils. They dry quickly and are easy to clean up. They're non-toxic, and still maintain the qualities of traditional oils.

the materials I used

support
canvas

other materials
fixative

water-soluble oil colors

CADMIUM YELLOW PALE · YELLOW OCHRE · PERMANENT ROSE · CADMIUM RED

ALIZARIN CRIMSON · VIRIDIAN GREEN · ULTRAMARINE BLUE · PRUSSIAN BLUE

RAW UMBER · TITANIUM WHITE

brushes and tools
nos. 5, 10, 12 sable brights
nos. 1, 4, 6 sable rounds
nos. 4, 8 sable filberts
2⅛" palette knife

By layering acrylic glazes over a tonal underpainting, I was able to keep my colors subtle and moody.

Susan Ashbrook

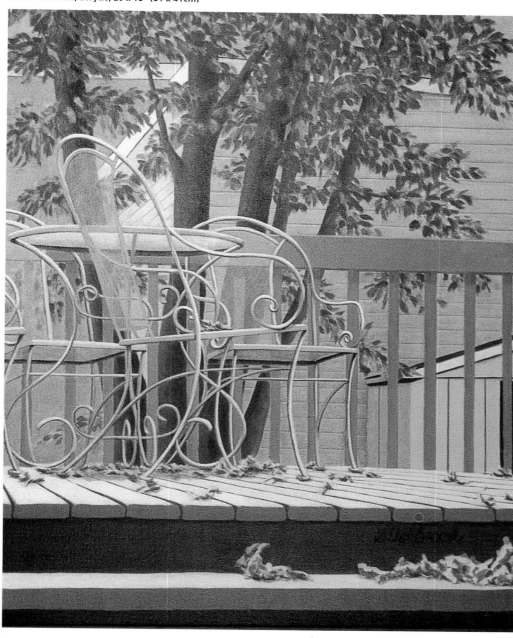

Outer Sanctum, acrylic, 20 x 16" (51 x 41cm)

what I wanted to say

This is my deck, my sanctuary, overlooking the Ottawa River. I like to spend time here on warm summer evenings, unwinding and visiting with friends. One day in early autumn, I came around the corner of the house and was struck with the foreboding feeling that comes when the leaves begin to fall. My sanctuary would soon be closed for the winter. I wanted to capture the peacefulness of this special place, while at the same time making a comment about its seasonal restrictions.

my design strategy

Through a series of drawings done on tracing paper (so I could easily make changes and refinements) I worked out the composition. I left in the garden shed because I thought it was helpful in drawing the eye from the table and chairs down to the leaves on the steps. But I eliminated some handrails and simplified my neighbor's house and garage so that they would not compete with the principle focus of the painting — the chairs, table and leaves.

my work process

- I began by transferring the final drawing to a stretched and primed canvas.

- My next step was to produce a tonal underpainting by using a series of seven pre-mixed values from black to white. I started with the areas of darkest value, which helped me gauge the rest. When the tonal underpainting was finished, it looked like a black-and-white photograph.

- When dry, I applied a glaze of acrylic matte medium tinted with Cadmium Yellow to provide a warm, unifying undercolor.

- Next came the application of color. After thinning each with matte acrylic medium, I applied all of my colors as transparent glazes over the underpainting. This allowed me to adjust the subtlety of colors in each layer.

- The highlights went in last.

- Once the piece was finished and signed, I applied two coats of acrylic matte medium over the entire surface to protect it and give it an even, satin finish.

try these tactics yourself

The acrylic glazing process is extremely helpful to new artists who have not yet mastered all of the fundamentals. By working strictly with tonal value in the underpainting, you can see the depth, form and contrast without the interference of color. You can then deal with color separately.

the materials I used

support
stretched canvas

brushes
½" and 1" flats
nos. 2, 6, 8 synthetic rounds

medium
acrylic matte medium thinned slightly with water

acrylic colors
Titanium White
Cadmium Yellow Lemon
Cadmium Yellow Medium
Yellow Ochre
Burnt Sienna
Burnt Umber
Ultramarine Blue
Prussian Blue
Paynes Gray

Susan Ashbrook lives in Ontario, Canada → www.susanashbrook.com

I wanted to entertain the eye with unconventional choices: common wildflowers and a glass jar as a container.

The Ball Jar, oil, 23 x 20" (58 x 51cm)

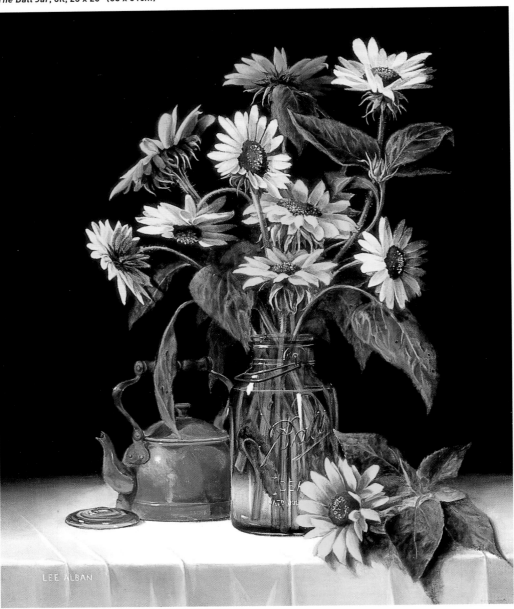

my inspiration

The antique blue Ball canning jar fueled this composition. Flowers are frequently arranged in delicate vases, but I was convinced that an unusual, less formal container would enhance the presentation as well as entertain the viewer. The composition might well have featured zinnias or some other botanical, but I visited a local grower and chose flowers from his "cut-your-own" field.

my design strategy

The size of the canvas was chosen to adequately convey the majesty of the subject. I then placed the Ball jar off-center, and carefully arranged the lighting to reveal its surface characteristics. Next, I placed the flowers at various heights and turned their heads to present interesting surfaces, tonal values and textures. I then used the downward angle of some of the leaves to intentionally guide the viewer from the bouquet to the copper kettle, to the Ball jar, and back to the floral. I used one stem to break the line of the table's edge.

my work process

- I chose to paint these flowers from life because it allowed me to see the subtle nuances of color and value that might not have been discernible in a photograph.

- Initially, I worked fast to get down my design before the stems and flowers wilted. I quickly sketched in the rhythmic positions of the flowers and stems with Raw Umber, not attempting to establish any detail.

- Then I began with the blossoms, painting directly, establishing the colors and values in one sitting. As the flowers died and were replaced, the challenge was to use the new flowers to help complete the details of the original blooms.

- I saved the painting of the Ball jar, copper teakettle and tablecloth for last. They weren't going anywhere!

the materials I used

support
double-weave Belgian linen, stretched and primed with 3 coats of rabbit skin glue and 2 coats of Lead White

brushes
various bristle filberts

various synthetic-blend filberts

various synthetic-blend rounds

medium
Maroger

oil colors

LEAD WHITE	TITANIUM YELLOW	CADMIUM YELLOW LIGHT	YELLOW OCHRE
CADMIUM RED LIGHT	CHROMIUM OXIDE GREEN	SAP GREEN	BURNT SIENNA
RAW UMBER	ULTRAMARINE BLUE		

Lee Alban lives in Maryland, USA → leealban@aol.com

I've tucked a hidden secret into my painting to reward those viewers who spend a long time looking at it.

Bayou State Garden, pastel, 12 x 12" (30 x 30cm)

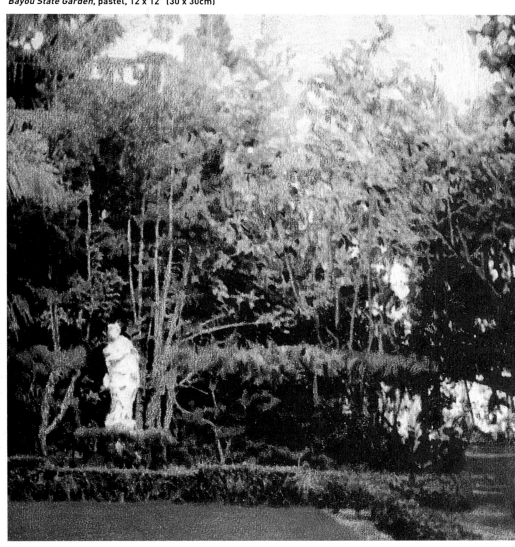

my inspiration

Something about the loneliness and isolation of the statue drew me in. Then I noticed her gaze seemed to fall on the urn. The precise geometry of immaculate grass and hedge in front, contrasted with the wild, sinuous disorder of trees behind her seemed an appropriate mirror for the mismatch of statue and urn. Since I like paintings that reward viewers for looking closely, I decided to make the statue and her surroundings the obvious subject while letting the urn — her object of desire — sneak up on the viewer who keeps looking.

my design strategy

The painting can be bisected into two almost perfect triangles: the denser trees, statue and lawn, and the airier expanse of trees with some tree limbs and the urn. In essence, there is one triangle for each actor in the drama. I wanted the statue to be the only light object in her triangle, and for the urn to be the weightiest object anchored in the other half. I took my color scheme from the Arts and Crafts movement. I felt the rose/olive fantasy range would provide more mood, less botany.

my painting approach

I work mostly in pastels, and generally work out my ideas with pastel in hand rather than from pencil sketches. I generally go through a number of iterations before I settle on a composition that pleases me. The recycling bag is filled with ripped-up attempts! But for me, this method keeps my work fresher than trying to follow pencil lines on the page.

the main challenge in painting this picture

I'm primarily a figurative painter, and this is one of a very few paintings I've done without a single living person portrayed. Relationship, drama, tension, character — these are the qualities that keep me fascinated and driven to paint. It wasn't until I found a way of setting the statue in her surroundings in a way that suggested tension and longing that the whole piece came to life for me.

my advice to you

When you find an object you like, such as an ordinary garden statue, investigate the way light and shadow, angle, view, surroundings, distance, your materials and even the strength or delicacy of your line or brushwork can contribute to telling an overall story. Then try painting a number of different stories with the same elements. The possibilities are limitless.

the materials I used

support
pastel paper in a warm, golden color

other materials
cotton swabs

Rebecca J Becker lives in Oregon, USA → rebeccajbecker@ix.netcom.com

William Bensen

Cool highlights drybrushed over my warm focal point exaggerated the glowing light in my subject.

Once upon a Time, oil, 20 x 24" (51 x 61cm)

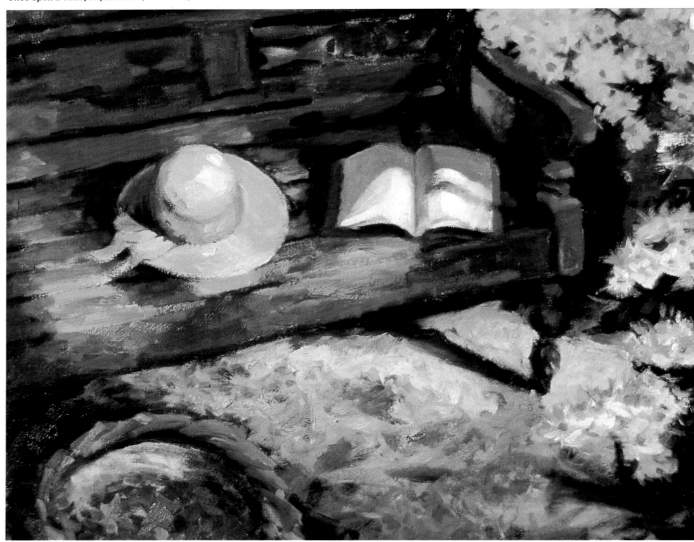

what I wanted to say

There are two consistent themes in my paintings: how light surrounds the environment, and the use of psychological perspective to engage the viewer. With this painting, I added the hat and the book to draw the viewer into the story: "Does the viewer not only feel the harmony of nature that surrounds us but also the peace that lies within?" Incidentally, the book is an anthology of children's stories, hence the title of the painting.

my design strategy

The painting is a design of golden ratios. The primary elements are off center: the bench, the book, the hat and the flowers. The only fixed element in the center is the open air, contributing a sense of "airiness" to the painting.

my work process

- First, I laid in a general sketch using diluted Ultramarine, which dried quickly.

- To block in my colors, I started with the dark, cool shades, gradually mixing in slight amounts of Indian Yellow and other warmer colors. I used the opposite approach to block in the light tones, beginning with combinations of warmer colors and then adding Alizarin and Ultramarine in various degrees. Then I let the canvas dry.

- Next came the fun part — the highlights. I used touches of cool Viridian to enhance the darks. I then mixed up a light, cool combination of Indian Yellow and white, which

I drybrushed over the warm color of the bench. The contrast of cool over warm made these highlights jump out.

the materials I used

support
stretched canvas

brushes
nos. 2–8 filberts

oil colors

CADMIUM YELLOW · INDIAN YELLOW · CADMIUM RED · ALIZARIN CRIMSON

COBALT BLUE · ULTRAMARINE BLUE · VIRIDIAN · TITANIUM WHITE

William Bensen lives in Virginia, USA → www.williambensen.com

The attention-getting vibration of orange against its complement, blue, inspired this dynamic floral still life.

Oranges & Peonies, oil, 20 x 16" (51 x 41cm)

the main challenge in painting this picture

I am not comfortable with orange as a dominant color for a painting, so I deliberately challenged myself to use orange. To make it exciting, I played off the optical vibration that occurs when a color is paired with its complement — in this case, a rich, bright blue.

my design strategy

I wanted a simple eloquence in my painting, so I arranged the setup with harmonious relationships in mind. Notice how the natural, irregular shapes offset the stronger lines of man-made objects. To balance the intense pairing of blue and orange, I then surrounded this focal area with neutrals, especially the stark white teacup. I also provided a small object (the cup) to contrast the large, arching canopy of flowers, and included an empty frame as a restful area to the busy-ness of the rest of the painting.

my work process

- First, I drybrushed with just enough Burnt Sienna to place the basic shapes. Then I put in the background color, leaving the areas for the flowers, pot and cup more or less untouched.

- My next step was to establish my transparent darks. I took a lot of care with these so that I wouldn't have to repaint them, which can make them overly heavy and dense.

- Turning to the flowers, I quickly laid in intense color in their centers and worked my way out, lightening my values as I went. I focused on injecting an emotional quality into the tender petals, rather than rendering them.

- I then developed the rest of the elements, working as simply and directly as possible, yet still providing the suggestion of detail. Giving the oranges enough weight to balance the vase of flowers was essential.

- Finally, I laid in the cloth with a palette knife. This texture makes the other elements look that much softer and delicate by comparison.

HOT TIP

One of the most difficult principles to understand is the delicate balance between bright and neutral colors. If you have an intense light source, the objects in direct light will be neutral and your shadow colors will be rich. But under a more subdued light source, the objects in direct light will have vibrant color and your shadows will be dull.

the materials I used

support
canvas-covered Masonite

brushes
bristle and sable flats

oil colors
Titanium White
Raw Sienna
Indian Yellow
Cadmium Red
Alizarin Crimson
Burnt Sienna
Viridian
Ultramarine Blue

Betty J Billups lives in Idaho, USA → www.bettybillups.com

I used bold, inventive color in the negative space to lift my subject.

Iris Pizzazz, watercolor, 30 x 22" (76 x 56cm)

my inspiration

My aim was to play with the shapes and color of a familiar subject. I wanted to twist and turn edges, create amusing patterns, and use bold, exciting color that would bear no relation to local (actual) color. This painting was the fourteenth in a series of experimental paintings of iris.

my design strategy

I zoomed in on the subject to create drama and chose colors that I thought would vibrate happily side by side. I limited my palette because sometimes the most dynamic paintings use only a few colors. I was particularly interested in exploring the juxtaposition of Manganese Blue and Cobalt with the addition of some subtle purples. I mixed in greens from the cooler part of the color wheel to create overall harmony. By using these three adjacent colors on the color wheel (an analogous color scheme) I unified the busy area at the bottom of the painting. The strong vertical lines in that area lead the viewer's eye upward. Once your eyes reach the flowers, the vivid red background spotlights the main blossom.

my work process

- Before beginning, I made a small pencil sketch using just three values: white, medium and dark. This helped me place the three big shapes in such a way that the negative space was just as interesting as the positive space.

- On top of this drawing I tested the three main colors I wanted to use.

- Then, using pencil on 140lb cold-pressed paper, I resketched the three major shapes.

- I applied color with a no. 16 round brush and 2" flat brushes, painting the large red negative spaces first, allowing them to define the positive shapes as I went. I didn't work with the intent of relating these shapes to reality — they just had to be interesting and fun.

- Because I was too impatient to prestretch my paper, I waited until the work was finished and

completely dry before I did this step. I wet the back of the paper, laid it flat, spread a towel on top, and weighted it down using my library of art books.

the materials I used

support
140lb (300gsm) cold-pressed paper

brushes
no. 16 round
2" flats

watercolors

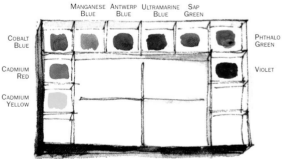

Painting the dark background first allowed me to accurately determine the correct values elsewhere.

Hillwood Garden, watercolor, 15 x 20" (38 x 51cm)

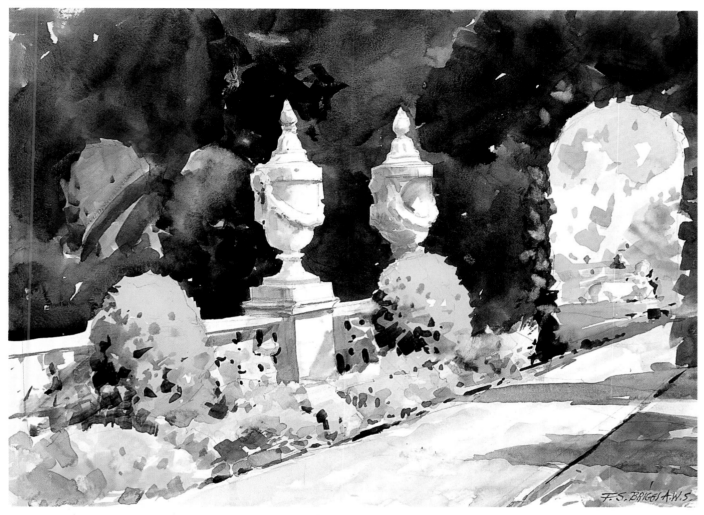

my inspiration

I was inspired to paint this corner of the garden at Hillwood House in Washington, DC because I have a fascination for garden urns. I wanted to convey the feeling of symmetry and balance reminiscent of the formal 18th-century French gardens.

my design strategy

I zoomed in on the scene for impact, filling the painting area with my subject. To offset the light stone urns, I used the very dark green shape of the hedge as a backdrop. The eye of the viewer is then led past the garden ornaments and through the open hedge to a stone sphinx in the distant garden.

my work process

- I usually work from light to dark, but this time I painted the intense dark background first. I needed to do it this way so that when I went to paint the subtle shading on the urns, I would have a clearer impression of what values to paint them so that they would read properly against the dark.

- From there, I was able to gauge and accurately put in the rest of the colors and values to suggest bright sunlight.

the materials I used

support
140lb (300gsm) cold-pressed paper

brushes
½" to 1½" flats
nos. 2, 4 rounds

watercolors

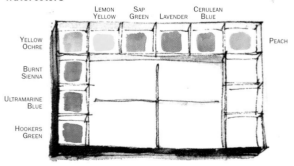

Frederic S Briggs lives in Maryland, USA → schulerschool@msn.com

Watercolor was the perfect medium for achieving the vivid colors and variety of edges I was after.

my inspiration

Foxgloves are flowers of woodland, heath and wayside common in Britain. Reseeding themselves in a transitory world known intimately only by the bumblebee, the foxgloves come and go, sentinels of summers past and present. Their sheer beauty captivates me. As I look closer, I enter a world of wonderful forms, stunning color, backlit stems and shadows. With my painting, I wish to capture their timeless look, to capture something of their beauty, something of their essence.

my design strategy

The foreground flowers are of primary importance, a subtle dominance that does not compromise the unity of the whole. I emphasized these with detail and contrast, while harmonizing the image with a restricted range of color. The diffused dark shadow area to the left adds depth without distracting, while the budding flower spike to the right balances the composition and also gives a feeling of layered depth.

my work process

- Working from reference photographs, I made a pencil drawing that I then traced onto stretched watercolor paper.

- I painted most of the foreground flowers individually, although I did paint some in pairs wherever I wanted a soft edge between them. For each flower, I applied a wash of color. While these washes were still wet, I then added a stronger mix of color to suggest subtle transitions of shadow or form. To create the highlights, I either left the paper untouched or used a damp brush to drag out the pigment, again before the watercolor was dry.

- I then painted in the dark stems behind the finished flowers before developing a darker, looser wash of color to suggest more foxgloves in deeper shadow.

- When putting in the spike of buds, I used a softer, less contrasting approach to make that area recede. I used the same approach to complete the background.

HOT TIP

If your wash gets a little too dark, you can still lift out a highlight while the pigment remains wet. Take a flat brush, squeeze out the excess water, then drag the brush edge on over the area you wish to highlight.

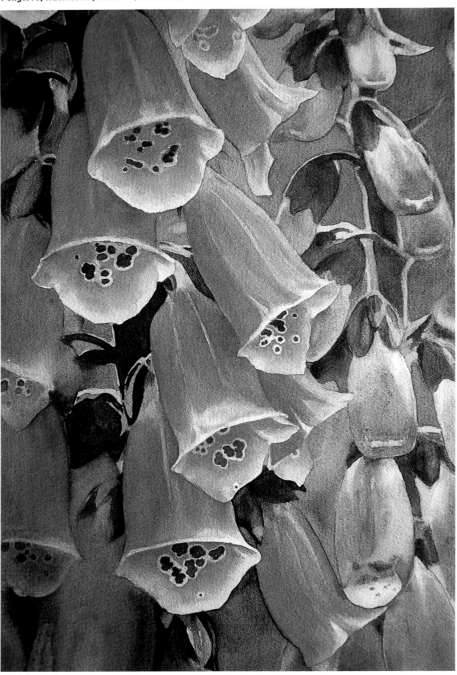

Foxglove, watercolor, 16 x 11" (41 x 28cm)

the materials I used

support
140lb (300gsm) NOT paper

brushes
nos. 5, 7, 8, 12 rounds
¼" and ⅞" flats

other materials
tracing paper

plywood board

gummed brown paper tape

plastic palette

kitchen paper roll

watercolors
Indigo Violet
Permanent Mauve
Permanent Alizarin Cimson
Ultramarine Blue
Winsor Blue
Burnt Umber
Raw Sienna

Lloyd Smith lives in West Yorkshire, UK → artistlloydsmith@hotmail.com

I positioned these flowers upside down to startle you into studying the painting more closely.

Home from the Market, watercolor, 17 x 22" (43 x 56cm)

Rosemary Butterbaugh

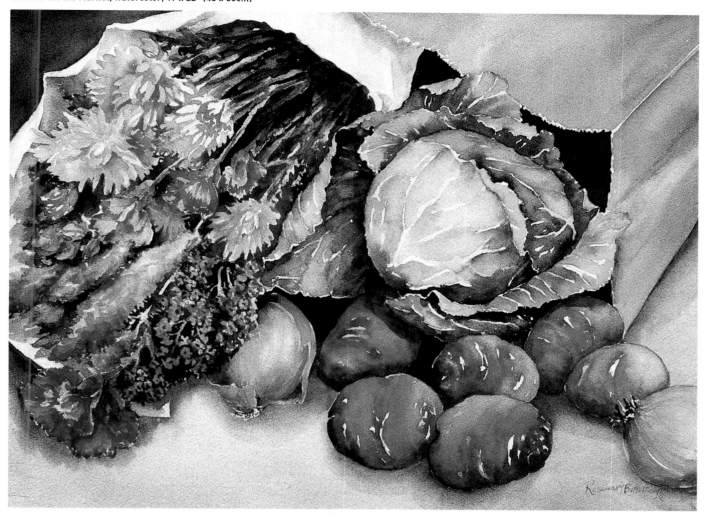

my inspiration

I love to paint vegetables as much as I do flowers, and in this case, decided to combine the two. Perhaps my delight in the beauty of vegetables comes from having them in my garden, watching them flourish from day to day. I call them "food for the spirit." At the market, I always stop to enjoy the bounty of color and pattern in the produce section. When I set this bag of groceries on the table, it called out to be a painting.

my design strategy

I had to find the right arrangement and point of view. Since we're used to seeing flowers standing up, not coming down toward us, I decided this upside-down viewpoint would make viewers look more closely at the

painting to make sure they were seeing things right. Tight cropping makes it seem as if the abundance of flowers and vegetables can't be contained by the edges of the painting. I positioned the potatoes to lead your eye into the painting from the bottom right, the opposite of what the "rules" say. The movement is then continued by the diagonal, curving flow across the page guiding you back to the tight circle around the flowers. The dark shadows and quiet areas calm the activity and vibrant color throughout.

my painting approach

- I both photographed and sketched the still life, trying to get the best of both worlds into the drawing. I then proceeded without masking fluid, painting

in a direct method and working around my whites.

- I like to let the water do most of the work, so I wet the areas one by one and flowed colors into them from loaded brushes. Whenever colors became too dark or muddy, I used a "thirsty" brush to pick up some of the excess. I mixed my colors according to whether the area was struck by light or in shadow.

- When the underpainting was dry, I redefined the forms with negative painting in darker values. It was important to have soft edges for the flowers to contrast with the solidity of the vegetables.

- Repeating colors throughout brought a sense of harmony to the overall painting.

the materials I used

support
140lb (300gsm) cold-pressed watercolor paper

brushes
nos. 12 and larger rounds

watercolors
Permanent Magenta
Permanent Rose
Phthalo Blue
New Gamboge
Raw Sienna
Phthalo Green
Lemon Yellow

Rosemary Butterbaugh lives in Indiana, USA → solarflair@seidata.com

Layers of transparent pigments helped me recreate the inner glow of the beautiful, sunlit flowers and vase.

Inner Glow, watercolor, 28 x 35" (71 x 89cm)

my inspiration

This painting happened quite by accident. I had set up this beautiful bouquet of flowers to enjoy in my studio without the intent of painting it. When the afternoon light drifted across the bouquet, it created a wonderful backlit effect that I just had to paint.

my design strategy

I used the design elements of contrasting color and tonal value. The viewer's eye is drawn into the painting by the strong, dark shadow, and then the eye is drawn up into the bouquet in a circular design. I intentionally played up the contrast of the delicate light-filled white flowers against the strong line and dark color of the vase to hold your attention.

my work process

- I took several reference photos to capture the lighting effect, although I completed my drawing from both the photos and the actual still life.

- After completing the drawing, I painted the background with a 1" flat brush, using mixtures of Rose Madder, Cobalt Blue and Aureolin. I wanted to establish this middle value first. I was careful to paint around each flower, rather than use masking fluid, which would create a hard line.

- Next, I painted the white flowers with the mixtures of the same pigments. I used several layers of paint, allowing each layer to dry completely before applying the next. This glazing technique allowed me to build up the depth of color while keeping transparency, creating a glow like a stained-glass window.

- Once the white flowers were completed, I painted all of the leaves with round brushes.

- When the bouquet was finished, I then painted the dark blue vase and the other darks. Here, I did mask off the highlights so that I could freely apply dark glazes wet-into-wet until I had built up rich, deep color. Phthalo Blue, Cobalt Blue and Opera were used for the darkest areas, with Sap Green for the stems.

- To complete the painting, I wet down the entire shadow area under the vase and painted with very saturated dark colors, using a wet-into-wet technique.

the materials I used

support
300lb (638gsm) paper

brushes
nos. 2, 4, 6, 8, 10 rounds
1" flat

watercolors
Rose Madder
Aureolin
New Gamboge
Opera
Cobalt Blue
Sap Green
Quinacridone Burnt Orange
Quinacridone Gold
Phthalo Blue
Ultramarine Blue

I used rich reds and other jewel-like colors to convey the warmth and comfort of a loving home.

Love At Home, acrylic, 20 x 47" (51 x 119cm)

my inspiration

A corner of our front room where the colors are warm and rich provided the perfect setting for this painting. It conveys the feelings of peace, warmth and comfort found in a loving home. In our sometimes wacky world, it's always nice to find refuge in a place where you feel safe — your home.

my design strategy

The most important design elements were color harmony, contrasting temperature and a wide range of lights and darks. Because the warm, jewel-like colors are comforting, the cool colors on the book and around the vase provide contrast, drawing the eye back to the focal point in the center of the picture. The dramatic light from the lamp reinforced the soothing effect.

my work process

- After sketching several ideas, I chose this composition.
- As my support, I used a painted panel cut from one of my unfinished paintings. The recycled painting's surface provided a nice ground for the new piece because it allowed me to start with rich texture and to leverage the original color into the new painting.

- With a watered-down mixture of Alizarin Crimson and Ultramarine Blue, I simply and quickly sketched out the composition.
- Next, I applied flat, midvalue color to each shape, creating an overall posterized look.
- Refining the color and adding dimension, I worked directly in the colored, flat shapes. I built up the dark areas with thin washes, worked on the mid-tones and painted the lightest lights with thick, juicy paint.
- I used simple, athletic strokes on the flowers, spending little energy on petal-by-petal details. I directly painted the flowers' reflection, then scraped to soften the edges, pushing them back.
- Finally, to add volume and depth, I included dark accents and highlights.

why I painted from life

I painted from life because it is the best way for me to accurately see color, tonal values and perspective. There's a wonderful urgency when painting from life, especially with fresh flowers, and that energy ends up in the final piece. Painting at night was also important for the following reasons: It allowed for consistent light; it created reflections in the windows, balancing the composition; and lastly, it made it easier to concentrate because my five daughters were sound asleep.

HOT TIP!

Using lamplight adds drama to a painting done at night, but also makes nailing shadow colors a fun challenge.

the materials I used

support
hardboard

brushes and tools
nos. 6, 8, 10, 12 bristle flats, rounds, and filberts

nos. 4 and 6 sables

palette knife

acrylics

Michael Card lives in Utah, USA → cardnyc@aol.com

Value contrast helps my painting read well from a distance, while textures make it interesting up close.

Baca House Portal, watercolor, 22 x 30" (56 x 76cm)

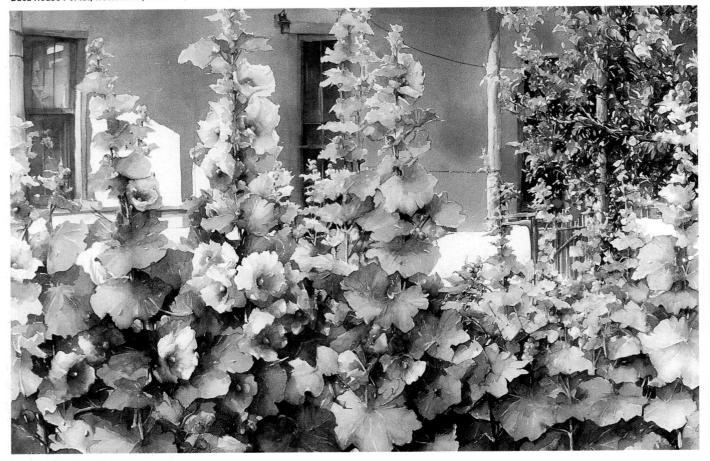

my inspiration

One day when my sister and I were taking photos of this home and its hollyhock-filled garden, the owner and her daughter invited us in. It has been my favorite site ever since. With this painting, I hope to convey my personal and emotional attachment to this charming place.

my design strategy

The design and flow of this composition were critical because hollyhocks are tall and vertical and I envisioned a horizontal format. I wanted the soft, transparent hollyhocks framed by the shadows to dominate, yet I also wanted to draw the eye back into the portal. The absence of the hollyhocks on the right is intentional so that your eye flows from left to right and proceeds up to the vines and back to the porch. I try to have my paintings read well from a distance and still hold your interest at close range.

my work process

- After sketching in pencil, I laid in a very light wash of Raw Sienna with a touch of Permanent Rose over the portal and the leaf area to make these shaded areas begin to recede.
- A dash of Cadmium Yellow established each flower.
- After letting these washes dry naturally, I used a combination of Hookers Green and sienn as — plus a significant amount of "grunge" (leftover colors) from my palette — in the leaves and flowers. Another technique I used is something I call "smashing," meaning I used all edges of the brush, right down to the ferrule, to loosely apply color. Later, I also used a toothbrush to add some texture to the leaves and walled areas.
- The shadows and details were added last with Paynes Gray. Where needed, I touched up with a razor.

why I work from life

Although I sometimes use photographs, I much prefer to work from on-site sketches. They help me understand and get closer to the emotion or feeling I'm after. Of course, painting from life is the best approach of all, since small, subtle details and shadows are more easily noted.

the materials I used

support
140lb (300gsm) cold-pressed watercolor paper

other materials
2H pencil
razor

brushes
no. 6 round
fan brush
toothbrush

watercolors

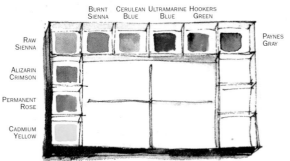

Carol Carpenter lives in New Mexico, USA → carolLcarpenter@comcast.net

I encouraged the hidden flower to take the limelight by adjusting the values surrounding it.

Perfection, watercolor, 30 x 22" (76 x 56cm)

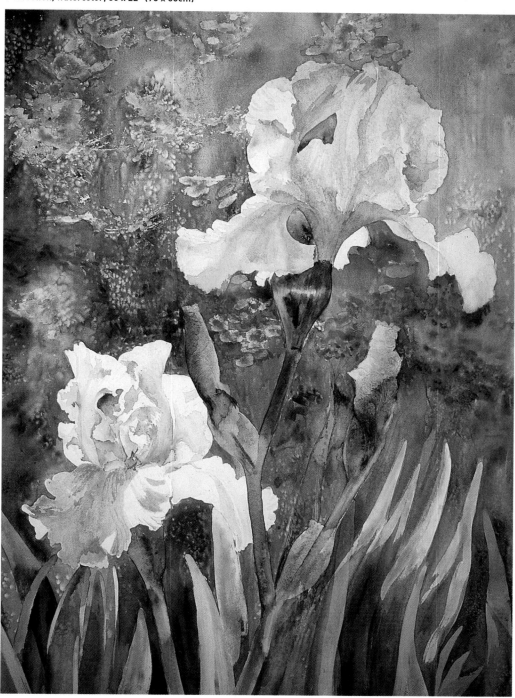

my inspiration

I always refer to the early evening as my happy hour. My garden beckons, and there I witness how the light changes the atmosphere. On this evening, I was particularly struck by the way the light hit the more secretive iris, putting the more forceful bloom in the shade — a metaphor?

my design strategy

I used the golden section to place my focal point — the sunlit iris. The light hitting the tops of the leaves on the right balances the overall shape of the two blossoms. I used a split complementary scheme: primary red, secondary purple and green.

my work process

• As the sun hit the blossom, I grabbed my camera to record the moment, then just as hastily made a few pencil sketches and watercolor notes.

• Before I began to paint, I projected my slides to get back the feeling of being in the garden. I used my sketches and notes to draw a detailed outline of the irises on a full sheet.

• Using an old bristle brush, I roughly applied masking fluid to the sweet rocket flower shapes in the background.

• I started painting the flowers using a wet-on-dry technique, floating extra color during the initial wash to strengthen my darks. I worked each petal individually to keep the shapes separated.

• Once the flowers were totally complete, I could easily judge the correct colors and values for the background. I wet a large section of the background with clear water and loosely dropped and flowed in colors, working fast to prevent hard edges and taking great care to paint around the flowers. A little salt allowed some of the early layers of color to shine through, giving a feeling of light.

• When the background was dry, I painted the leaves negatively, removed the masking fluid and loosely suggested the sweet rocket.

the materials I used

surface
hot-pressed paper

brushes
nos. 10 and 6 sables and bristles
squirrel mop

other materials
masking fluid

watercolors
Aureolin
Cadmium Scarlet
Permanent Rose
Magenta
Cobalt Violet

Ultramarine Blue
Cobalt Blue
Antwerp Blue
Viridian Green

Susan Chater lives in Ontario, Canada → www.susanchater.com

My desire was to create a romantic feeling by using luminous light, gentle colors and soft brushwork.

ARTIST
26

Sherry Chien

Corner Fragrances, oil, 18 x 14" (46 x 36cm)

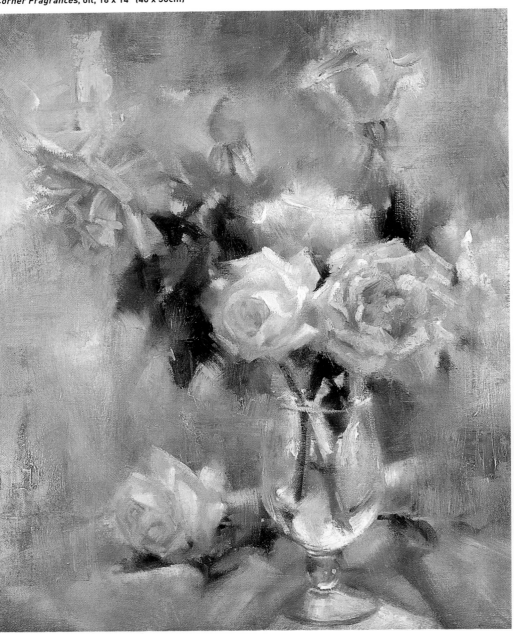

my inspiration

These flowers from my friend's garden are different from those usually found at flower markets, and I couldn't resist their beauty. Of all the flowers that I have painted, roses have the most variation. They look so simple, yet each petal has its own character and irregular shape.

my design strategy

The yellow and orange roses are the focal point of this painting. To allow the colors of the flowers to pop out, I used deep green for the leaves and various shades of blue for the background.

prep step

Before beginning to paint, I made several different compositions, arranging and rearranging the flowers and colors in the vase, then recording each one with a digital camera. After reviewing the results, I picked three I liked. One by one, I recreated the setups and did small color studies. I then made a final choice as to the basis for my painting.

my painting approach

- I painted primarily from an enlargement of my selected photo. However, I also referred to the color study to capture the feeling of the moment and to represent true tones.

- At first, I kept everything simple. When looking at the flowers, I focused only on their general shapes, avoiding detail.

- I wanted to create a sense of depth with the flowers, so edge control became very important. Where values were similar between two shapes, I blended the edges to make that area recede. On the other hand, if the values were high in contrast, I created sharp edges to make those areas stand out.

- To harmonize the color, I added accents of my main colors' complements.

- Finally, I added highlights on some roses and on the glass to draw your attention to the focal point. Luminous light, combined with soft brushwork, helped to establish the romantic mood.

Sherry Chien lives in California, USA → www.sherryzart.com

the materials I used

support
canvas

brushes and tools
nos. 4, 6, 8, 10, 12 brights and filberts
palette knife

oil colors

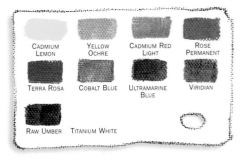

CADMIUM LEMON · YELLOW OCHRE · CADMIUM RED LIGHT · ROSE PERMANENT
TERRA ROSA · COBALT BLUE · ULTRAMARINE BLUE · VIRIDIAN
RAW UMBER · TITANIUM WHITE

To invite you to walk into this landscape, I used diagonal lines and warm and cool colors.

In the Vineyard, oil, 20 x 24" (51 x 61cm)

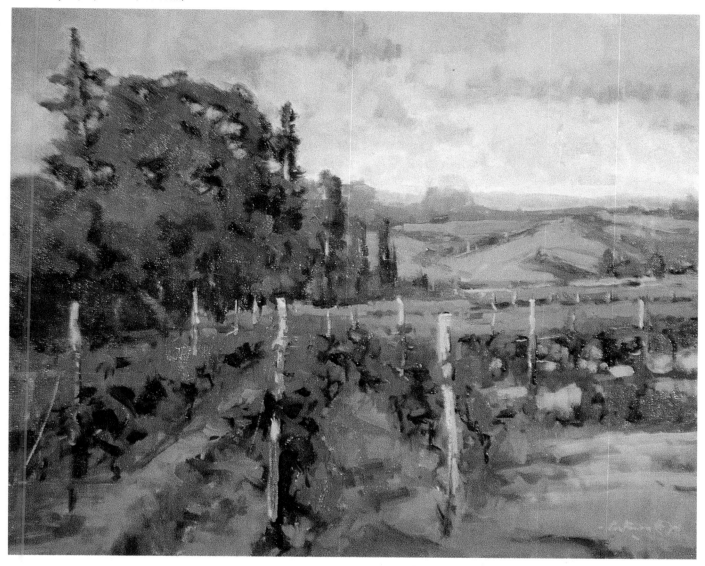

my inspiration

This scene is mostly invented, but not without inspiration and research. Wanting to do some vineyard paintings, I explored several in my local area and in the Oregon wine country. I wanted the viewer to say, "I'd like to take a walk in that landscape and feel the warm, late summer day."

my design strategy

My plan was to create a bold, simple design using the rows of vines as a central lead-in. Light patterns on vines and stakes take the eye back into the landscape, where it is drawn to the warm reds of the distant clouds. My hope was to lead the viewer's eye back over

the painting via the diagonal patterns on the middle distant hills. I used light and shadow to create harmony of tonal values.

my work process

- I made a preliminary sketch at a farm in Oregon.
- Then, back in my studio, I used my oils to establish dark patterns, not letting the dark accents become overbearing.
- Because the overall painting would have a lot of warm tones, it was critical for me to give enough cool relief. Therefore, I tried to keep light and air in the shadow areas so that the overall value patterns were harmonious, yet would still read as landscape

planes of foreground, middle ground and background.

- Once the painting dried, I went back over it using a thin layer of painting medium so I could see the value relationships.
- I repeated this process until I got the look and feel I wanted.

my oil palette

I used a simple three-color palette with some premixed gray paints. Together, these provided plenty of color variety.

my advice to you

I think the main challenge for artists is to first make a good design plan. Without that, success is possible, but not probable.

the materials I used

support
alkyd-primed canvas

painting medium

oil colors
Middle Gray
Ultramarine Blue
Titanium White

Cadmium Lemon
Permanent Red
Cold Gray

Gene Costanza lives in Oregon, USA → www.genecostanza.com

Through a dramatic arrangement of light and shadow, I conveyed power, beauty and optimism.

ARTIST
28

JD Cummings

Sunflower Power, oil, 48 x 36" (122 x 91cm)

what I wanted to say

I was inspired by the forceful feeling evoked by the morning sun dancing on the sunflowers, and how they conveyed power to the surrounding objects. I was transfixed by their beauty and optimism. They made an important statement about life, an affirmation that we too can tap into the power of the moment. We can all have our day in the sun.

my design strategy

I wanted to make a strong statement, so I began by choosing a large canvas. I then treated the dominant objects as if they were actors in a play, the stars of the show, with co-stars and a supporting cast. To balance the dominant, large elements, I arranged, added and subtracted smaller elements until I got the look I wanted. Together, these elements formed an eye-path that looked like the letter Z, which created a rhythm for the overall painting. I then used light and shadow to enhance the drama, placing the shadows so that the more important elements would stand out and be noticed. I used colors in the same way, with the warmer and more intense colors coming forward and cooler tones receding into the background.

my painting approach

- Oil primed linen is my favorite painting surface because it's smooth and easy to wipe clean. I prepare a canvas by covering it with a thin, transparent wash of warm color. Then I draw in the large, dark shapes with a large brush.

- I prefer to develop the painting as a whole, working from thin paint to thick. This allows me to see the relationships between the colors as they are placed next to each other. Getting these relationships right as I go along helps me achieve color harmony as well as luminous light.

- As details are added, the advantages of painting from life are apparent. I am better able to perfect my edges and to accurately record the values and temperatures of my shadows.

the materials I used

support
oil-primed linen

brushes
a variety of bristle flats

oil colors
Cadmium Lemon Yellow
Cadmium Yellow Light
Cadmium Orange
Cadmium Red Light
Permanent Rose
Cerulean Blue
Cobalt Blue

JD Cummings lives in Indiana, USA → paintdoggy@verizon.net

Careful cropping allowed me to focus on the compelling dichotomy between geometric and organic shapes.

Rose Arbor, acrylic, 16 x 20" (41 x 51cm)

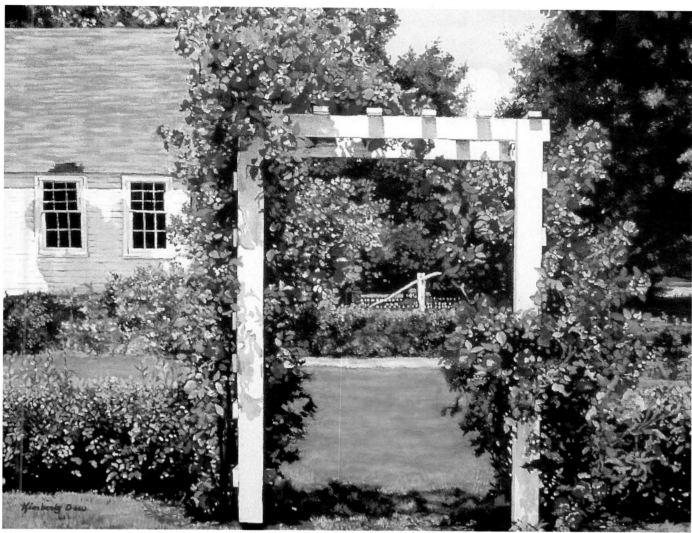

my inspiration

My desire to paint this gorgeous spring scene arose primarily from the interesting contrast between the delicate shadows on the arbor and the sharp geometry of the structure itself. The greens also offset the reds. Together, the elements presented an image of natural renewal and freshness that epitomizes spring.

my design strategy

I closely cropped in on only those elements that were important to my design. I wanted the scene to be partially framed by the arbor, inviting the viewer to walk on through. The sharp angles and lines compared to the more free-flowing shadows on the arbor created a compelling visual dichotomy.

my work process

• On site, I did some quick color sketches and shot photos for reference. From these, I did a light pencil sketch on canvas. I used a straightedge to draw straight lines, but kept in mind that the old building was not perfectly aligned.

• I carefully laid in the darker colors first, then proceeded to layer the lighter colors. I used various techniques, including drybrush on the grass and thick pointillism for the shrubs and roses. Acrylics are perfect for these techniques.

the materials I used

support
canvas

brushes
round and flat

acrylics

	CERULEAN BLUE	CHROMIUM OXIDE	PHTHALO GREEN		SAP GREEN	
CADMIUM RED DEEP HUE						IVORY BLACK
RAW SIENNA						
CADMIUM YELLOW MEDIUM						
TITANIUM WHITE						

Kimberly R Dow lives in Texas, USA → www.kimberlydow.com

I used an African-inspired geometric border to balance and contain my free-flowing, rhythmic design.

Poppies, Pods & Weeds with Kuba Border, watercolor, 22 x 30" (56 x 76cm)

ARTIST
30

Louaine Elke

my inspiration

I was impressed by the endless delicate variations of the poppy blossoms in my garden. I was also intrigued by the visibility of the whole life cycle, ranging from buds to blossoms to seedpods.

my design strategy

The basic design is a cluster of the dominant red poppy blossoms on the left, which diffuses in the center area and moves to the lower right corner. This design arrangement offers visual movement, yet is still balanced.

I deliberately left the small shapes of white paper at the lower left and the upper right to further support the design structure. they also provided an opportunity to include an African Kuba fabric border in the open areas. The border's visual importance

fluctuates, but creates a visually pleasing counterpoint encompassing the painting.

color concepts

In the hierarchy of my color scheme, red-orange is dominant, followed by a lower saturated green, then purple and yellow.

my work process

- Working wet-into-wet, I laid in the generalized red-orange blossom shapes. When the paper was dry, I protected the fluid quality of these shapes with masking fluid.

- When the masking fluid was dry, I wet the paper and poured a series of weak solutions of primary colors onto the paper, helping the paint flow by tilting the backing board. First, I poured

cool yellow from the lower left to the upper right, then cool red from upper left to lower right. Before making the final pour of cool blue, I again used masking fluid to retain some shapes. Each pour was allowed to dry before the next.

- I then painted negatively around shapes of leaves, stems, buds,

pods and generalized plant forms. Some of the greens created by the pouring process were enhanced with Sap Green.

- As a last step, I added the geometric border.

- After reviewing the overall work, I determined it needed a final application of neutralized blue to heighten contrast and depth.

the materials I used

support
140lb (300gsm) cold-pressed watercolor paper

brushes
2" flat

nos. 10 and 14 rounds

¾" angled shader

other materials
white masking fluid

watercolors
Phthalo Red
Aureolin
Rose Madder Genuine
Cobalt Blue
Indigo
Burnt Sienna
Sap Green

Louaine Collier Elke lives in Oregon, USA

Through joyful, vivid colors and imaginatively stylized designs, I created a painting that grabs your attention.

Flower Power, acrylic, 36 x 48" (91 x 122cm)

my inspiration

There were no flower gardens in Spanish Harlem where I grew up, but there was imagination. Learning to be acutely aware of my surroundings and drawing inspiration from my environment were survival skills that have since become a useful part of my painting process. Even though I now live beside a lake in southern Ontario, I still paint "inner landscapes."

my design strategy

I wanted this painting to reach out and grab you, so I put the flowers at eye level to create a sense of intimacy. Then I used bold shapes with warm, bright colors in the foreground against cool, dark colors in the background for extra punch.

my work process

- Over time, I created thumbnails of imaginary flowers. After deciding on the painting size, I enlarged each flower in blue pencil on tracing paper. Then I cut out the flowers, arranged them on the canvas and taped the pieces together. I transferred the images to the canvas with carbon paper.

- After drawing over the carbon line with a permanent black fine marker, I painted the whole canvas with Hookers Green. This wash was light enough to still show the black lines, yet dark enough to create a base color.

- I worked from dark to light, painting the foreground first, using thicker, juicy paint for the flowers and finally drybrushing in the shadows.

the materials I used

support
stretched, gessoed canvas

brushes
nos. 2, 4, 10, 12 bristle rounds

acrylics

medium
acrylic matte medium

Henry Fernandes lives in Ontario, Canada → www.VerdeVisions.com

By focusing on gesture instead of detail, I was able to engage the viewer's imagination in the painting.

Sunflowers, oil, 16 x 12" (41 x 30cm)

ARTIST
32

Mary K Forshagen

my inspiration

I was inspired by the rich color and lyrical nature of these sunflowers. I was trying to capture their essence, their gesture, with as few brushstrokes as possible and without too much detail. I wanted the viewer's eye and imagination to finish the painting.

my design strategy

I arranged the pattern of yellows to create a beautiful abstract design, and used the sequence of darker centers to move your eye through the painting. Overall, I wanted the painting to be a harmony of yellows and golds.

my work process

- Working outdoors in natural light, I painted this setup *alla prima*, all at one sitting. I find that the variety of color, texture and luminosity of live flowers cannot be replicated by photographs or artificial flowers.

- On a white canvas, I applied a thin wash of Indian Yellow to indicate the pattern of yellows. This tone provides a rich luminosity that cannot be achieved with any other color.

- Next, I blocked in the other shapes with their local colors until the canvas was covered.

- Then I took great care to observe the negative shapes made by the flower petals and defined as few of those as possible to indicate the character of each flower.

- Next, I added thicker paint to those petals in direct light that I wanted to emphasize, again being careful to vary each shape.

- As I focused on making a variety of edges, I placed the hardest edges near the focal point.

- After stepping back to observe, I intensified the rich color of the blue vase.

try these tactics yourself

Always be aware of your personal reaction to your subject. Try to paint your *feeling* about the subject, not every detail. See how much you can express with a single spontaneous brushstroke.

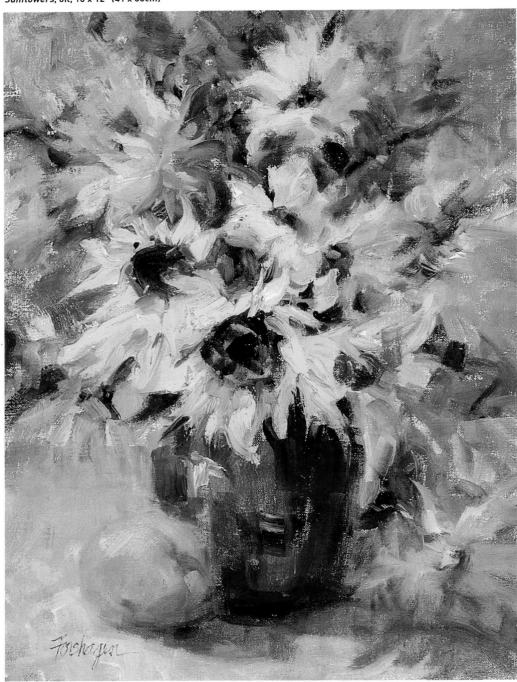

the materials I used

support
Belgian linen glued to board

brushes and tools
bristle brushes
palette knives

oil colors
Titanium White
Indian Yellow
Cadmium Lemon
Cadmium Yellow Light
Cadmium Orange

Permanent Rose
Alizarin Crimson
Cobalt Blue
Ultramarine Blue
Viridian

Mary K Forshagen lives in Texas, USA → www.forshagen.com

Repetition with variation of shape contributed rhythm and movement to this studio still life.

Bloomin' Perfect, oil, 20 x 30" (51 x 76cm)

my inspiration

While visiting a local garden center, I was attracted to the bright red geranium blossoms with their green foliage. They were lined up in simple clay pots on wooden tables — a "bloomin' perfect" idea for a painting.

my design strategy

I decided to paint the geraniums as a still life setup on a table in my studio. Nature provided most of the elements and principles of design. The complementary colors of red and green unified the painting. The oval shape of the blossoms was repeated in the leaves and in the clay pots, although I did vary the sizes of the ovals and their placement to add rhythm and to allow the viewer's eye to move easily around the painting. The ovals were then balanced with the straight edge of the table. A spotlight helped to create more interesting positive and negative shapes.

my work process

- First, I sketched a thumbnail value plan. I also took a digital photograph, which I printed out in both grayscale and color.

- I toned the entire canvas with a thin wash of red-orange. While it was still wet, I used a soft cloth and a brush dipped in odorless turpentine to place the main objects and wipe out light areas.

- I mixed complementary reds and greens in the values needed. I then painted in a traditional manner, working from dark to light and thin to thick. I constantly looked at the setup for the values and shapes, later turning to the reference photos for more information on lights, halftones and shadows as the blossoms and leaves changed positions.

- I worked over the entire painting, gradually adding more detail until it felt right to me.

the main challenge in creating this painting

Red was a bit of a challenge in this painting. I didn't want it to go pink in direct light, so to retain the intensity of the flowers' colors while still achieving a three-dimensional form, I allowed the red-orange base to stand alone in the lightest parts of the flowers. Then I added mixtures of Cadmium Red Light and Quinacridone Red for the halftones and shadows of the petals.

the materials I used

support
stretched canvas

medium
fast-drying medium

odorless turpentine

oil colors

CADMIUM YELLOW LIGHT CADMIUM RED LIGHT QUINACRIDONE RED ULTRAMARINE BLUE

TITANIUM WHITE

brushes and tools
nos. 2–12 sable and bristle filberts and brights

fan brush

palette knife

Sharon Forthofer lives in Missouri, USA → sf@tanglewoodbrushstrokes.com

It's the contrast of dark, neutral tones in the background that gives my bright colors extra intensity.

ARTIST 34

Stacy Giebler

Peach Rose, acrylic, 36 x 24" (91 x 61cm)

my inspiration

Flowers, especially these roses, inspire me because they have amazing properties. They glow, somehow giving off even more light than they receive from their environment. I've tried to capture this magical quality on canvas through intense color and value in unexpected places. This is what really makes art magical for me — it's always full of surprises.

my design strategy

I want the viewer's eye to go right to the main flowers, travel back into the distance of the painting, then be led back to the rose in the foreground. This is achieved through a flowing composition, the sharpness (or blurriness) of edges and especially through color. The colors in the background are neutral, while the colors and values in the foreground, even in shadows, are the most intense.

my painting approach

I see painting as a process of sorting and sculpting. I began with a simple line drawing, then brushed in the darkest values. As I worked my way forward from the background, more details and lighter, brighter colors were added. For the final touch of the painting, I laid in the most intense colors and the lightest values. Most people are surprised to learn that I spend more than 75 percent of my working time on the background of most paintings, rather than on the central flowers. This really creates the mood I wish to achieve.

the main challenge in creating this painting

Intense color was absolutely essential to conveying the mystical quality I wanted. As colors are mixed, they lose intensity, so I used many of my pigments directly from the tube whenever possible. Oranges are a particular challenge — I'm always trying new combinations to find an orange that blazes off the canvas.

the materials I used

support
gessoed canvas

brushes
¼" and ½" flat
smaller round

acrylics

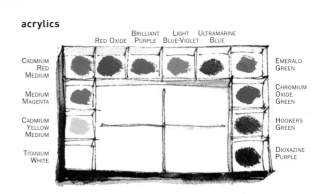

Stacy Giebler lives in Nebraska, USA → gieblerfamily@msn.com

Soft transitions in the background create a sense of depth in this close-focus image.

Peony's Waltz, watercolor, 15 x 22" (38 x 56cm)

my inspiration

One early morning while walking to my studio, I saw the light hitting the budding peonies and reflecting in the water droplets. The distilled light and color were so intense that I felt compelled to express my sense of wonder. Running for my camera, I took a series of photos and sketched the main elements.

my design strategy

I simply wanted to zoom in on the dominant elements: the water drops, the contrasting lights and deep shadows, the bright pinks and reds juxtaposed with the deep teal of the background.

my work process

• Starting with a precise drawing, I heavily masked out the flowers, stems and a few light areas of the background.

• After the mask had dried, I wet the paper and poured the intense teal and blue pigments over the background, creating the rays of light. While the paint set, I tipped and rolled the paper, meanwhile dropping in other colors and clear water. The spontaneous shapes that arose created depth and hinted at organic elements (distant leaves and stems). In some areas I dropped in a few grains of coarse salt.

• When the paper had dried, I peeled off the masking fluid. Then, using disposable brushes and toothpicks, I applied more masking fluid to cover the water drops, the veins in the leaves and any highlights.

• I then built up the flower and leaves with transparent layers, sparingly using coarse salt to create texture.

• Finally, I removed the mask and finished the water drops and shadows. I picked out a few highlights with a craft knife.

why I chose this medium

Watercolor is the ideal medium for me because the flow of the pigment on wet paper creates organic shapes that mimic nature perfectly in terms of texture and random spontaneity.

the materials I used

support
300lb (638gsm) paper

brushes
2" sable
½" and 1" flat
nos. 0, 4, 8, 12, 16 rounds

watercolors

other materials
craft knife
coarse sea salt
masking fluid
toothpicks
plastic cup for mixing wash

Sherrill Girard lives in Ontario, Canada → www.sherrillgirard.com

Notes of color that visually align created sweeping movement across this dynamic composition.

Flowers in a Salviati Vase, oil, 36 x 40" (91 x 102cm)

ARTIST
36

Sonia Grineva

my inspiration

I was excited by the idea of painting a large still life of flowers because big canvases allow more freedom of expression. Recently, I had purchased a Salviati vase in a beautiful ochre color. I thought it would perfectly complement many of the flower arrangements I envision painting.

my design strategy

I wanted the viewer's eye to wander around the canvas, feeling the space and resting naturally on the flowers. For this reason, I chose a bouquet that included a variety of shapes and colors, keeping in mind how the flowers would play off each other in the composition. I wanted to create a massive visual effect while capturing the beauty of the flowers and the stunning richness of their colors.

follow my eye-path

Placing the large white flowers against the dark background set up a contrast that dominated the picture. The red flower on top added an additional point of interest. Then, to further direct the viewer's eye around the canvas, I aligned the lilies horizontally. The blue flowers move toward the upper left corner while the yellow and purple flowers move toward the upper right, adding more movement to the composition. In contrast to the horizontal direction of the lilies, the vase added a vertical orientation.

color concepts

The soft, round shape and bold yellow color of the vase enhances the composition. The shapes and colors of the cloth on the table, as well as the interesting surface of the table itself, add to the sense of movement. The green then ties it all together.

my painting approach

- I painted from life and worked in natural daylight for a more spontaneous result.
- After sketching the flowers in the vase with a light neutral color, I studied the different relationships and movements to establish the composition.
- Next, with a big brush, I blocked in large parts of the canvas to define the space. I worked on a double oil-primed linen surface because it allows the brushes to slide around easily.
- Often I changed colors, moving them around on the canvas rather than concentrating on specific parts, a technique that created sudden transparencies defining depth in the picture.
- I then looked at the painting from a distance of eight or nine feet to make sure all of the elements were in proportion and related well spatially.
- At the final stage of the painting process, I added details to key points where I wanted the viewer's eye to rest.

the materials I used

support
double oil-primed linen

brushes
nos. 4, 6, 8, 10, 12 filberts

oil colors

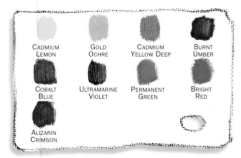

CADMIUM LEMON GOLD OCHRE CADMIUM YELLOW DEEP BURNT UMBER
COBALT BLUE ULTRAMARINE VIOLET PERMANENT GREEN BRIGHT RED
ALIZARIN CRIMSON

Sonia Grineva lives in New York, USA → www.grinevaart.com

A few carefully rendered details fool your eye into thinking this painting is more intricate than it is.

Samovar & Lilies, oil, 24 x 30" (61 x 76cm)

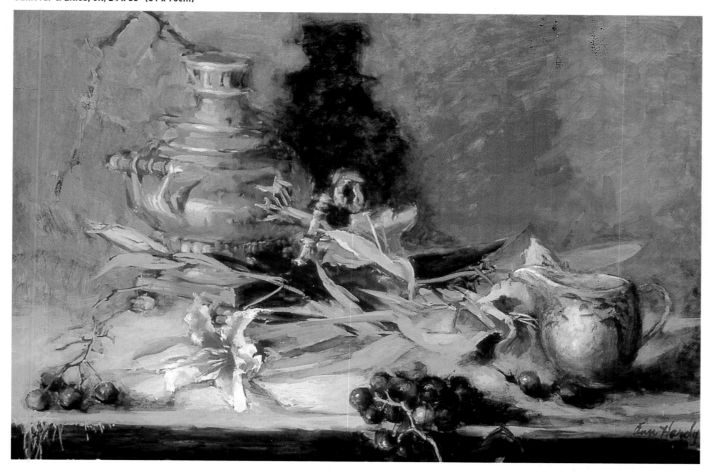

ARTIST
37

Ann Hardy

my inspiration

I found this wonderful old samovar in an antique shop in Poison, Montana, and I could hardly wait to include it in a painting. However, I didn't want my still life to focus on just this one element. I was determined to create a cohesive image that appeared fairly polished and inviting, but would surprise the viewer by being rather loosely painted when studied close up.

follow my eye-path

I wanted the viewer to follow the values from lightest to darkest by entering at the left lily, traveling to the samovar and then making a circle back to the middle grapes.

my work process

- I did not do a detailed drawing of the setup on my canvas, but simply started with some marks to determine the size and placement of my objects.

- After squinting carefully at my arrangement, I first put in the shapes of the darks, including the shadows, then went straight for the lightest values on the lily on the left. This established my range of values so that I could gauge the accuracy of the rest of my values in between.

- Continuing to squint at my setup, I developed the rest of the objects and the background simultaneously. By varying the values and color temperatures, and by deciding where to lose some edges and sharpen others, I was able to make the objects read as three-dimensional forms.

- Last, I chose to carefully render just a few of the details and placed some well-considered highlights. After letting it sit for a few days on my fireplace, where I could view it as I cooked meals, I made some minor adjustments that refined and completed the image.

my advice to you

- Squint to abstract those darks and lights, and remember to squint as the painting progresses to check on the values. Your overall image should be broken up into three or four general values, or it will look spotty and uneven.

- Be very concerned with brushstrokes. Put that paint on in an interesting way with love, with feeling, with sensitivity — then leave it alone.

the materials I used

support
canvas on panel

oil colors

brushes
soft flats and brights

Ann Hardy lives in Texas, USA → www.annhardy.com

Vibrant color and a dynamic contrast of light and shadow added excitement to this unusual subject.

ARTIST
38

Judy Heyer

Say It with Flowers, oil, 18 x 14" (46 x 36cm)

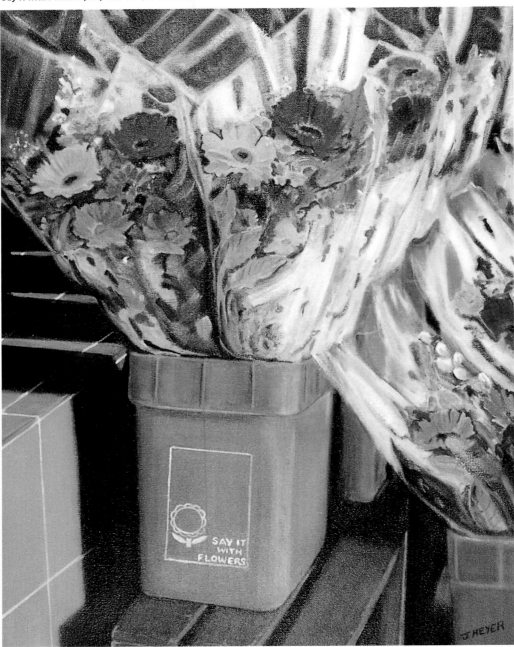

my inspiration

What initially excited me about this scene, which I stumbled upon at the waterfront market in Vancouver, British Columbia, was the dramatic effect created by the play of light and shadow on the tile and the exuberant display of flowers begging to be taken home. The inscription on the green bucket, "Say It with Flowers," added another layer of meaning. To me, flowers are a cause for celebration and have a language all their own. They say "I feel," "I care," "I am sorry" or simply "I am happy to be alive." Because I'm enamored with flowers, many find their way onto canvas — even cut, wrapped in cellophane and unceremoniously plunked into green plastic containers.

follow my eye-path

Since I worked from a photograph, the elements of the design were already established and only required slight adjustment. The viewer's eye is first drawn to the light and shadow on the tile, then wanders through the bouquets of flowers, then back to the white, stamped inscription.

my work process

- I prefer to work from life and wanted an accurate likeness of cellophane-wrapped flowers. So I purchased several bouquets from a local vendor to get a better feel for the way cellophane reflects light — a real challenge to paint! The flowers that I painted were a combination of those in the photograph and some that I purchased.

- Creating a small preliminary sketch in my studio helped me resolve my composition. I then transferred my drawing to a canvas that had been toned with a Cadmium Yellow wash.

- To begin, I blocked in larger shapes, paying particular attention to parallel lines. Once I was satisfied with the correct placement, I concentrated on smaller areas, such as the individual flowers.

- Finishing touches, such as the lettering on the plastic container and nicks in the bench, were made after the painting was dry.

HOT TIP

When working from photographs, values can be lost. Backlighting a photo can help to overcome this. I simply hold the photo against the light from a desk lamp set up close to my easel. This enables me to gauge the values.

the materials I used

support
stretched canvas

brushes
nos. 2–8 brights and filberts

medium
oil-painting medium

oil colors
Cadmium Yellow
Yellow Ochre
Cadmium Orange
Cadmium Red
Primary Red
Ultramarine Blue
Phthalo Blue
Phthalo Green
Cobalt Violet
Burnt Umber

Judy Heyer lives in British Columbia, Canada → jheyer@dccnet.com

The buoyant, airy quality in this floral painting came from contrasting layers of transparent and opaque media.

Vintage Bouquet, mixed media, 36 x 24" (91 x 61cm)

my inspiration

A striking color combination of a deep burgundy and a yellow-green was my inspiration. I arranged a loose collection of daylilies, philodendron, various other green plants and a grapevine. My intention was to pull the viewer in with the depth of the bouquet under the canopy of philodendron, and to contrast the heavy saturation of the burgundy with the airiness of transparent layers of other light colors.

follow my eye-path

I placed the dominant deep maroon bouquet in a forward position, off center, contrasted with the yellow-green lilies and the blue-green background. The eye-path is circular with two dimensions: One dimension is the semi-circular curve moving left to right from the leaf at the top to the grapevine leaf at the bottom. The other dimension is the curve moving from right to left from the flower tips to the large leaves, thus completing the circle. The central bouquet is circling forward like a cone.

my work process

- First, I taped several sheets of newspaper to a ¼" Masonite board. Then I taped my sanded pastel paper over the newspaper for a cushioned support.

- Next, I selected my palette of colors and mixed my neutral background.

- Before beginning to paint, I photographed my subject for reference. I also photographed different stages to see it with a different perspective. However, I began the process by working from life.

- Over a loose, gestural drawing, I began to apply my mixed media layers — liquid acrylics, watercolors and gouache, adding in a liquid retarder when required. This method of multiple layering helped to develop the colors, depth and tonal values in the arrangement.

- To push paint and to model certain areas of leaves or petals, I used an angled chisel color shaper. Sometimes, especially in the darkest areas, I removed paint with a clean brush and a paper towel to recover color. The grapevine I left unpainted, while I scraped out some areas with a palette knife to keep them sharply visible.

- Having completed the majority of my wet media work, I then drew the gesture of the philodendron with charcoal. I also used pastel pencils for fine line details, such as the leaf veins.

- Next came drawing, sculpting and layering with hard and soft pastels.

- The last step was sculpting the illusion of a vase and the pale shadows of the leaves.

the materials I used

support
sanded pastel paper

brushes
1½" synthetic flat
nos. 6, 8, 12 filberts
no. 6 angled chisel shaper

medium
liquid retarder

other materials
palette knife
masking tape

mixed media
watercolor
gouache
liquid acrylic paint
hard pastels
soft pastels
pastel pencils
charcoal pencil

Marcia Holmes lives in Louisiana, USA → www.brunnergallery.com

I layered on wet, transparent washes to recreate the enchanting, misty colors of an English spring.

The Blue Hills, watercolor, 22 x 30" (56 x 76cm)

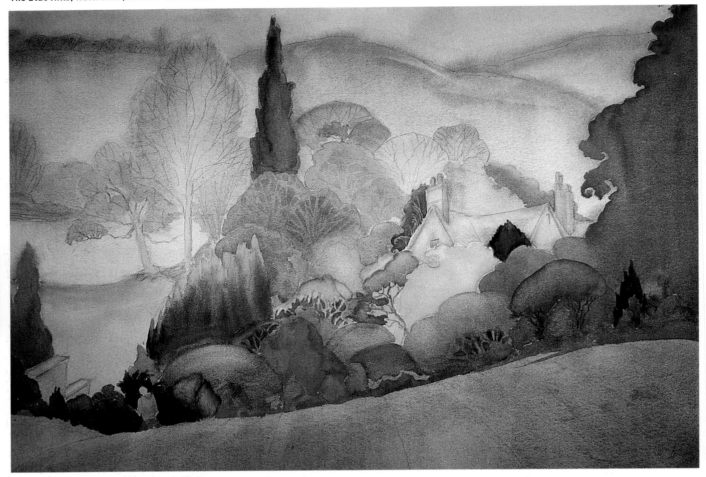

ARTIST 40

Lou Jordan

my inspiration

In 2002, I realized a long-time dream of touring England with a group of fellow artists. One morning we visited a lovely tiered garden. It was a glorious spring day, misty with amazing English light. I was overwhelmed with the colors' beauty — the yellow-green and violet everywhere and the surrounding blue hills.

my design strategy

I wanted this image to be fanciful and enchanting, so shape and color became my allies. The rounded and playful shapes contrast with the straight lines, creating a wonderful rhythm that swings your eye around the painting. The harmonious colors help recreate that misty morning.

my work process

- Over my pencil drawing, I applied three to six individual glazes of very pale, transparent colors (Aureolin, Rose Madder Genuine and Cobalt Blue) to tone the paper a luminous gray.
- I was able to mix gorgeous greens from Lemon Yellow and Ultramarine Violet.
- Wet-in-wet, I quickly brushed in delicate washes over the hills and foreground, using a soft 1½" hake so I wouldn't disturb the earlier layers.
- While the paper was still damp, I put in the trees and shrubbery using Ultramarine Blue and other intuitively chosen colors. I did some negative painting in the foreground, but deliberately left the background trees vague.
- To refine the image, I redid the stepped wall to point it in and up, enhanced the foreground with Violet, and finished with the figure going down the hill.

HOT TIP

When you're traveling and don't have a lot of time to set up and paint at a great location, settle for making one color sketch to record the general tones of the area. Then shoot as many rolls of film as you can, and let them inspire you when you return to your studio.

the materials I used

support
140lb (300gsm) cold-pressed paper

brushes
large ox hair mop
1½" hake
no. 8 round

watercolors

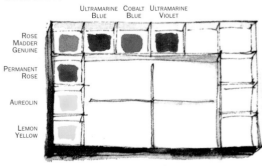

Lou Jordan lives in Louisiana, USA → www.loujordanart.com.

To recreate the morning light deep within the delicate flower, I used transparent glazes.

Smiling Peony, watercolor, 18 x 23½" (46 x 59cm)

ARTIST
41

Shoko Judd

my inspiration

As a keen gardener, I have often watched flowers coming into bloom. This particular flower blossomed in the morning light. I wanted to capture that moment when the light was shining into the flower, casting beautiful shadows and patterns and showing the delicate petals and golden stamen.

my design strategy

I included two flowers in the design to suggest that there were many more. Directing the viewer's eye around the bowl of the main flower, I then guided the eye farther to see the other flowers. Most important was the line of light inside the flower.

my work process

- Using three photographs and a live flower from my garden, I first made a 5 x 7" sketch. After enlarging the drawing to full size, I transferred it to paper.

- I chose a limited palette of three non-staining, transparent primary colors — Cobalt Blue, Aureolin Yellow and Rose Madder Genuine — thus avoiding a muddy effect. To offset the lighter flowers, I used darker Prussian Blue mixed with the petal colors for the background.

- Except for the bright white areas, I placed a thin wash of pale yellow over most of the paper to create a glow.

- I treated each petal separately. Repeated glazes produced many grades of tonal values.

the materials I used

support
300lb (638gsm) rough paper

brushes
nos. 4, 6, 8, 12 rounds

watercolors

AUREOLIN YELLOW ROSE MADDER GENIUNE COBALT BLUE PRUSSIAN BLUE

Shoko Judd lives in British Columbia, Canada → csjudd@axionet.com

By enlarging the image, I hoped to reveal the finer points of the flower that might otherwise be overlooked.

Fatima, oil, 24 x 30" (61 x 76cm)

ARTIST
42

Marla Karimipour

my inspiration

Out hunting for trilliums in the woods near my home, I came across a carpet of flowers illuminated by a small patch of late afternoon sunlight. The way the light seemed to shine through this single flower took my breath away. My goal was to bring out the often overlooked details that added personality to the flower.

my design strategy

By enlarging the flower, I hoped to reveal the fine points in its anatomy and texture. The lighting plays a major part in the design because the shadows cast by the sunlight enhance the natural organic shape of the flower.

my work process

- Trilliums are protected flowers in Michigan, so taking one to the studio to paint was out of the question. But I wanted to show the flower in natural light because it evokes sensory feelings that are extremely difficult to replicate indoors. For these reasons, I shot several reference photos.

- Back in the studio, I made a compositional/value sketch.

- On the canvas, I first blocked in the darkest shadows using a mixture of Prussian Blue, Raw Umber and Titanium White (my favorite color mix for its richness and versatility). I added Cadmium Yellow Light to suggest reflected color where applicable.

- After the darks were completed, I painted most of the other shadow detail lightly and roughly on the dry canvas. I then added Titanium White around the shadows and blended everything together, creating mid-tone shadows.

- Next I added and enhanced small details, such as the petals, flower centers and leaves.

- Finally, I put in the background, using my favorite neutral mix.

the materials I used

support
medium-textured cotton duck canvas

brushes
nos. 4, 6, 8, ⅜" and ½" sable flats and brights

my advice to you

If you want to paint in this tight, realistic style, having a good understanding of drawing (perspective, shading, detail and so forth) is essential. You can master this skill on your own just by grabbing a sketchbook and pencil and devoting a lot of time to practicing. In my experiennce, patience and persistence are the most important tools needed in becoming an artist.

oil colors
Titanium White
Cadmium Yellow Light
Permanent Rose
Cadmium Red Dark
Raw Umber
Prussian Blue

Marla Karimipour lives in Michigan, USA → www.mkarimipour.com

I kept the color harmonious and neutral in order to focus on the shapes and bright whites.

Callas & Begonia, oil, 30 x 20" (76 x 51cm)

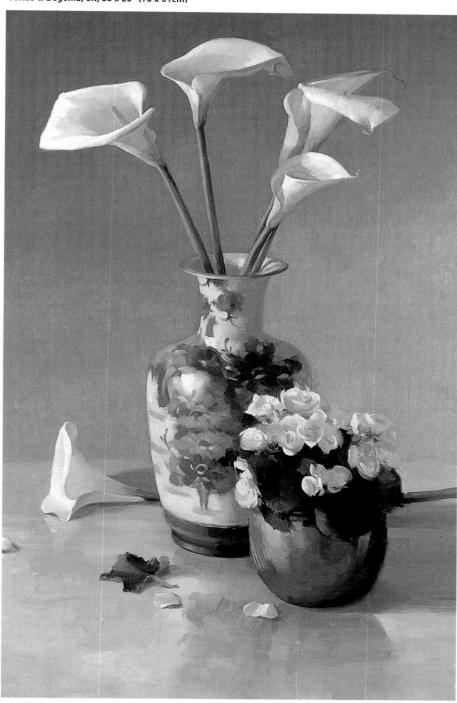

ARTIST
43

Laurie Kersey

my inspiration

My inspiration for this piece was the analogous color harmony of bright whites and warm neutrals, along with the graceful forms of the calla lilies as the were juxtaposed with the smaller, busier forms of the begonias.

my design strategy

I wanted a quiet, harmonious piece, so I kept the background simple in shape and neutral in color. I was going for a balance of large, simple shapes (background and table), mid-size shapes (the vase, flower pot and cast shadows) and small shapes (the flower). I was also looking for a balance of simple areas (background and table) and more complex areas for added interest (the patterned vase, cluster of begonias and scattered petals).

about the light

This setup was placed on my kitchen table, next to a large, sliding glass door that faces north. The cool light that flows in from the left has a beautiful, subtle, cool, calm effect on anything I place there. It's a softer light that brings out the subtleties of my subject more than any other light source. I find it a refreshing change of pace from the warm light sources that I often paint under (sunlight or lamp), plus it challenges me to reverse my temperatures (cool light/warm shadow).

my work process

- On a stretched linen canvas lightly toned with Burnt Umber acrylic, I sketched in the basic shapes with thinned oil paint.

- I then began to scrub in the background thinly with a large bristle filbert and unthinned paint, creating a value gradation from left to right. With a softer brush, I very lightly "wisped" over the background in vertical strokes to eliminate any visible brushstrokes, making the background smooth and unobtrusive.

- Since I was painting from life, I needed to get the flowers in quickly, before they wilted. With a no. 4 or 6 bristle flat, I painted in the callas directly, again with unthinned paint, but thicker and with undisguised brushstrokes. Next, I turned my attention to the begonias and painted them quite directly as well. At this point, the flowers were pretty well finished.

- Once the "perishables" were taken care of, I could work all over the whole canvas, bringing the rest of the items up to the level of the flowers and adding accents and highlights where needed. I tried to keep my painting pretty direct, so most areas have only one layer of paint.

the materials I used

support
stretched portrait linen, primed with acrylic

brushes
nos. 2–10 bristle filberts and flats

oil colors
Titanium White
Yellow Ochre Pale
Cadmium Yellow Deep
Cadmium Red Light
Alizarin Crimson

Ultramarine Blue
Viridian
Sap Green
Burnt Sienna
Burnt Umber

Laurie Kersey lives in California, USA → www.lauriekersey.com

Simply having fun with paint techniques allowed me to inject fresh, sunny colors and textures into my work.

Buckets of Blooms II, watercolor, 14 x 21" (35 x 53cm)

ARTIST

44

Ruth Eiring King

my inspiration

Painting flowers gives me the chance to paint the wonderful, bright colors I love. I especially enjoy painting the traditional, garden-variety flowers with which I am familiar. I always have my camera handy so I never miss an opportunity to photograph subjects I'd like to paint. I was especially attracted to these galvanized buckets. I knew their dented, rusty surfaces would be fun to paint, requiring a number of different techniques.

color concepts

This painting was designed by combining portions of several photos, with an eye toward color. I wanted the yellow of the delicate, yet hardy, California poppies to dominate the painting but still harmonize with the surrounding colors.

my work process

- I drew a loose thumbnail sketch to establish the composition, but continued to refer to my photos for the flower shapes and colors.
- I began with the flowers, doing each bloom, petal and leaf separately, one layer at a time. Each consecutive glaze added a detail, shadow or color change.
- I then masked off the flowers just above the buckets so that I could apply an even, flowing wash over that entire area. I had a lot of fun here, dropping in and glazing on blues and splatters of Dragons Blood (similar to Burnt Sienna). After the shine was gone, I spritzed on water with a spray bottle to put more texture in the buckets.
- To complete the dark background, I wet the paper around the flowers and leaves and dropped in wet paint.

the materials I used

support
140lb (300 gsm) cold-pressed paper

brushes
nos. 6, 8, 12 rounds

watercolors

PERMANENT ROSE · QUINACRIDONE CORAL · NEW GAMBOGE · AUREOLIN · ULTRAMARINE VIOLET · PHTHALO VIOLET · SAP GREEN · VIRIDIAN · HOOKERS GREEN · COBALT BLUE · ULTRAMARINE BLUE · DRAGONS BLOOD

Ruth Eiring King lives in Colorado, USA → kingsart@fone.net

I kept this painting loose with soft edges and energetic brushwork.

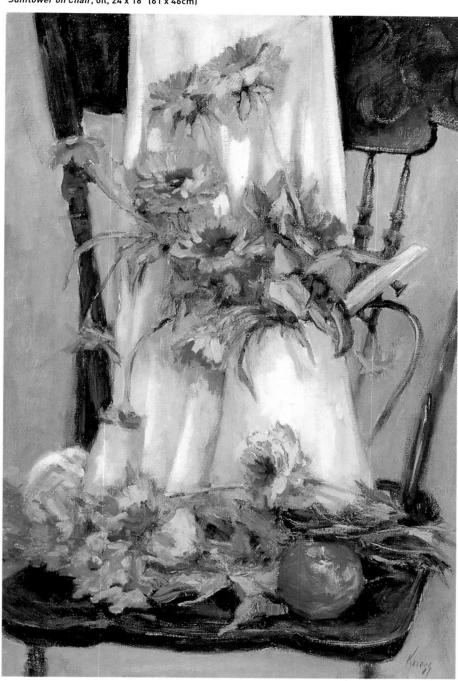

Sunflower on Chair, oil, 24 x 18" (61 x 46cm)

my inspiration

I loved the old-fashioned flowers my friend picked from her garden and brought to my studio, so I wanted a nostalgic, homey feel that was strong, but not cutesy. To achieve that, I added an antique chai and an old coffeepot, and placed the remaining flowers and an apple on the seat of the chair.

my design strategy

I primarily used warm colors, especially on the black chair that would have been too dull and out of character if painted just as it was. To keep the viewer's eye moving around the painting, I emphasized the droopy flowers and the strong curve of the coffee pot handle.

my working process

- I painted from life without using reference photographs because photos lack emotional charge for me.

- After setting up the still life, I lit it, making sure the pattern of light and shadow worked with my overall design.

- Next, I used L-shaped pieces of cardboard to visually "crop" the setup in a variety of ways.

- My beginning marks set the rhythm, an essential part of the composition. By "rhythm" I mean the direction and speed for the eye-path. In this case, I rapidly brushed a thin wash of orange paint in an S-shape, and strengthened that by blocking in the flowers.

- Blocking in light and shadow patterns, I strived to paint the essence of the flowers rather than every petal. Wanting to grasp the moment, which results in a livelier painting, I kept it loose with many soft edges and energetic brushwork. Because live flowers must be painted quickly while they're fresh, I immediately went for the correct color and value. Then I used a paper towel dipped in turpentine and paint to cover the remaining canvas.

- Once satisfied with the flowers, I finished the foliage, pot and chair. I painted this in one afternoon, with touch-ups on the chair and pot the following day.

my advice to you

Paint from live flowers, and paint quickly! Remember, the chair and pot will be there tomorrow; the flowers and shadows they cast may not. Most important, loosen up and have fun.

Patricia Kness lives in Minnesota, USA → www.patriciakness.com

ARTIST 45

Patricia Kness

the materials I used

support
canvas

brushes
nos. 2, 4, 6, 8 bristle filberts and flats

medium
alkyd walnut oil diluted with one-third turpentine

oil colors
Titanium White
Lemon Yellow
Cadmium Yellow
Yellow Ochre
Cadmium Red Light
Alizarin Crimson
Burnt Sienna
Ultramarine Blue
Ivory Black

Value contrast makes these irises stand out, while harmonious colors hold the painting together.

Grandpa's Iris, watercolor, 15 x 22" (38 x 56cm)

ARTIST
46

Loren Kovich

my inspiration

I had two reasons for painting these irises: their extraordinary shape and their unusual color. I had never seen irises this color.

my design strategy

I wanted to show off the shape of the iris on the left. By cropping in tight, I also made the background, negative shapes as interesting as possible. If you look closely, you'll notice that the background areas are all different in shape and size. One of the most important design principles I was concerned with was the contrast between the flowers and the background. I really wanted the pale irises to pop out. To accomplish this, I made the background extremely dark. However, the painting is unified with blues and violets, even a cool peach, throughout.

my work process

• I drew the irises on a half sheet of 300lb cold-pressed paper, and then masked them out with a liquid mask.

• I then wet the entire page and painted wet-into-wet using Ultramarine Blue, Permanent Blue, Olive Green and Paynes Gray. I did some negative painting to save the lighter flower shapes suggested in the background.

• When this dried, I didn't think the background was dark enough, so I used an airbrush to apply a mixture of darker blues and Paynes Gray to soften up some hard edges I didn't like.

• After the background was completely dry, I removed the mask and painted the flowers. I painted a light wash of cool peach color (New Gamboge mixed with Permanent Rose) over both irises, adding more color to intensify the edges of the petals.

• After this dried, I proceeded to paint each petal with the wet-into-wet method, working fast to maintain soft edges. I used a complementary purple color for the shadows and an analogous mixture of Olive Green and Ultramarine Blue for the stems and leaves.

The main challenge in creating this painting

I found it challenging to balance the subtle colors and to control the hard and soft edges in the petals. I had to work quickly, yet carefully, to achieve these results.

the materials I used

support
300lb (638gsm) cold-pressed paper

brushes
2" wash
nos. 3, 5, 10 rounds

watercolors

ULTRAMARINE BLUE PAYNES GRAY

PERMANENT BLUE

OLIVE GREEN

PERMANENT ROSE

NEW GAMBOGE

Loren Kovich lives in Montana, USA

My slick surface allowed me to lift out sparkling highlights for a sunny effect.

Key West, watercolor, 13½ x 17½" (34 x 44cm)

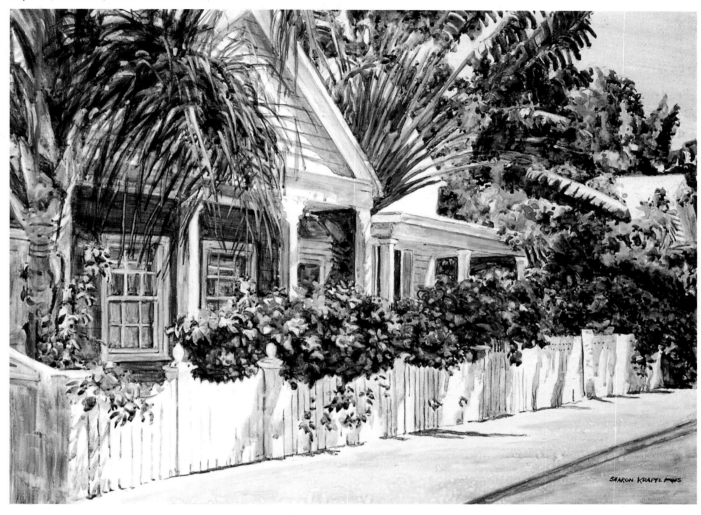

my inspiration

On a trip to Key West, Florida, I was struck by the contrast between the busy tourist areas and the more peaceful, genteel neighborhoods with colorful flowers spilling over white picket fences. I spent a wonderful morning walking around, photographing the interesting homes and gardens in the sunny Florida light. It was this feeling I tried to capture in my painting.

my design strategy

I used color and contrasting values, as well as the perspective of the house and sidewalk, which point down to the flowers, to draw your attention to my center of interest — the pink flowers. Also notice how the palm fronds arch over the flowers.

my work process

- Working from photos and a small color thumbnail, I drew a rather detailed drawing on slick, hot-pressed board.
- Using a limited palette, I painted from light to dark, working around the whites. First, I put in the shadows and sky in a variety of purples and blues. Then I went into the leaves and darker shadows under the porch, again leaving the flower shapes white. Notice how I widely varied the colors throughout the leaves, using everything from yellows and oranges to blue and violet.
- Switching to round brushes, I popped in the bright flowers.
- After evaluating my values, I felt I needed darker accents for balance. I then lifted out some highlights and lighter areas in the flowers and leaves with a wet brush.
- Finally, I splattered paint and water on the street and sidewalk for texture.

something you could try

Experimenting with a variety of papers and boards gives your work a new look and keeps you challenged. Here, I used hot-pressed illustration board, which has a slick surface. This makes it hard to paint washes or large areas smoothly and to layer on darks without lifting back the first layers. However, I experimented until I resolved this problem by using thicker paint on the brush. The beauty of the slick board is that it enables you to wipe back, giving those areas a kind of milky look and unveiling a unique texture created by the brushstrokes.

the materials I used

support
medium weight, hot-pressed illustration board

brushes
½", ¾" and 1" flats
nos. 4, 6, 8 rounds

other materials
water sprayer
toothbrush

watercolors
New Gamboge
Permanent Rose
Antwerp Blue

Sharon Krapfl lives in Iowa, USA → fredksharonk@aol.com

I created a quiet, intimate painting that intrigues the viewer with subtle tones and glowing light.

Evening Magnolias, oil, 18 x 24" (46 x 61cm)

ARTIST
48

Mary Kay Krell

my inspiration

I wanted to paint an elegant, richly colored and detailed image of a Magnolia Grandiflora. These May-blooming blossoms from my tree will always be a favorite subject for my still lifes.

my design strategy

The qualities I strive for in a still life are dramatic light and mystery, yet with a casual air. My aim is to elicit a "wow" from my viewers by quiet, subtle means, not with flamboyant, overwhelming color.

I wanted the primary flower to glow with subtle color, so I surrounded it with darks. But I made the secondary bloom, which is in shadow, quite colorful. The oranges on the other side balance this color while also offsetting all the cool tones. The pattern in the Far Eastern tapestry in the background mimics a large flower, adding more harmony.

my work process

- Under natural light, I waited for the exact moment of sunset when all was tinged with a warm glow to photograph the setup. From an 8 x 10" print, I did a light but detailed pencil drawing on gessoed board.

- My initial underpainting was very loose, done primarily to establish color and value.

- I then gradually refined the painting, going over my original oil sketch at least two more times until I reached the degree of polish I was striving for. I painted wet-into-wet, but took care not to muddy my colors.

- As I neared the finish, I slowed down to spend more time pondering. I studied the values, focal points and overall effect of light, and found I needed few changes to finish.

my advice to you

- Control your color. I am finding that I can tone down my colors and still have the painting work.

In fact, a painting is often more effective with subtler color.

- And let me be frank: If you want to paint still life, get darn good at it before you exhibit your work. Otherwise, you will not be taken seriously.

the materials I used

support
primed gesso board

oil colors
Naples Yellow
Yellow Ochre
Lemon Yellow
Cadmium Yellow Medium
Cadmium Red Light
Phthalo Rose
Alizarin Crimson
Magenta
Cobalt Violet

brushes
nos. 2–14 blended-fiber flats, filberts and rounds

Phthalo Violet
Prussian Blue
Ultramarine Blue
Manganese Blue
Cerulean Blue
Sap Green
Viridian
Burnt Sienna
Raw Umber

Mary Kay Krell lives in Texas, USA → mkkrell@comcast.net

The lyrical lines of the foreground objects draw your eye into the shadowy depths of this dramatic still life.

The Love Birds, oil, 20 x 16" (51 x 41cm)

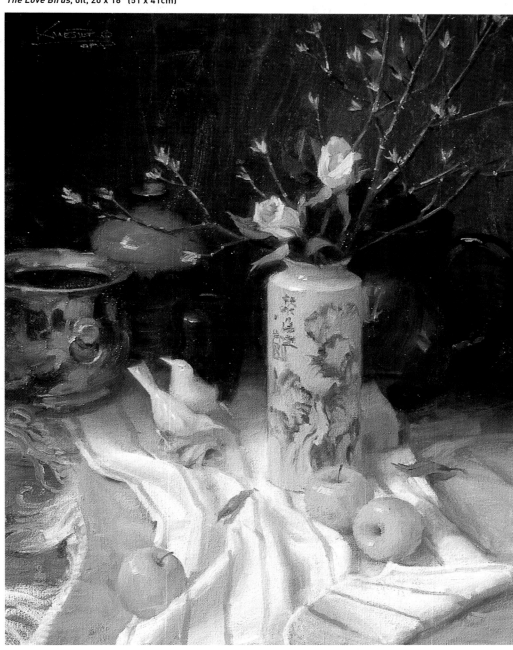

ARTIST
49

Robert Kuester

a commission story

This painting was commissioned by a woman who brought me the love birds and sprigs of willow in spring, both of which seemed to symbolize the season. I organized the composition by adding more to these two items, creating an arrangement that was both delicate and mysterious.

my design strategy

In major and minor divisions of space, I often honor the golden section. Here, I allowed the top area to be dark and the smaller bottom part to be basically light. As the lights graduate into dark, the oriental vase and the birds have their base in yellows and whites. The background then serves as a foil for their interesting contours. The roses are the apex, with dots of opening buds behind them. The dark pots made the dark void richer with form and color. The repeat of yellow apples on yellow cloth is purposeful, as are the diagonal folds, all leading the eye back into shadow with their lyrical lines.

my painting approach

• I started by placing objects and shifting them around until I attained sufficient movement and contrast in strategic places. I monitored my results by viewing the arrangement through L-shaped croppers.

• Using a variety of earth colors, I toned the canvas with medium-light values in the bottom section and mid-dark values above. I then wiped out the light lights and added the dark darks.

• Once my value pattern seemed secure, I painted as directly as possible, retaining brushwork to show the process. I worked from thin to thick, keeping shadows thin and getting heavier in the lights. Adding a small drop of clove oil to my palette allowed me to paint wet-into-wet on successive days.

the materials I used

support
stretched acrylic-primed cotton canvas

brushes
bristle brights, very large to very small

medium
emulsified linseed oil

water-soluble oil colors

Cadmium Yellow Medium Yellow Ochre Burnt Sienna Cadmium Red Medium
Quinacridone Red Ultramarine Blue Sap Green Ivory Black
Titanium White

Robert Kuester lives in New Mexico, USA → kuesterart.com

The brilliant daylight enhanced the built-in contrast of this plant.

Joyce E Lazzara

ARTIST 50

my inspiration

I love to use exotic plants as my subjects. I seek out the most beautiful specimens bathed in just the right light. There is a perfect sunlight that casts the most interesting shadows and transforms color, completely changing some colors altogether and making parts of the plants seem almost transparent. This only happens during a couple of hours during the day.

my design

As its name suggests, the giant bird of paradise is very large. Rather than paint the plant smaller than it was in order to fit it on my small canvas, I chose to zoom in and paint it life-size. I was drawn to the contrast in shapes and colors. The bright white, spiky flowers were dramatic against the huge, rounded, dark green leaves. I tried to paint this plant as it appeared in the perfect, transforming sunlight.

my work process

- Working from several photos and part of the live plant, I first made a sketch with vine charcoal, then sprayed it with a workable fixative.
- When this was dry, I began my traditional oil painting by laying a wash over the drawing with a mix of turpentine, Burnt Sienna and a little quick-drying medium.
- As soon as this dried, I covered the entire canvas with thin paint, laying in the color and tonal values.
- I let this dry for a day or so, and then started the fun part — putting in the details. I worked from darks to lights and back and forth.
- I glazed some areas to brighten or darken others, until the painting came alive.
- I added the highlights last.

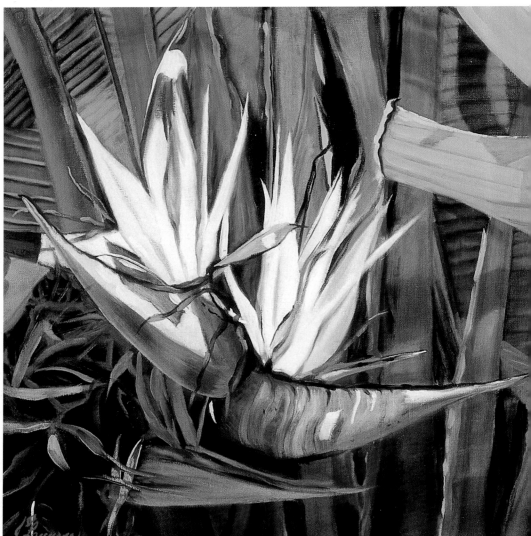

Nicolai, oil, 18 x 18" (46 x 46cm)

here's a hint

To supplement drawing and painting from life, I take digital photographs, storing my images on CD-ROM for quick access and to save space. I don't try to be the best photographer, because I'm only collecting the visual information I will need later for painting. I shoot several photos of the subject to make up for changing wind and cloud cover.

the materials I used

support
stretched portrait linen

medium
quick-drying medium

brushes
nos. 2–12 bristle brights and filberts
nos. 1, 2, 4, 6, 8 sable flats and rounds
1"–4" blenders

oil colors

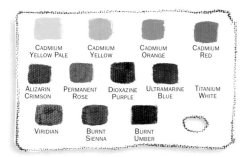

CADMIUM YELLOW PALE CADMIUM YELLOW CADMIUM ORANGE CADMIUM RED
ALIZARIN CRIMSON PERMANENT ROSE DIOXAZINE PURPLE ULTRAMARINE BLUE TITANIUM WHITE
VIRIDIAN BURNT SIENNA BURNT UMBER

Joyce E Lazzara lives in Florida, USA → www.joycelazzara.com

The cotton buds in this painting not only add interest, they highlight the focal point and unify the composition.

Cotton and Sunflowers, watermedia, 40 x 30" (102 x 76cm)

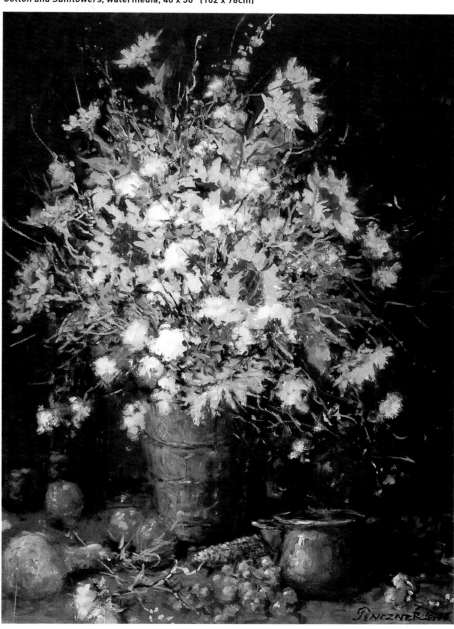

my inspiration

I saw cotton plants for the first time when I immigrated to the USA in 1951. I have been fascinated by them ever since, and I always have some in my studio.

my design strategy

I painted the background very dark, and all the other objects are painted in middle values. Only the cotton buds and some tiny highlights are white. These rare spots of white unify the painting and guide the viewer to the focal point.

follow my eye-path

The viewer enters the painting near the single bright cotton bud at lower left. From there, the highlights on the grapes lead the eye over to the vertical highlight on the teapot, which in turn leads the viewer to the flowers.

special techniques

Although I paint with watercolor, I use white gesso and Titanium White acrylic when adding highlights. This gives the finished painting some texture and opacity.

the materials I used

support
artboard

brushes
nos. 6–20 sables

medium
white acrylic gesso
Titanium White acrylic

watercolors

Paul Penczner lives in Tennessee, USA

My challenge was to maintain a sense of depth in this vertical, shallow space.

Poppies, oil, 48 x 25" (122 x 63cm)

my inspiration

I was attracted by the ragged edges of the petals and the dazzling complementary color.

my design

Because the image is shallow — it appears to be only a few inches deep — I designed my path of red to unfold from top to bottom rather than from foreground to background.

color concepts

I would call this subject inactive because there is no implied movement. By using values of two complementary colors — red and green — I made the plants active without making the composition too busy.

my work process

- I applied gesso to my birch plywood painting surface and toned it with Venetian Red. Then I transferred my line drawing with sanguine chalk.

- For my underpainting, I used glazes of Phthalo Blue, Burnt Sienna and white to divide colors into warm and cool.

- Using an alkyd medium, I glazed with powerful and transparent colors such as Phthalo Green and Quinacridone Red.

- I worked wet-into-wet in the light areas, using more opaque colors like Cadmium Red and Chromium Oxide Green. I dulled the intensity of these colors to maintain realism.

the materials I used

support
cabinet-grade birch plywood

brushes
nos. 1–12 synthetic sables

medium
alkyd medium

chalk
sanguine

oil colors

ZINC/TITANIUM WHITE MIX | YELLOW OCHRE | CADMIUM RED LIGHT | VENETIAN RED

OXIDE OF CHROMIUM GREEN | BURNT SIENNA | QUINACRIDONE RED | PHTHALO GREEN

PHTHALO BLUE | PERYLENE MAROON

David Dodge Lewis lives in Virginia, USA → dlewis@hsc.edu

David Dodge Lewis

ARTIST
52

This spray of flowers expresses dynamic movement and exuberance.

Sunbursts, colored pencil, 16 x 20" (41 x 51cm)

my inspiration

I always try to create a picture with depth, movement and no discernible pencil marks. But I also want the image to seem tactile. I want the viewers to think they can almost *feel* the flowers.

my work process

- Using a reference photo, I made a light but fairly complete graphite drawing directly on white 8-ply museum board.

- I began applying color in the light areas, erasing my drawing as I went.

- I mixed and scrubbed darker areas as I progressed, using very heavy pressure — beyond burnishing. I almost felt each petal as though I were sculpting the flower out of the board.

- Not only covering, but completely obliterating the surface texture of the paper, I filled in the dark background and large areas last. I used a razorblade to remove color from areas that couldn't be erased.

- I finished by carving sharp edges into my picture with graphite pencils ranging from 2B to 6B.

- Finally, I sprayed fixative on the piece to prevent wax bloom and bring out the colors.

the materials I used

support
8-ply white museum board

other materials
F graphite pencil

nos. 2B–6B graphite pencils

white plastic eraser

brush

razorblade

fixative

wax-based colored pencils
Lemon Yellow
Canary Yellow
Deco Yellow
Sunburst Yellow
Jasmine
Sand
Yellow Ochre
Goldenrod
Light Umber
Raspberry
Sepia
Lime Peel
Olive Green
Dark Green
White
Black

Heidi J Klippert Lindberg lives in Washington, USA → lindberg@interisland.net

Complementary colors, brushwork and contrast, made this static subject exciting.

Complements, oil, 30 x 24" (76 x 61cm)

Lucy Mazzaferro

ARTIST 54

my inspiration
I was inspired by the rhythmic gesture, strong color, and dancing interaction of the orange lilies and the white snowberries.

follow my eye-path
I wanted the viewer to read the painting from left to right, following the direction of the light. I placed a small, bright vase at lower left to encourage the viewer to enter the painting at that point. From there, the snowberry branch leads up to the lilies, which are the focal point of the composition. Another snowberry branch leads the eye down to the persimmons on the table.

my work process
• After lightly toning my canvas with a unifying color (Transparent Oxide Red), I massed in the design using thin paint, then wiped out the lights with a paper towel.

• After finding the darkest dark and the lightest light, I quickly began working on the flowers because I knew they would not hold their pose for long and their color would fade.

• I used thick impasto paint on the highlights and frontmost lilies to make them come forward, and painted the flowers in the background with thin paint and soft edges.

my brushwork
Brushstrokes are the language of painting. I tried to capture the gestures of the flowers and leaves with descriptive brushstrokes and thick paint. In the dark areas and background I kept my strokes quiet. I use big brushes for large areas and small brushes for details.

advice for painting florals
When painting floral subjects, choose only a few flowers to be the stars. By painting greater detail in these flowers, you can make them come forward. Likewise, by painting the background flowers thinly and with soft edges, you can make them appear to recede. This technique allows you to paint a three-dimensional bouquet, rather than an assembly of individual flower portraits.

the materials I used
support
double oil-primed stretched linen canvas

brushes
nos. 2, 4, 6, 8, 10, 12 bristle filberts

medium
Maroger

oil colors

NAPLES YELLOW · CADMIUM LEMON · CADMIUM YELLOW PALE · CADMIUM ORANGE

CADMIUM RED LIGHT · TRANSPARENT RED OXIDE · ALIZARIN CRIMSON · RAW UMBER

ULTRAMARINE BLUE

Lucy Mazzaferro lives in Mississippi, USA → lucymazzaferro@aol.com

I wanted line and color to work together to lead your eye around the painting.

The White Vase, oil, 36 x 26" (91 x 66cm)

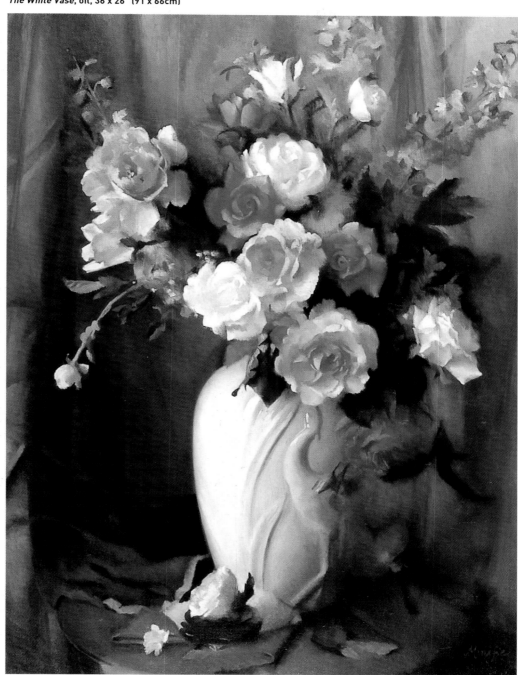

color concepts

It's very difficult to make something white the center of interest. The minute you add color somewhere else, it draws the eye away. To keep the focus on the flowers, I mixed in pink and red blooms.

I used a complementary, greenish background, generally making it dark behind lighter flowers (left side) and light behind darker flowers (right side).

follow my eye-path

I wanted the viewer's eye to enter the painting near the small vase stand at the bottom left. From there, the vase's fluid, arabesque lines lead the eye to the flowers. The pink and red blooms create their own flowing line across the arrangement, maintaining interest at the focal point.

my preparatory process

- I spent a day or two setting up the flowers and finding the right color combinations and design.
- Then I did a small pastel sketch to see how my ideas would really look and to determine the shape of my canvas.
- I did the initial lay-in with rather thin paint, aiming to define placement, color notes and accurate values.
- Only when all those things were working together and the drawing was right did I go on to the final painting stage, bringing it to a finish.

even accomplished artists do this

I squint with my eyes a lot to see the big relationships between values and edges.

painting flowers from life

Unlike many artists, I paint flowers from life. I get a much better sense of form and color because I don't have to interpret three dimensions from a two-dimensional image. I also find the camera makes everything appear hard-edged. When painting from life, it's much easier to see the soft and lost edges.

Mary Minifie

ARTIST 55

the materials I used

support
single-primed stretched canvas

brushes
various filberts

oil colors
Cremnitz White
Cadmium Lemon Yellow
Viridian
Cadmium Scarlet
Permanent Red Violet
Ultramarine Blue
Alizarin Crimson
Ivory Black

Mary Minifie lives in Massachusetts, USA → www.maryminifie.com

This unusual viewpoint fascinated me and created drama in this composition.

Joye Moon

ARTIST
56

my inspiration

The island of Isola Bella is a short boat ride off the coast of Stresa in northern Italy. The entire island is a multilevel formal garden enhanced by a spectacular variety of sculpture. Each garden offers an unusual view. I wanted to compose a painting focusing on one of these unusual views.

my work process

- Working from a small ink sketch and photos, I applied masking fluid with a small palette knife to hold the white of the paper.
- To set the tone of the daylight, I washed in the lavender sky.
- I painted various green washes as the foundation for the trees and bushes.
- Next, I moved on to the sculptures, painting them as backlit silhouettes.
- I painted the flowers as color shapes. Keeping some areas simple helped lead the eye to the sculptures.
- Finally, I removed the masking fluid and painted the coral and orange flowers.

something you can try

I never use shades of gray for shadows. I prefer to combine the sky color I have chosen with the colors of the flowers or other objects, such as the sculptures, to create the shadow color. This simple color technique adds life to the shadow areas.

the materials I used

support
140lb (300gsm) cold-pressed paper

brushes
nos. 4, 6, 8 rounds
1" flat

watercolors
Cadmium Yellow Light
Quinacridone Gold
Permanent Orange
Quinacridone Coral
Lavender
Phthalo Green
Indigo

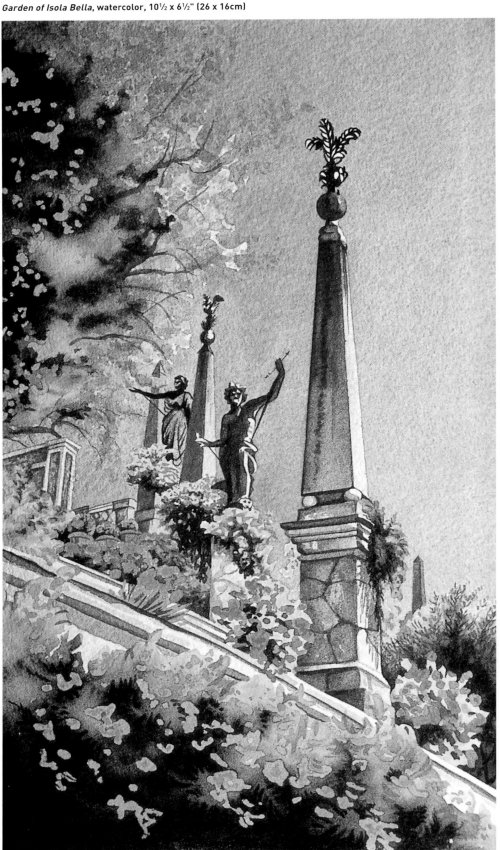

Garden of Isola Bella, watercolor, 10½ x 6½" (26 x 16cm)

Joye Moon lives in Wisconsin, USA → www.joyemoon.com

Sharp edges, thick paint and purity of color define the highlights in this painting.

Backlit Roses, oil, 12 x 9" (30 x 23cm)

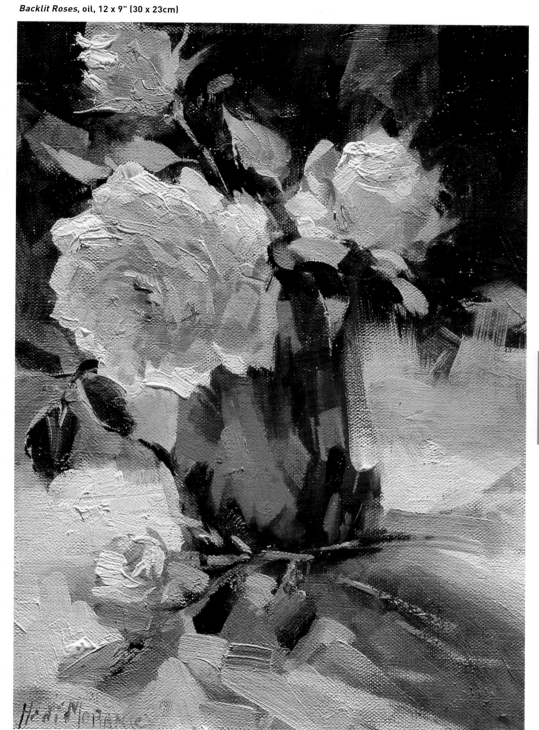

Hedi Moran

ARTIST
57

my inspiration

What I found most exciting was how the bright sunlight poured through the red glass vase and highlighted the edges of the fresh withe roses.

my design strategy

My design strategy was based on the letter T, with the largest objects across the top of the painting. My intent was to establish an eye-path from the largest flower in the upper left focal area down through the brightest part of the vase. The eye would then progress back up to the flower in the upper right quadrant and around, returning to the focal point.

color concepts

I painted the highlights on the petals with thick paint and sharp edges, making them stand out sharply from the darker values in the shadowy areas. Although the red vase was glass, it and the stems inside it cast a shadow. I painted the shadow with muted, dark red tones, but where the light shone straight through, I added a few streaks of bright red.

get right to it

To make the most of my initial excitement about my subject, I start not with a drawing, but by spontaneously filling the canvas with transparent colors — in this case, Indian Yellow and Sap Green for the flowers and background, Alizarin Crimson for the vase. Only when the canvas was fully covered did I start to apply opaque paints.

taking the still life outdoors

Outdoor lighting conditions can be very exciting, but they're shortlived. I arranged these flowers in the red vase and photographed them outside in the sunlight — freezing them, so to speak — for future reference.

the materials I used

support
stretched canvas

brushes
various bristle brushes

mongoose flats

oil colors

Indian Yellow
Cadmium Yellow Light
Cadmium Orange
Cadmium Scarlet
Alizarin Crimson

Ultramarine Blue
Indigo
Sap Green
Ice Blue
Titanium White

Hedi Moran lives in Arizona, USA

This painting radiates warmth because I eliminated white from my palette.

Villa Geranium, oil, 30 x 24" (76 x 61cm)

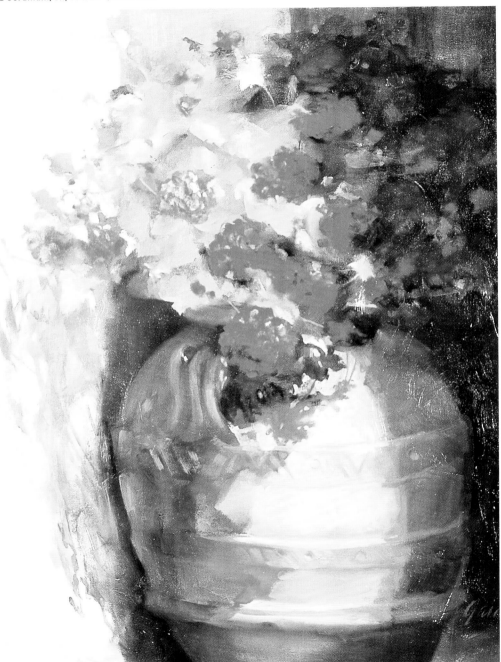

Gail Morrison

my inspiration and challenge

I wanted to capture the patterns of sunlight on this large terracotta orcio. At the same time, I would need to balance the volume of the terracotta, the mass of blooms and the intricate shadows.

sculpting with paint

- In some areas of the painting, the paint is relatively thin. The cast shadows and the ochre-stained walls of the villa held a world of warm and cool colors — I included both as I saw them. Some of these initial washes of color remained unchanged.

- However, while painting the three-foot-tall pot and the large flowering geranium, I moved masses of paint. I felt I was vicariously building the pot as I laid paint in "coils" of Terra Pozzuoli to create its volume.

painting the flowers

By defining a few of the foreground blossoms, I made the other blooms believable as well. When you paint flowers, examine the leaves and petals, touch the stems and understand how they branch.

hot color

- This painting is about heat — my palette needed to be as hot as the sun-drenched wall. I eliminated white from my palette and substituted Naples Yellow Light.

- In this painting there's only a hint of cool blue in the delicate shadows cast on the villa wall, reflected from the foliage.

- As the painting neared completion, I glazed much of it with Transparent Orange and Maroger medium to heighten the sun-drenched effect.

the materials I used

support
oil-primed linen

brushes
nos. 4, 10, 16, 22 filberts and brights

medium
Maroger

oil colors
Naples Yellow Light
Cadmium Yellow Pale
Naples Yellow Deep Extra
Terra Pozzuoli
Scheveningen Red Medium
Alizarin Crimson
Cadmium Green
Green Earth
Ultramarine Blue Deep

I used subdued color and tone to convey a somber mood.

Longer Days II, watercolor, 15 x 22" (38 x 56cm)

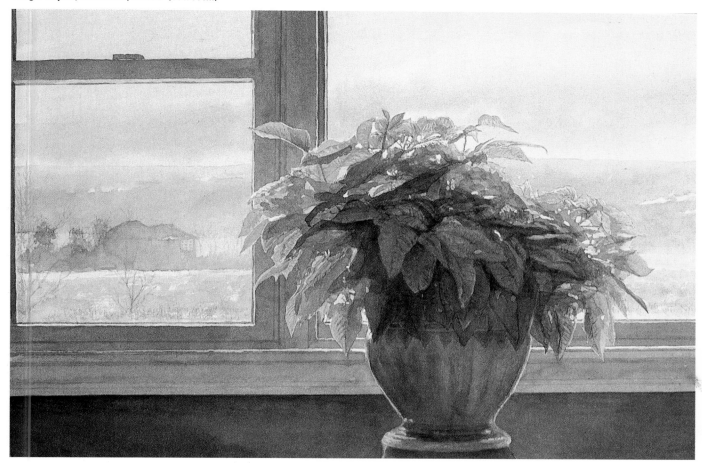

creating mood

The eerily backlit plant stand in this painting belonged to my wife's grandmother, who had recently become too old to care for her own home. I wanted to paint this brightly lit subject, yet create a somber, moody painting lamenting the everchanging nature of life.

To accomplish this, I limited the tonal variance within the composition. I darkened the frame window and the wall but lightened the darkest details in the flower and stand. I carefully mixed very muted green and pink colors for the leaves of the plant. The subdued complements allowed for plenty of visual interest and some excitement in the painting while still projecting a solemn and thoughtful overall mood.

my work process

- I took a digital photo of this scene, then adjusted the composition on my computer.
- I made a detailed drawing and selected my pigments by mixing large wash areas and key colors.
- At this point I masked the areas that needed to be preserved as bright light or white paper.
- I started painting by washing in the sky. I progressed to the window frame, then to the plant and stand.
- While laying in the color for the plant, I painted the leaves individually, wet-into-wet, using both green and red.

- I adjusted tonal relationships by glazing with neutral or complementary colors. I glazed the window frame, wall, and middle areas of the plant and stand three or four times to bring them to their final values.

- Finally, I removed all the masking and rendered the details of the stems, lines on the window casing, and a few of the background trees.

the materials I used

support
300lb paper, stapled to board

other materials
masking fluid with pen applicator

watercolors

brushes
nos. 6 and 12 round sable washes
small dagger sable

NEUTRAL TINT

BURNT SIENNA

MAGENTA

CADMIUM YELLOW

COBALT BLUE

William Mowson lives in New York, USA → bmowson@twcny.rr.com

I added the pears to pull some of the color and weight of the gladiolas down into the bottom of the painting.

Nancy Nordloh Neville

ARTIST 60

Glads and Pears, watercolor, 24 x 17" (61 x 43cm)

my inspiration

During a walk through an open-air farmers market, I was taken by the buckets of waist-high gladiolas. The pears were the perfect choice to bring color down into the lower portion of the image because they echoed the yellow-peach color in the glads.

my design strategy

I painted the flowers going off the top of the canvas to convey their height. To create movement, I chose a simple glass vase that would reveal the twist of the stems. One pear reflecting through the glass gives the composition depth. I gave a lot of attention to the distribution of space, including the negative space.

my work process

- I began with a small thumbnail sketch in very transparent watercolor. Then I created an outline directly on the watercolor paper, drawing through the container and noting the waterline.
- Painting quickly, I created the flowers with both hard and soft edges. I painted without a lot of glazing, misting with a fine spray as the painting progressed.
- I painted the stems inside the container before I painted the container, allowing some of the stems to define the edges of the blooms.
- I painted the glass when the stems were only slightly dry.
- After the glass and stems were dry I went back in with Olive Green darkened with blue to help define the stems.
- I painted the pears last, bringing the color of the flowers down into the bottom of the painting.
- Finally, I flicked a little Cerulean Blue on the glass to give it a bit of sparkle.

my advice to you

- Know your subject. Really look at the flowers and learn how they are constructed.
- But when it's time to paint, don't feel like you have to put all these details in. Keep it simple.

the materials I used

support
140lb (300gsm) cold-pressed paper

watercolors
Mauve
Mars Violet
Cadmium Yellow
Olive Green
Cobalt Blue
Winsor Lemon

brushes
nos. 8, 12 sables

Cerulean Blue
Cadmium Orange
Permanent Rose
Burnt Sienna
Cobalt Violet

Nancy Nordloh Neville lives in Ohio, USA → bnneville@aol.com

Side-by-side, the complementary colors yellow and purple create a lit effect within the roses.

Still Life with Roses, oil, 24 x 24" (61 x 61cm)

solving design problems

- The beauty of sunlit flowers is hypnotic, so I didn't need much more in terms of composition. But even the simplest design can pose problems. I thought the teapot shape was boring, so I added the tangerines to break up the edges. The fruit and tablecloth also help lead the eye around the painting.

- To keep the viewer's eye from following the edge of the table out of the painting, I made the table similar in color to the background. and placed the tablecloth so the eye would follow its edges instead.

- The red roses were every bit as spectacular as the yellow, but I wanted the yellow roses to be the focal point. I painted them brightly and with more detail so they would stand out.

color concepts

The centers of the yellow roses are made of strong brushstrokes of yellows and pale purples. These colors create a warm/cool contrast that the eye interprets as light and shadow. The result is a lit effect.

my work process

- Working from a life study, I used a small brush to define shapes.

- I then blocked in large masses, working from dark to light.

- Next I perfected edges and added interest with thick brushstrokes .

- I painted the final accents, stepping back frequently to make sure I was achieving the effect I had in mind. I went back several times to add texture and warmer colors.

the materials I used

support
primed Masonite

oil colors
Cadmium Yellow Light
Yellow Ochre
Hansa Yellow Orange
Cadmium Yellow Medium
Cadmium Red Light

brushes
nos. 10, 12 filberts

Raw Umber
Quinacridone Red
Ultramarine Blue
Viridian Green
Titanium White

Gregory Packard lives in Wyoming, USA → www.gregorypackard.com

I mimicked brilliant, dappled sunlight with thick dabs of white over dark greens.

SeKyoung Park

ARTIST
62

my inspiration

The morning light in this garden was so powerful that it changed the color of the greens, even seemed to alter the physical shape of the flowers.

follow my eye-path

I wanted the viewer's eye to enter the painting near the yellow flowers at the bottom. From there, the eye would travel up the right edge of the concrete wall and spiral into the center of the painting, where the light is brightest.

color concepts

Although there were many colors of green in the garden, I chose to paint with different values of just a few greens. This technique preserved the core beauty of the image, avoiding a chaos of too many colors.

I used very dark greens and very bright highlight colors to create the most contrast possible.

I used both my thumb and my paintbrush to apply the big, bold dabs of white. This is a dramatic lighting effect, and must not be overused.

my work process

- I started with a very basic sketch — just a couple of light pencil lines to establish the main composition.

- Over the top of this I applied a light green foundation with a broad, flat brush. I covered the majority of the canvas, but excluded the areas I planned for bright light.

- I painted in big dabs in the brightly sunlit areas, overlapping layers to make the leaves and flowers part of the lighting.

- To finish, I applied thick, rough, touches of white for highlights.

something you can try

I painted wet-into-wet with several partially mixed colors, using my canvas as a palette and not giving the paint too much drying time between the layers. This creates an extra depth of shade that expresses the energy of an image.

Morning Garden, oil, 30 x 24" (76 x 61cm)

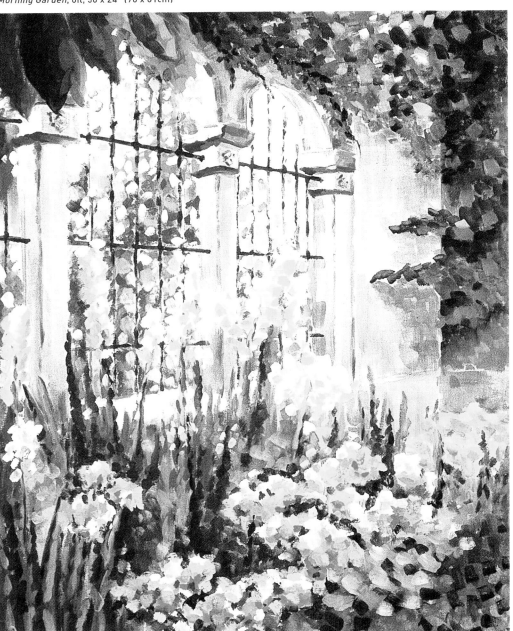

the materials I used

support
stretched canvas

brushes
a variety of flats and filberts

oil colors

TITANIUM WHITE AZO YELLOW DEEP SAP GREEN ALIZARIN CRIMSON

IVORY BLACK

SeKyoung Park lives in British Columbia, Canada → sekyoungpark@telus.net

The extreme contrast of tonal values makes this floral stand out in a crowd.

One Pure Thought, watercolor, 22 x 30" (56 x 76cm)

Heidi Lang Parrinello

ARTIST 63

my inspiration

To me, iris seem to have almost human characteristics. When I found this pure white flower, the shadow on the right petal was so interesting it seemed to come from the plant itself. I decided to capture the shadow and, in doing so, capture the flower's "one pure thought."

my color plan

I chose a split complementary color scheme for this painting: two colors next to each other on the color wheel and one color on the opposite side of the color wheel. In this case, I used blue-green, blue-violet and yellow-orange.

my work process

• I painted the shadows on the flower with values of blue-violet.

• I used blue-green for the background. When I wanted to scrub out some highlights, I used an old scraggly brush.

• To add interest and drama to the overall cool palette, I painted the beard of the iris and the veining on the petals yellow-orange.

• I left the white of the paper for the petals themselves. The high contrast of the white against the dark, blended background really lets the petals do the talking!

the materials I used

support
300lb (638gsm) cold-pressed paper

brushes
nos 6, 8, 10 rounds
liner

watercolors

PRUSSIAN BLUE · ULTRAMARINE BLUE · VIRIDIAN · ALIZARIN CRIMSON · NEW GAMBOGE

Heidi Lang Parrinello lives in New Jersey, USA → heidialang@aol.com

Diagonal shadows and backlighting create a powerful mood in my painting.

Secret Garden, watercolor, 22 x 30" (56 x 76cm)

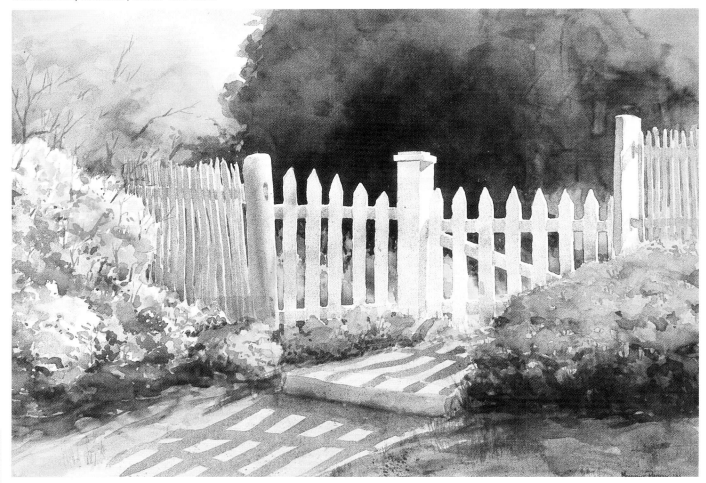

Monique Parry

ARTIST
64

my inspiration

The late afternoon light backlit the fence and cast an eye-catching shadow, creating an interesting composition.

follow my eye-path

I painted the center stile — the focal point in this picture — with sharp edges and high color and value contrast. The light and shadow on the walkway lead the viewer's eye into the painting and to the stile. From there, the eye progresses to the stile on the right, then across the background mass and down, returning to the focal point.

my work process

- I began by pouring pale washes of yellows, pinks and blues onto wet paper, tilting the paper so that the colors would blend.

- After drying, I carefully drew in the fence and gate, blocking in the other elements.

- I rewet the paper and added more color with a 1½" wash brush, softening the edges as I went along.

- Next, I worked wet-into-dry and from light to dark, beginning with the fence and walkway. Because I didn't use masking fluid, I preserved dry paper in the areas I wanted to remain light. The paint only flowed where the paper was wet.

- I built up the rest of the painting with a series of washes for the flowers and shrubs.

- I finished by adding shadows, the spattering on the walkway, and the suggestion of branches.

I worked from light to dark, from large to small.

try this yourself

Pouring paint onto wet paper at the start of the painting process infuses a soft glow that unifies the painting. The process works best when the warm tones, especially the yellows, are applied first. In *Secret Garden*, the only area that has no warm color is a very small portion of the sky.

the materials I used

support
300lb (638gsm) cold-pressed paper

brushes
1½" wash
6, 8, rigger
nos. 10, 12, 16, 28 rounds

watercolors

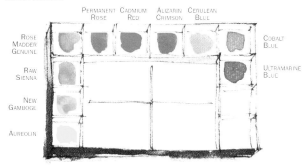

Monique Parry lives in Arizona, USA → www.parrygallery.com

I used nature's palette of complementary colors to make these tomatoes really stand out.

Tomatoes, watercolor, 28 x 20" (71 x 51cm)

my inspiration

I spotted these tomatoes — all in different stages of ripeness — in my mother's garden in Warsaw, Poland. The red tomatoes were almost translucent in the strong sunlight. All I had to do was find the best angle from which to paint them.

color concepts

Growing in the garden, the red tomatoes appear among the complementary green foliage. Using these complementary colors side-by-side in the painting not only shows the tomatoes in their natural setting, it adds interest and highlights the focal point. Notice that the red color of the tomatoes is reflected on the stems.

my work process

• I began with a value study and then prepared a pencil sketch.

• I gradually developed colors and values by applying multiple layers of transparent watercolor.

• I applied warm colors first, then the cool ones.

• In some areas of the background, I applied color wet-into-wet to create soft edges.

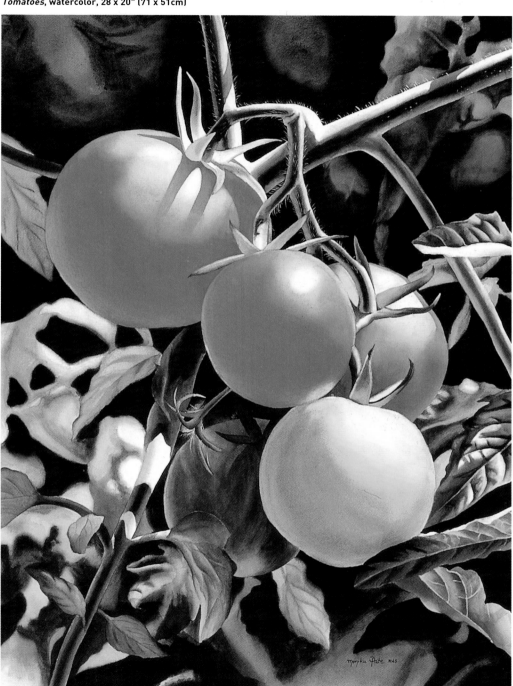

Monika Pate

ARTIST
65

the materials I used

support
300lb (638gsm) rough paper

watercolors
New Gamboge
Vermilion
Phthalo Red
Permanent Alizarin Crimson
Burnt Umber

brushes
nos. 10, 12, 14 flats

Ultramarine Blue
Phthalo Green (Blue Shade)
Sap Green
Indigo

Monika Pate lives in Iowa, USA → mpate65@mchsi.com

By backlighting these white flowers, I accentuated the color variations in these sunstruck blooms.

Luscious Whites, oil, 24 x 20" (61 x 51cm)

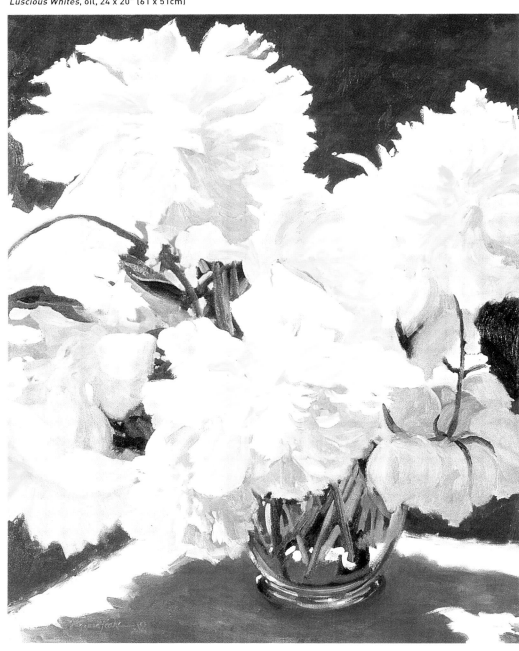

Virginia Peake

ARTIST 66

my inspiration

When I cut a bouquet of white peonies in my yard, I was stunned by the luscious abundance of the flowers — their variations of color, the fullness of the heavy blooms, and the way the whites shimmered in the sunlight.

my design strategy

Lit from the front by strong sunlight, these flowers would be dull, washed-out white. By backlighting the arrangement, I preserved the large color palette these peonies have in the middle values of the blossoms.

my medium

I use water-soluble (sometimes called water-miscible) oil colors. These colors wash out of the brush with water.

my work process

- I photographed the flowers for reference during painting, then made a detailed pencil drawing on my canvas. I sealed this with a workable fixative.

- I toned the entire canvas with a hot pink wash that I allowed to peek through and hold the painting together.

- After the wash had dried, I painted the darks using pigment mixed with a quick-drying medium. The medium kept the darks thinner, glossy and rich.

- I applied the middle values carefully, squinting to check myself and ignoring small details. I varied the color a lot to avoid boring the viewer. I let this stage dry overnight until tacky.

- Finally, I applied the whites — almost literally the icing. I dragged heavier paint over the underpainting and adjusted values within the complicated blossoms. Details were added, and voila!

HOT TIP!

Sometimes you need thick, single strokes to add punches of color or highlights. To avoid fussiness or mistakes, just touch the canvas lightly with your brush to check value and color. Then go ahead and make a single, strong stroke.

the materials I used

support
stretched canvas

brushes
various sizes of filbert

medium
quick-drying medium

water-soluble oil colors

ULTRAMARINE BLUE	PHTHALO GREEN	PERMANENT GREEN	BURNT SIENNA
CADMIUM RED LIGHT	ALIZARIN CRIMSON	CADMIUM YELLOW DEEP	CADMIUM YELLOW LIGHT
COBALT BLUE	TITANIUM WHITE		

Virginia Peake lives in Connecticut, USA → www.virginiapeake.com

I created a feeling of intimacy by making several changes in the composition of this scene, taken from life.

Overlooking the Sound, oil, 18 x 14" (46 x 36cm)

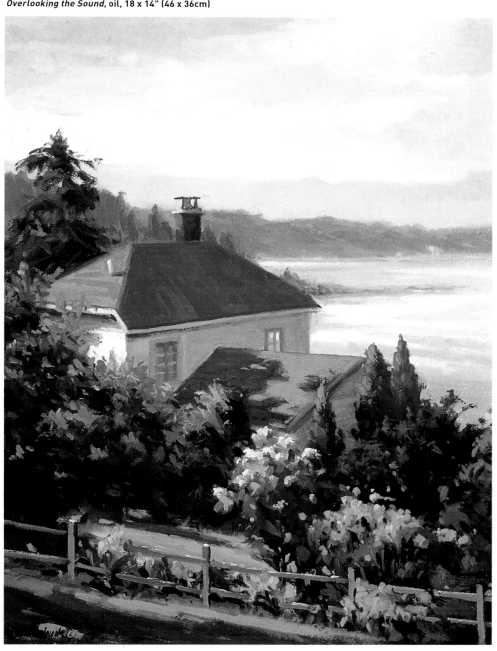

my inspiration

I thought the aerial point of view of this house on Puget Sound was very interesting. The distance across the Sound created a striking contrast between the values and colors of the hills in the background and the house and garden in the foreground.

perfecting the composition

I took several liberties with the subject. To replace the unsightly apartment complexes near the beach, I simply added an extension to the right side of the house. I increased the size and importance of the plantings, added the fence, and increased the intensity of the light on the house. These changes made the scene more intimate.

my work process

- I painted a value study on location. In the studio, I altered the composition to my liking.

- I used a round bristle brush and paint diluted with mineral spirits to draw the subject on gessoed Masonite.

- I began painting in earnest by laying in the darkest darks.

- Working progressively toward the lights, I made sure to use accurate values and color. At this stage, I worked with paint thinned with mineral spirits.

- I added painting medium to my second layer of paint, which started with the sky and progressed from top to bottom, background to foreground.

- The final step was to analyze the whole painting for areas needing refinement.

keep this in mind

Contrast makes paintings interesting. Try to incorporate all of these, and more, into your work.

- dark vs. light
- large vs. small
- bright vs. dim
- close vs. far
- hard vs. soft
- diagonals vs. horizontals vs. verticals

John Pototschnik lives in Texas, USA → www.pototschnik.com

John Pototschnik

ARTIST
67

the materials I used

support
¼" Masonite, primed with acrylic gesso

brushes
nos. 2–8 bristle flats

medium
quick-drying medium

mineral spirits

oil colors

TITANIUM WHITE ULTRAMARINE BLUE ALIZARIN CRIMSON CADMIUM YELLOW

CHROMIUM OXIDE GREEN

Amid all the warm colors, the cool pink peony gets your attention fast.

Diane Rath

ARTIST
68

Peonies & Peaches, oil, 24 x 20" (61 x 51cm)

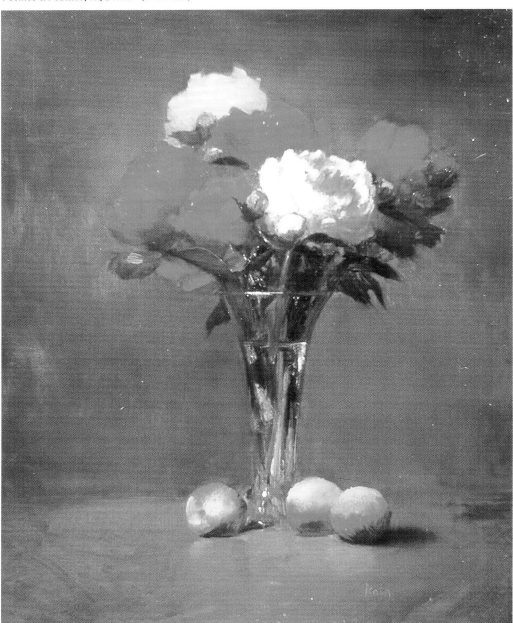

my inspiration

I love peonies so much that I paint them every day when they are in bloom, borrowing a few from my neighbors, the vacant house down the alley and a few from the city courthouse garden late at night when no one is looking.

my design strategy

I bring the viewer into the painting from the lower left. Following the light, the eye ascends up to the lit pink peony and on around the bouquet. The clarity of the glass vase is an interesting contrast to the opaque flowers and fruit.

my work process

- I massed in the design using brown made from transparent red, yellow and blue.

- I start painting shapes, breaking large shapes down into smaller ones. I worked slowly in this stage because the foundation had to be correct or the painting would never work.

- I painted the background with little color to support the more colorful subject, pulling my brushstrokes inward toward the center of the canvas.

- Next I painted the shadows, viewing the formed and cast shadow as one shape — a cup to hold the light.

- I then painted the light objects. I incorporated a bit of background color into the flowers closest to the back.

something you can try

Peonies are fun to paint with a palette knife. Give it a try!

- Sweep your strokes from the center of the flower out in a cuplike direction.

- Scrape some of the paint off the flowers further away to create distance; thinner paint recedes.

- Switch to your brush and "carve" background into the edges to form the petals.

- Finally, add details to the front flowers with a smaller brush to bring them forward.

advice for painting flowers

- Paint the shadows of your flowers in warm colors so they appear alive.

- Add the reflected lights you see last, and don't let them compete with the light values of your focal point.

- See the shadow shape as a cup holding the light. This makes the painting much easier!

the materials I used
oil colors

CADMIUM YELLOW LIGHT ALIZARIN CRIMSON TRANSPARENT OXIDE RED SAP GREEN

ULTRAMARINE BLUE

Diane Rath lives in Lake Bluff, Illinois, USA

I used hard and soft edges strategically to increase the realism of my painting.

Pink Peonies, oil, 14 x 18" (36 x 46cm)

my inspiration
I love the way the heavy peonies settle into their positions like a model relaxing into the pose.

my design strategy
The design is a light shape sandwiched between two darks. The contrast helps to define the center of interest, the large peony to the right of center. There are a number of other design principles at work: repetition and variation in the flower shapes, dominance of the center of interest, and a unifying cool color harmony.

my work process
- I made several thumbnail sketches and toned my stretched linen with a light wash of Viridian and Alizarin Crimson. Using vine charcoal, I sketched in the placement of the main elements.
- Next, I established my lightest light and the darkest dark.
- I scumbled in the background with a no. 12 bristle flat brush, then blocked in my design with a no. 10 bristle filbert. My light was cool so I made my shadow mixtures warm.
- After I completed the block-in, I began to add more detail using two no. 6 sable flats — one for warm colors and one for cool.
- I painted the sharpest edges at the center of interest. Working out from there, I made the edges away from the focal point less sharp. I also made the other flowers darker and grayer.

- On reflective surfaces, I painted the highlights with one very sharp edge and one softer edge to create realism.

my advice to you
- Paint the big shapes first so they "read" as three-dimensional forms. Then worry about details.

- Pay attention to edges by squinting at your subject (not your canvas) to find the sharpest edge. Then compare and subordinate all other edges to that sharpest edge.

the materials I used
support
stretched linen

brushes
no. 12 bristle flat
no. 10 bristle filbert
no. 6 sable flat

other materials
vine charcoal

oil colors
Yellow Ochre
Cadmium Red Light
Alizarin Crimson
Viridian
Ultramarine Blue
Ivory Black
Titanium White

Bill Schneider lives in Illinois, USA → www.schneiderart.com

Backlighting was the key to producing exciting contrasts in light and shadow.

Fresh from the Garden, watercolor, 16 x 22" (41 x 56cm)

Karen Shelton

my inspiration

The exquisite colors of the flowers and their interesting shapes inspire me to show appreciation for the beauty of the natural world as it entwines with mine.

my design strategy

I am always attracted to strong light and shadow and find extreme contrast exciting. Bright, early morning sun came in my kitchen window and backlit this arrangement. The colors of the flowers in both bright light and deep shadow fascinated me. I was also pleased with the way the oak table looked in bright light and with the shadows filled with colorful reflections. Flowers spilling informally out of the basket created a happy and relaxed mood.

Karen Shelton lives in Virginia, USA

my work process

- I began with a fairly detailed drawing, then applied a few dots of masking fluid in the depths of the basket to maintain the light peeking through.
- I began to paint, jumping from one part of the painting to another. I worked wet-into-wet in small areas, never wetting the whole sheet.
- I then used scrubbers to soften some edges and bring back lost spots of light.

backlighting flowers

Backlighting shows off the delicacy of the flower petals and makes interesting shadows in overlapping petals.

the materials I used

support
300lb (638gsm) cold-pressed paper

watercolors

ALIZARIN CRIMSON, FIRE ENGINE RED, RED HOT MOMMA, GAMBOGE, QUINACRIDONE PINK, ULTRAMARINE BLUE, COBALT BLUE, PHTHALO GREEN, AUREOLIN, QUINACRIDONE GOLD, QUINACRIDONE BURNT ORANGE, BURNT UMBER

working from photos

I work from photos to capture the light and the flowers at their peak.

brushes
nos. 4, 6, 8, 12 nylon sable blends
bristle scrubbers

I wanted my loose, gestural painting style to convey this man's passion for his garden.

Day Lily Man, oil, 30 x 30" (76 x 76cm)

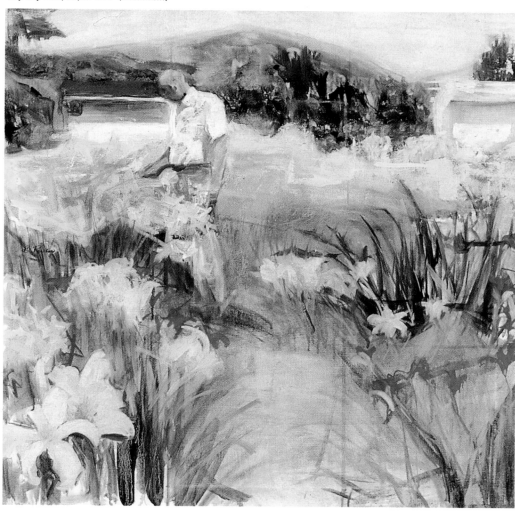

my inspiration

Day Lily Man is part of a series of studio paintings of people in gardens. My inspiration for this painting was a man so passionate about flowers that each summer he would turn his entire yard over to a glorious display of hundreds of multicolored daylilies.

my design strategy

I chose a square canvas because, in Christian art, the square has been an emblem for the earth. The eye-path in the foreground reflects the overhead sky, then leads to the figure encircled by his flowers. A curving line of cream, red and yellow lilies in the left foreground flows back to a solid mass of yellow, moving horizontally left to right behind the figure.

color concepts

Repetition of red, yellow, blue and white throughout the composition integrates the garden/figure/earth with the buildings/mountain/sky.

I used a limited pure color palette, which is made up of a warm and cool version of each primary color. Not only is this palette vibrant and lively, it naturally leads to harmony.

my work process

- I drew a grid on my canvas and thumbnails to help me keep the composition coherent later, when I would be painting freely and loosely.

- I sketched thumbnails from photos, then transferred the composition to canvas with vine charcoal.

- Although I spent a great deal of time thinking about concept and content for *Day Lily Man*, I painted it quickly in three short sessions.

- In the first session, I loosely massed in the garden area, figure, buildings, trees and mountain range using a large filbert and thinning the paint with medium.

- I refined the buildings and figure in the second session.

- The third session involved detailing the foreground flowers and leaves.

take note

Set against the diffused light of a hazy summer day, flower colors seem more intense than in brilliant sunny conditions. Take photos in both conditions and compare.

the materials I used

support
stretched canvas

brushes and tools
nos. 6–14 bristle filberts

oil colors

medium
mix of turpentine, stand oil and gum Damar

PERMALBA WHITE CADMIUM LEMON YELLOW CADMIUM YELLOW DEEP CADMIUM ORANGE

DEEP RED MADDER BLUE BLUE

Bennette A Rowan

ARTIST
71

Bennette A Rowan lives in Tennessee, USA → auxford@preferred.com

The curved reflections of stripes give the silver vases instant volume and density.

Sweetpeas with Red Stripes, watercolor, 23 x 28" (58 x 71cm)

Suzy Smith

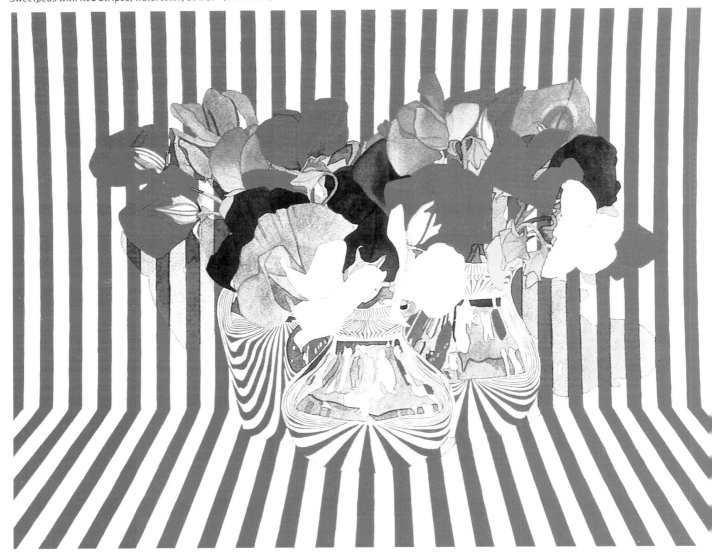

my inspiration

I try to set up still lifes that you would not necessarily see in everyday life, the kind that would make you take a second look. I am always fascinated by reflections and refractions, and love the way the red and white stripes curve on the silver vases in this painting, giving them instant volume and density. The contrast between the hard edges of the stripes and the free flowing lines of the flowers are compelling to me.

my thoughts on design

I don't ever choose an eye-path for the viewer to follow in my paintings because I don't ever follow the same eye-path of a painting twice.

a tip for painting red

When I paint red, I start with more Cadmium Red Light than Alizarin Crimson. Once the orange component of the color is lost, it is hard to get back.

advice for painting florals

• Try not to overpaint flowers. Transparent washes characterize flower petals much better than solid pigment.

• Discover what endears you to certain flowers, and then explore the flower, either in different settings or in combination with other flowers.

the materials I used

support
300lb (638gsm) cold-pressed paper

brushes
nos. 2/0, 6, 12 sables

watercolors

Suzy Smith lives in New Mexico, USA → www.suzysmithart.com

I composed this painting like a snapshot to evoke the sights and smells of a busy outdoor market.

Market Flowers, acrylic, 22 x 28" (56 x 71cm)

my inspiration

I visited an outdoor market one sunny day to take photos of the fresh flowers for sale. As I walked through the market, I came across these flowers lined up in a row with the sunlight gently beating down upon them.

my design strategy

I wanted to accurately represent these flowers as I saw them: in front of a chain link fence on a warm, sunlit day. You can just see another, lower, row of flowers peeking into the picture at the bottom. I could have left these out, but their presence contributes to the impression of the hustle and bustle of people milling about, looking, tasting, buying and selling.

my painting process

- I often work from photographs. In this case, I took several pictures at the market and was particularly struck by this one.
- I sketch directly onto my canvas, mixing and adding layers of color as I go.
- I use flats for filling in, filberts for areas that require edges, and small rounds for details.
- I use acrylic gloss medium to add transparent layers — in this case, on the flower petals and leaves.

something you can try

I add acrylic gloss medium to my paint so I can layer transparent color. This technique is particularly useful with leaves and flowers.

the materials I used

support
stretched canvas

brushes
various sizes of flats, filberts and rounds

acrylics

medium
acrylic gloss medium

Tish Smith lives in Ontario, Canada → tishartstudio@netscape.net

I made the background flowers look misty to add depth to this painting of sunlit crocuses.

Crocuses, pastel, 7¾ x 10½" (19 x 26cm)

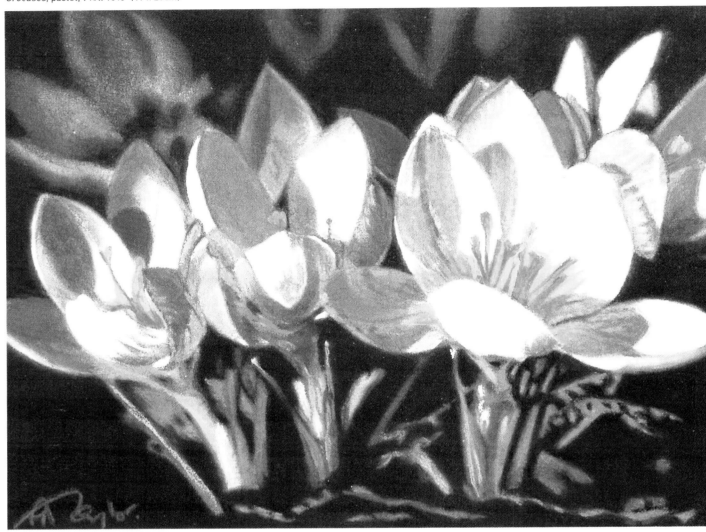

Patricia Taylor

ARTIST 74

my inspiration

Walking in my garden, I was inspired by the bright sun on this little patch of crocuses.

color concepts

The blue, orange, mauve and yellow of the flowers were a natural gift of complementary colors. The addition of the green of the stems created a simple split complementary color scheme. I enriched the orange shades of the cedar and leaf debris on the ground to carry through the vibrant color of the flower stamens.

my work process

- Working from a photograph, I roughly sketched the whole composition with medium-textured pastels, which I rubbed in with my fingers to cover the sanded board smoothly. I left a border around the edge of the sanded board so I could rest on and turn the painting without smudging it.
- I highlighted and intensified the color with softer pastels.
- For detail work I used a fine, worn-down bristle oil-painting brush to clean and brush away excess pastel from the fine edges, giving the flower parts definition and clarity.
- I left completion of the dark background until last. I rubbed in black over a first layer of burgundy pastel because black alone was too intense.

special techniques

I painted the distant row of crocuses faintly and then, while working on the background, ran my chalky finger lightly over them to create a misty look and a feeling of depth.

the materials I used

support
blue-gray sanded board

tools
artist's gum eraser
worn bristle brush

split complementaries

A split complementary color scheme is made up of two colors that are adjacent on the color wheel (yellow and green, in this case) and one color opposite these colors (purple).

Patricia A Taylor lives in British Columbia, Canada → trishart@telus.net

Spiky shapes and hints of color draw the viewer into the mystery of what lies beneath the snow.

Flowers with Early Snow, watercolor, 20 x 12" (51 x 30cm)

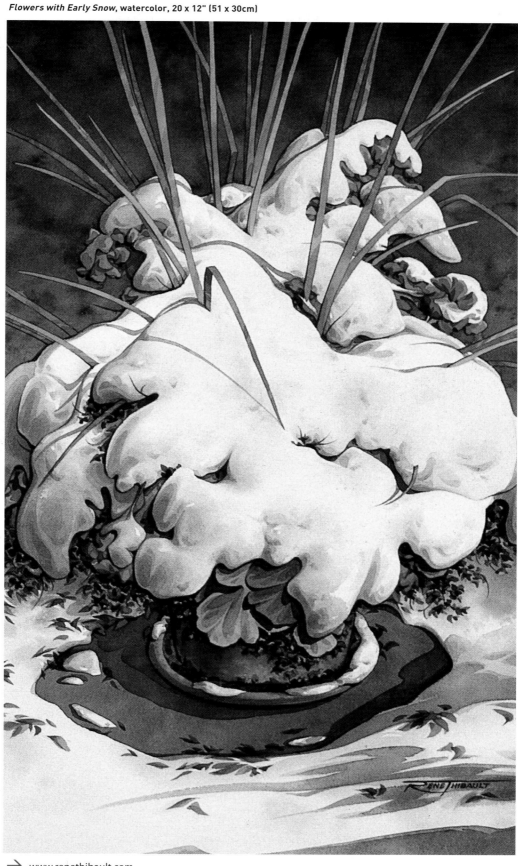

my inspiration

The subtle mystery of what might be shrouded under thick snow has always appealed to me. When two days of snowfall smothered the still-blooming plants decorating our front entry, I couldn't resist painting the result.

my design strategy

A few tonal patterns dominate the format of this painting. The dark and neutral background visually presents to the viewer the white clumps of snow and the supporting elements at the base of the plant. The white foreground quietly echoes the strong central shapes. Delicate bursts of petals and leaves provide contrast and hint at what is under the snow.

my work process

- I sketched several thumbnails, using only the most appealing aspects of my reference photos. I concentrated on the tonal elements of the composition.

- I lightly drew my design onto a watercolor board, evaluating and refining the composition.

- I then applied masking fluid to the blades of grass, the only elements that required it.

- I painted in the darker background with a flooded no. 10 round, allowing various colors to mingle together to create a richly textured area.

- I rubbed off the masking fluid and continued to develop the rest of the painting through a buildup of very fine patterns using a no. 6 round and a no. 1 liner.

the materials I used

support
cold-pressed board

brushes
nos. 6 and 10 rounds
no. 1 liner

other materials
3H pencil

watercolors
Chinese White
Quinacridone Gold
Permanent Rose
Phthalo Blue (Green Shade)
Ultramarine Blue

Rene Thibault lives in Alberta, Canada → www.renethibault.com

Rene Thibault

ARTIST
75

Careful layers of color linking crisp windows add new dimension to this floral still life.

White Roses I, watercolor, 22 x 15" (56 x 38cm)

Marilyn Timms

my inspiration

On a rainy winter day, a simple bouquet of white long-stemmed roses brought a rush of delicate scent and elegance into the studio.

my design strategy

A powerful vertical orientation sets the basic design for this piece, plus the incorporation of several windows — or layers — that partly trap the objects within.

follow my eye-path

A trail of white baby's breath leads the eye in and up to the focal point white rosebud. Then, suggested leaves and half-painted roses swirl you out and back in again at the top.

my work process

- Working on a nearly vertical easel, I laid in broad color washes on dry paper using transparent non-staining paint. I watered the edges to keep the forms understated.

- I created the texture in the lower half of the painting by pulling taut plastic wrap into the fresh wash, then removing it once the paint had dried slightly.

- After this initial lighter value layer was completely dry, I outlined the first, large window with masking tape.

- I defined the objects inside this first window more clearly, using mostly opaque colors and paying particular attention to bringing out the inside corners of the window area. I then removed the tape around the first window and let the paper dry.

- I taped a second, smaller window and painted the middle to dark washes.

- After removing this tape, I painted the smallest pinpoint darks with staining paints.

designing my palette

I use three core groups of paint.

- *transparent non-staining* (Aureolin, Rose Madder Genuine, Cobalt Blue, Burnt Sienna)

- *opaque* (Ultramarine Blue, Cerulean Blue, Yellow Ochre)

- *staining* (Alizarin Crimson, Prussian Blue)

the challenge of this painting

Creating windowed layers requires careful planning. The first washes must softly depict all of the objects that will be part of the finished piece. This composition won't work unless the major shapes connect through and outside each window.

the materials I used

support

140lb (300gsm) medium-finish rag paper stretched on board

brushes

2" wash

large sable round

1" flat

various small rounds

watercolors

Aureolin

Cobalt Blue

Rose Madder Genuine

Burnt Sienna

Cerulean Blue

Yellow Ochre

Alizarin Crimson

Prussian Blue

Marylin Timms lives in British Columbia, Canada → www.timmsfineart.com

The subject of this piece is not the flower, but the fluid, circular movement.

In Motion II, gouache, 15 x 15" (38 x 38cm)

my inspiration

I wanted to convey my enjoyment of flowers, not just a representation of their form and color.

my design strategy

The emphasis of the piece is not on the flower itself but on the fluid, circular movement in and around it. I painted the colors as distinct, abstract shapes that, when viewed from a distance, work together. The colors work well together because they're so close in value to each other.

my work process

- First, I made several preliminary sketches and sample palettes.
- I laid down the design and further defined color values using watercolor. I also created watermarks in the background to help me define the abstract shapes along the edges later on.
- When dry, I went over it with gouache, being very careful to maintain existing abstract shapes while creating new ones that would further enhance the illusion of circular motion. I used a matte opaque extender to keep the gouache from lifting when I needed to rework an area.
- I glazed in several layers to achieve a rich, dark green background.
- To maintain the cohesiveness of the piece, I gave even the near-white colors their own distinctive hues.

the materials I used

support
140lb (300gsm) hot-pressed paper

medium
matte opaque extender

gouache
Cadmium Red
Carmine
Cyan
Yellow Ochre
Cadmium Yellow Pale
Viridian (Hue)
Prussian Blue
Permanent White

Annette Novoa lives in New Jersey, USA → www.anovoa.com

I made this still life dynamic with diagonals and a special outlining technique.

Iris, oil, 10 x 8" (25 x 20cm)

my inspiration

When spring flowers bloom in Michigan, it seems as if the whole earth is celebrating its release from winter's long, cold grip. I was inspired by this flower's bold but delicate color combination and the power of the single bloom.

my design strategy

I wanted this painting to delight the eye with color, texture and motion. I created a dynamic composition with diagonal lines. Some of these were already present in my subject, a single, gorgeous iris bloom.

The stem of the flower is at a slight angle, and the lower petals of the iris are diagonal relative to the upper petals. These diagonals are balanced by the upright yellow petals and the diagonal bands of color in the background. If you pay attention to diagonal forces in your painting, you can achieve a balanced, dynamic composition and keep the viewer's eye within the picture plane.

working with a palette knife

I always paint primarily with a palette knife. While painting this iris, I was careful to create the directional strokes and edges that I wanted in the petals and stem.

special techniques

In order to bring the bloom forward on the picture plane, I used a brush to gently work blue and green tones of paint up against the edges of the petals and stem, creating a gentle outline. This accented the profile of the bloom and added a darker value to the painting.

Diane Van Noord

ARTIST 78

the materials I used

support
Masonite primed with gesso

brushes and tools
palette knife

no. 8 bristle bright

medium
turpenoid

oil colors

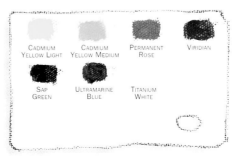

CADMIUM YELLOW LIGHT CADMIUM YELLOW MEDIUM PERMANENT ROSE VIRIDIAN

SAP GREEN ULTRAMARINE BLUE TITANIUM WHITE

Diane Van Noord lives in Michigan, USA → www.dianevannoord.com

An open gate, the promise of cool shade, and a bright, disappearing path draw the viewer into this painting.

my inspiration
The old bricks and antique wrought iron gate of this Palm Springs oasis gave me a profound sense of welcome that I tried to recreate in this painting.

my design strategy
The partially open wrought iron gate is an invitation to enter the painting. Sunny skies and distant palm trees contrast with the cool shaded areas inside. At the end of the brick pathway is a strong light that draws the visitor in.

my work process
- I worked from both memory and photographs, choosing photos with strong contrast.
- Next I sketched the composition in pencil, marking the lightest light with an X to remind me to leave the white of the paper.
- Working wet-on-dry, I created a pattern of lights and darks with washes of warm (Raw Sienna) and cool (Antwerp Blue) tones.
- At this point, I began a color card on similar watercolor paper. (See illustration below.)
- I then painted a dark area to use as a benchmark by which to compare values. A value viewfinder is one of my most important tools.
- After the previous layers were dry, I slowly built the values with glazes of transparent colors to create depth and richness.

something you can try
Make color cards with info on the subject matter, location, date, title and selected palette swatches. Experiment with combinations of pigments, identifying them on the card. Label every pigment to make it easier to duplicate the exact color in future paintings. I even keep track of the time I spent on the painting!

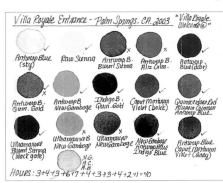

my color card for this painting

Villa Royale Welcome, watercolor, 22 x 15" (56 x 38cm)

Andrea Vincent

ARTIST
79

the materials I used

support
300lb (638gsm) cold-pressed paper

brushes
no. 10 sable round

tools
HB outline drawing pencil
value viewfinder

watercolors
New Gamboge
Raw Sienna
Quinacridone Gold
Quinacridone Red
Ultramarine Blue

Antwerp Blue
Burnt Sienna
Caput Mortuum Violet
Indigo
Permanent Alizarin Crimson

Andrea Vincent lives in Illinois, USA → www.andreavincent.com

The complementary background enhances the drama of the hot poppies in sunlight and shade.

Poppy Drift, pastel, 27 x19" (69 x 48cm)

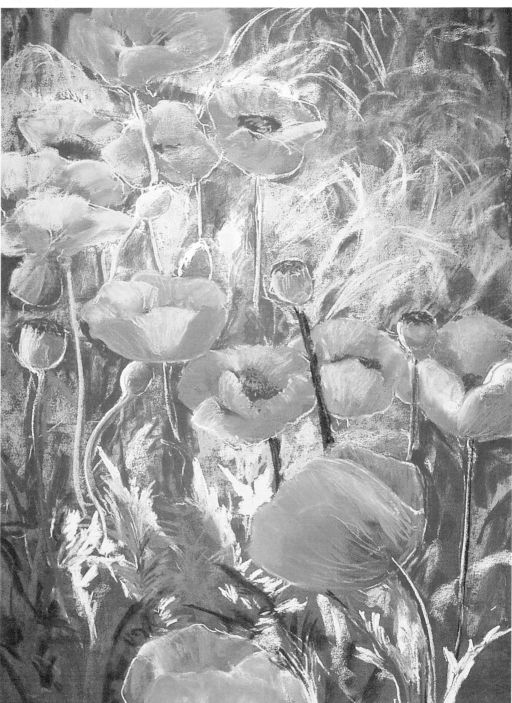

Ann Kelly Walsh

my inspiration

My friend has a lovely garden where a bed of poppies spills down the side of a rolling hill. I love to see the sun making the poppies brilliantly translucent.

my design strategy

I chose a diagonal line for the blooms as they traversed the hill. It is a more interesting pattern than a simple mass. I left out the sky to give the feel of being in the garden.

color concepts

To enhance the brilliance of the red-orange poppies, I used a complementary blue-green in the background foliage. I made sure to include the dramatic purple of the poppy's throat and the yellow-green light on the leaves and seed pods. I added some cooler plants behind my poppy drift to directly complement their brilliance.

my work process

- I made two quick thumbnails — horizontal and vertical — to see which worked best.
- Using vine charcoal, I loosely placed the poppy pattern on the paper.
- Despite the threat of crow's feet, I squinted to identify the most important lights and darks. I blocked in the darker passages in the lower section using the sides of my harder pastels.
- Then, using cool colors one value lighter, I blocked in the negative spaces around the poppy drift.
- I blocked in the poppy flowers loosely as well with an average warm color.
- Within about 20 minutes, the paper was covered and I was ready to begin refining each section in direct reference to the others.
- I finalized the painting without considering poppies or leaves or even naming what I was painting. Instead, I concerned myself with the shapes of light, the shapes of dark, the temperature of those shapes, and the overall pattern.

using a viewfinder

My viewfinder is my most valued tool. It enables me to block out the extraneous and assists me in finding my composition. The viewfinder I use has three different window formats. It also has another set of three windows covered in red film. Viewing through the dark red allows you to concentrate on value. It is also useful again at the end of painting to make sure your values are consistent and dynamic.

the materials I used

support
sanded board

tools
vine charcoal
viewfinder

Ann Kelly Walsh lives in Ontario, Canada → lakwalsh@sympatico.ca

I wanted these spontaneous shapes and colors to overwhelm the viewer with the joy of spring flowers.

Rock Garden, mixed media, 22 x 30" (56 x 76cm)

my inspiration
My wife's rock garden responds early to the longer days of spring. I spent several sunny mornings sitting in the rock garden being warmed by the sun and drawing plants at eye level.

my design strategy
I wanted to place the viewer in the rock garden, close up, overcome by the allure of this miniature world. Within this motif I explored the dual contrasts of warm against cool colors and hard, angular lines against soft, organic lines and shapes.

my work process
- Without sketching or drawing my subject, I laid in large, soft-edged shapes with a 2" brush on wet watercolor paper. My goal was to create an exciting, spontaneous division of space while also leaving ample white.
- During this process I added exciting spots of color to create variation and interest within and around the larger shapes.
- When the paper dried, I drew directly and quickly with black water-soluble crayon to carve out flower shapes and rock.
- I then used smaller brushes to enhance and integrate the contrasts and define the subject.
- I ran washes over some of the water-soluble crayon lines to create lost and found edges.

using sedimentary colors
I used sedimentary colors because I wanted that sense of being so close to the plants that their texture becomes noticeable. I also used sedimentary colors for some specific qualities: I love the way Manganese Violet and Burnt Sienna mingle wet-into-wet, and I'm especially fond of the neutral lavender produced by painting over reds with Viridian.

the materials I used
support
140lb (300gsm) cold-pressed paper

medium
black, water-soluble crayon

watercolors

brushes
1" and 2" flats
wash brushes
no. 14 round

Quinacridone Burnt Orange · Quinacridone Gold · Cadmium Yellow · Indian Yellow · Burnt Sienna · Quinacridone Red · Permanent Rose · Viridian · Quinacridone Violet · Manganese Violet · Ultramarine Blue

Thomas A Wayne lives in Washington, USA → tawayne@msn.com

Starting with a solid black canvas gave this contemporary still life an old-world feel.

Imagine What's in Store, oil, 39 x 48" (99 x 122cm)

Chuck Wood

my inspiration
This storefront in Southern Ireland had been painted black and white, which saved all of the primary colors for the fruits and flowers. The three parrots hanging from their perches above the grapes are actually whimsical portraits of the shopkeepers themselves.

my design strategy
The shopkeeper had done some of my design work for me by arranging the flowers and fruit in the window. I made only minor changes in size and shape to improve balance. When composing the painting, I used a viewing angle I thought would

be the same as a shopper passing by. I had to be careful to keep the storefront from detracting from the flowers and fruit.

my work process
- I began by painting the canvas completely black.
- While the canvas was drying, I made a drawing on thin tissue. I relied on photographs for the details, because I do little sketching on site.
- I transferred one section at a time from the drawing to the canvas as needed.
- I added details and modified values as necessary.

Chuck Wood lives in Illinois, USA

the materials I used
support
stretched linen

oil colors

CADMIUM LEMON CADMIUM YELLOW CADMIUM RED ALIZARIN CRIMSON

BURNT SIENNA OXIDE OF CHROMIUM CERULEAN BLUE ULTRAMARINE BLUE

IVORY BLACK TITANIUM WHITE

brushes and tools
nos. 2, 4, 6, 8, 10 sable rounds
palette knife

ARTIST
82

I simplified detail to convey the shining mood and atmosphere of the scene.

Spring, oil, 14 x 18" (36 x 46cm)

my inspiration

This shining ocean of yellow flowers appeared in April. I wanted to duplicate the scene so I would always have it in front of me.

my design strategy

The dark foreground comes forward, while the simple flowers there create an eye-path toward the field of lighter flowers in the middle. The big, flat shapes in the background minimize the viewer's focus on that area. I used purples in the background to bring out the complementary yellows in the flowers.

my work process

- I planned the overall design for the painting from the photo in my head. I drew simple lines with a small brush for placement.
- Next, I created light and dark areas. I mixed odorless turpentine into the darks so they would dry quickly.
- After that, I started to put in midtones, avoiding detail. At this point I established the overall color and the mood of the painting.
- I rendered the details of houses and trees, and added thick paint to the flowers to bring them forward as the focal point.
- Finally, I put some dark accents under the trees and light accents on the foreground flowers to enhance contrast.

the materials I used

support
stretched canvas

brushes
various filberts and brights

oil colors

medium
odorless turpentine

linseed oil

TITANIUM WHITE CADMIUM YELLOW CADMIUM RED CERULEAN BLUE

ULTRAMARINE BLUE

Hye Seong Yoon lives in California, USA → www.hyeseong.com

I reproduced the tangle of nature by lightly brushing my thick paint with a tissue.

Ramblin' Roses, oil, 18 x 14" (46 x 36cm)

my inspiration

I love to paint the wild excitement that you find in a less-manicured garden setting like this one.

my design strategy

In this composition, I wanted to emphasize the mob of wild roses swooping down toward the up-reaching delphinium. It was important to capture the randomness that occurs in nature.

I planned my color values carefully so that the greens didn't compete with the brilliance of the blooms. I made the background recede by painting it with softer, cooler colors.

my work process

- I first designed my composition with a wash of Burnt Sienna, then lifted out the light areas of each rose with a turp-soaked sable brush.

- I blocked in my darkest greens first, working form dark to light and from thin paint to thick.

- I applied the medium- and light-value greens very thickly with a small, pointed palette knife.

- Then, to create the tangle of the deepest, darkest inner foliage, I lightly whisked a tissue randomly across the thick paint, causing twigs and underbrush to appear, mimicking nature.

- In the background area, I was careful to soften the edges and contrasting colors with the flat surface of my palette knife.

- I laid in the pink roses and purple delphiniums with thick paint on my palette knife, again working from dark to light pink.

special techniques

Nature is a tangle! Paint very thickly, then brush lightly across the wet paint with a tissue, a ribbon, or even a brush that has only a few bristles left. You may be surprised at what happens!

my advice to you

- Keep your greens grayed down to make the flowers look their brightest. I mix a lot of Yellow Ochre, Burnt Sienna, Alizarin Crimson and Dioxazine Purple into my blues to create rich greens. (I seldom use greens from the tube.)

- Surround bright colors with grayer colors to make them pop.

- There is always variety in nature. Paint variety into each blossom, tree, each shape of color. Some will be more distinct, others more abstract, with softer edges.

the materials I used

support
primed stretched canvas

oil colors
Titanium White
Zinc Yellow
Cadmium Yellow
Phthalo Yellow Green
Yellow Ochre

brushes and tools
nos. 4-8 hogbristle flats and filberts
flexible, pointed palette knife

Burnt Sienna
Alizarin Crimson
Cobalt Blue
Ultramarine Blue
Dioxazine Purple

Cindy Harlan Youse

ARTIST
84

Cindy Harlan Youse lives in Ohio, USA → www.grandfinale.info

I used a novel underpainting technique to add interest and enhance color unity in my painting.

Lilies from North Island, NZ, watercolor, 14 x 10" (36 x 25cm)

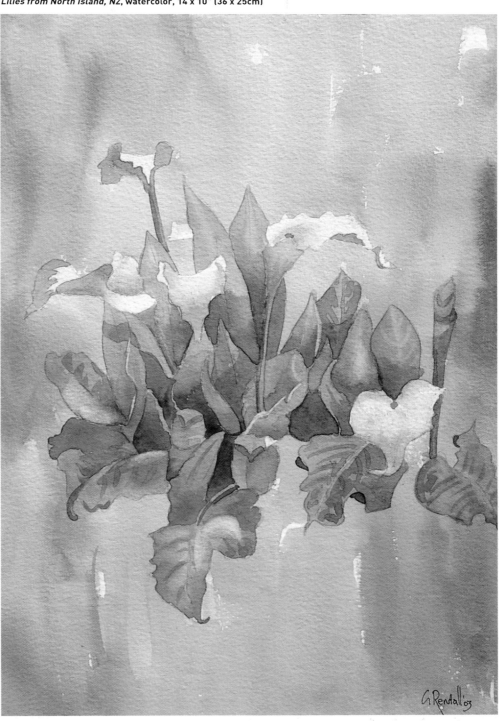

my inspiration
The strong foliage and beautiful flowers of these lilies, which I found growing among weeds during a trip to New Zealand, practically begged to be painted.

my design strategy
I didn't want to paint the flowers in their weedy background. I could have resorted to the classics — a wet-in-wet wash or painting a background around the completed subject — but none of these options excited me. I decided to try a new technique that would create an abstract, but visually interesting background.

my work process
- First I masked out the white flowers.

- Then, with the dry paper at a steep angle, I dropped on color — greens, yellows, yellow-orange and a bit of straight orange, allowing the colors to merge. I chose colors that would work well with the subject. The orange pistils in the flowers inspired me to dash in the orange splotch on the right side of the painting.

- When the background was dry, I lightly traced my drawing onto the paper using a lightbox.

- Next, I began to paint the leaves, beginning with light washes and progressing to darker washes. I defined the leaves as I went, lifting out veins here and there with a tissue.

- I then painted the negative areas — the darks between the leaves — softening edges where necessary.

- The flowers required little painting, just a few shadows and shading.

added effect
The colors of the underpainting shine through the subject itself, producing beautiful variations in color and a degree of unity in the painting. Try using this technique both on dry paper and wet-in-wet. Don't worry if some areas of the paper remain white.

Gavin Rendall

ARTIST
85

the materials I used
watercolors
Cadmium Red
Alizarin Crimson
Cadmium Yellow
Lemon Yellow
Viridian
Prussian Blue

support
140lb (300gsm) NOT paper

brushes
1" flat
nos. 6 and 10 rounds

Gavin Rendall lives in Surrey, UK → westrayroots@bigfoot.com

Warm and cool tones of white bring out the details in these flower petals.

Ruffled Joy, oil, 35½ x 59" (90 x 150cm)

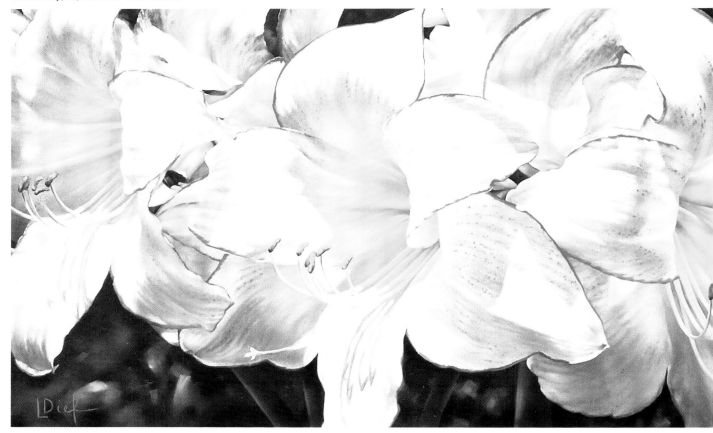

Lyn Diefenbach

my inspiration

Hippeastrums flower with what appears to be unfettered joy. Their ruffled, velvety petals are clothed in colors from the subtlest of whites to vibrant reds and oranges.

my design strategy

The large scale of the work (almost 5 x 3') guaranteed the need for photographic reference. I was fortunate to have taken a good clear image with a lovely play of light and dark. I cropped the photo so that the flowers filled most of the image. The strong diagonals and curves of the main flower ensured that the eye would not stop at the central bloom, but travel outwards and return. The red edges of the petals provided a little bit of zip.

my work process

- I toned my primed canvas with Lemon Yellow acrylic paint as a foundation for the yellow-green flower throats.

- I then drew the image lightly with willow charcoal, using the grid method on a scale of 1:10.

- I mixed my huge palette of oil colors, mixing in white for cool colors and Naples Yellow for warmer colors.

- My initial blocking-in established tones and colors. I worked from dark to light with paint slightly diluted with turps.

- When this layer was dry, I applied a light coat of retouch varnish, which brought each color up to the same level of sheen. I repeated this every day to build luster.

- I then repainted the whole canvas with more care, paying careful attention to tones and emulating the depth of the throat, the satin texture and ruffled quality of the flowers.

- I worked wet-into-wet from the background to the major shapes.

- The red edges and speckles were added upon the completion of each petal while the paint was still wet.

- When I could step back and be satisfied with tones, values and colors, the painting was finished.

painting flower portraits

Pay attention to the individual proportions and personality of your flower, just as when you are painting a portrait of a person.

the materials I used

support
acrylic-primed stretched canvas

brushes
½", ¾", 1" synthetic blends
no. 8 cat's-tongue sable

oil colors

medium
willow charcoal
turpentine
spray retouch varnish
Lemon Yellow acrylic

CADMIUM LEMON CADMIUM YELLOW PALE INDIAN YELLOW NAPLES YELLOW

SAP GREEN PHTHALO GREEN COBALT VIOLET PHTHALO RED

CADMIUM RED DEEP ALIZARIN CRIMSON

Lyn Diefenbach lives in Queensland, Australia → www.ldief.com

ARTIST 86

I wanted these water lilies to be as realistic as a photo, but as natural and lifelike as my memory.

Pond of Tranquility, pastel, 21 x 27½" (53 x 70cm)

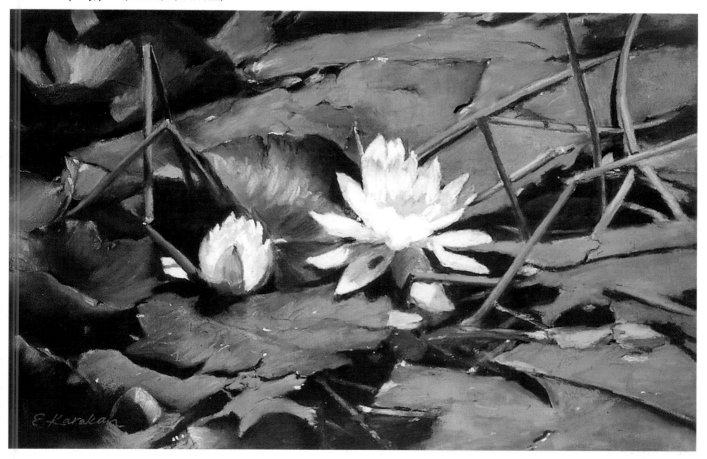

my inspiration

Pregnant with my daughter, I took a break from the milling crowd at an art festival to rest my feet near a beautiful lake. I found these water lilies there, and wanted to capture the feelings of peace and romance they evoked in me.

my design strategy

I tried to create a visual balance between freedom and control, painting the water lilies as realistic as the photo in my hand, but as natural and lifelike as the image in my memory.

I implied form, texture, distance, atmosphere, light and shade with tonal variation in the background. The high color contrast between the flowers, background and leaves draws the viewer's eye to the water lily in full bloom. The eye then travels clockwise and back to the center of interest. The angular structure of stems creates more interest in the painting and unifies it as well.

my work process

- I didn't have any pencil sketches or visual notes to refer to, so I relied on a photo for composition and subject detail.
- First, I did two watercolor renderings in warm and cool colors, the same size as the photo. Then I tested some pastels on a piece of paper.
- Once I was happy with my choice of colors, I enlarged the photograph to the actual size of the painting and transferred the image onto the art paper.
- From there, I blocked in the darks, working in four sections (left to right) and then as a whole picture.
- Next, I painted the leaves using a lost and found technique, rubbing the color in with my fingers. I used various tones of green to give depth, eliminating some of the detail from the background.
- Finally, I added highlights and shadows to the water lilies using subtle tones of color to create mood and atmosphere.

working from photographs

When working from a photo, use artistic license to eliminate detail, crop, rearrange and enlarge the subject.

my advice to you

Broaden your senses! Introduce poetry to your work, and paint what you are feeling as well as what you are seeing.

the materials I used

support
medium-weight, tinted pastel board

tools and materials
workable fixative
kneaded eraser
cotton or wool swabs

 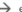

Emi Karakan

ARTIST
87

I used bright light, rather than shadow, to create mystery.

Magic Gate, watercolor, 33½ x 45" (85 x 114cm)

Andrzej Gosik

my inspiration

Some friends of mine have a garden that has several special and mysterious places. When my friends asked me to paint some pictures for them, it was the perfect opportunity to use watercolor for one of its ideal purposes — painting plants in sunlight.

my design strategy

The focal point of this picture, the gate, separates the viewer from the foreground shade passage and the dazzlingly lit open-air space beyond. Because the sunlight past the gate is too bright to show detail, the viewer will be curious about what lies in that area.

my work process

- I took a series of photos at different times of day. Choosing the image with the showiest

lighting, I made pencil sketches to identify the brightest light and deepest shade.

- After sketching the design on watercolor paper, I applied masking fluid to the lightest areas.
- I began painting in the bright space behind the gate, then moved to the lighter parts of the greenery.
- Then I applied the shade on the wall on the right side and the gravel area, using a spray bottle and tissue to create texture.
- The greenery near the gate, leaves on the wall, and details of the gate itself were next.
- I moved on to the climbing branches and their shadows.
- After removing the masking fluid, I continued to add details to leaves and the gate. I left

white paper where I wanted to indicate strong light.

- The last step was to intensify the foreground leaves and shadows and paint the flat stones on the path. I also added detail to the gravel on the ground.

light and watercolor

I think of watercolor painting as organizing light on a sheet of paper. Watercolors allow you to define areas of light with large sweeps of the brush while also incorporating small subtleties. Making preliminary sketches helps me find ways to strengthen the effect of the light.

the materials I used

support
rough 95lb (200gsm) paper

brushes
nos. 12, 19 ox hair flats
nos. 2, 8, 12 sable rounds
no. 2 sable liner

tools
facial tissues
spray bottle with water

watercolors
Cadmium Yellow
Yellow Ochre
Raw Sienna
Burnt Sienna
VanDyke Brown
Indian Red
Cadmium Red Light
Ultramarine Blue
Viridian
Hookers Green Deep
Sap Green

Andrzej Gosik lives in Warsaw, Poland → www.galeria.rad.pl/gosik

The small patch of sky outside this triangular composition keeps your eye moving.

Lilac, watercolor, 12 x 10" (30 x 25cm)

my inspiration

I grew this lilac from a runner of the original plant in my late father's garden. I wanted to express my attachment to and enjoyment of this beautiful, fragrant plant.

my design

I arranged the flower masses into a roughly triangular structure, with the larger blooms as the focal point in the upper right. The viewpoint of the painting is low, looking up to the small area of sky. This helps draw the eye through the painting. Although the flowers on the left are less defined, they complete the triangular composition.

my work process

- Working wet-into-wet, I placed the initial flower masses, making sure to leave a small area for sky.

- I let the paper dry a little and dropped in stronger colors to emphasize the shape of the flower heads.

- After applying the strong complementary colors of the foliage, I removed some color to define the leaves and flowers.

- Finally, I used glazes to add highlights and shadows.

the main challenge in painting this picture

I painted the lilac both from direct observation and photographs. I did, however, modify the composition to make it more pleasing and to suit the watercolor techniques I would use. I often work freely, wet-into-wet without any initial drawing. Therefore I planned my composition carefully before I started.

something you could try

Painting wet-into-wet is an adventurous approach. You have to be prepared for unplanned effects such as texture and granulation. However, working wet-into-wet lends a freedom and dynamism to your painting. Use quality paper with good lifting properties to give yourself more confidence in the process. I use paper blocks so I don't have to stretch paper. Paper towels and tissues are very useful for controlling pigment movement.

Bryn Miles lives in Gloucestershire, UK

Bryn Miles

ARTIST
89

the materials I used

support
140lb (300gsm) cold-pressed block

brushes
nos. 2, 7 sable rounds
1" mop

watercolors
Ultramarine Blue
Prussian Blue
Violet
Sepia
Carmine

Emerald Green
Russian Green
Neutral Tint
Burnt Sienna
White gouache

The semi-abstract background complements the horticultural realism of these daffodils.

Daffodils, oil, 22 x 18" (56 x 46cm)

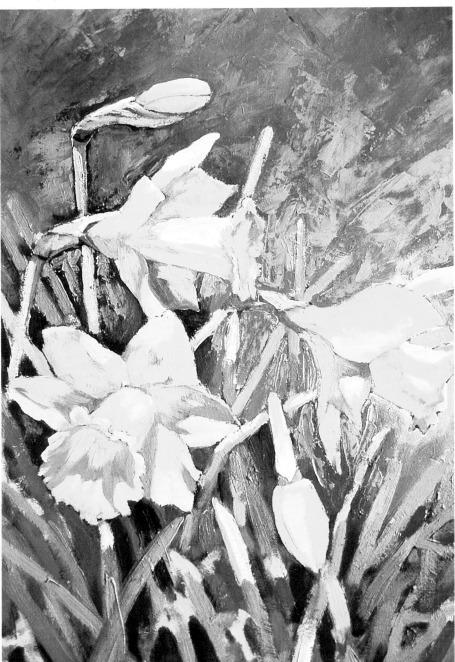

my inspiration

After a long, cold, dull Scottish winter, the arrival of the daffodil is heartwarming. Before I became a full-time artist, I worked in horticulture. This gives me background knowledge of the flowers and plants that I now paint.

my design strategy

Working from photographs, I placed the blossoms in a triangle shape with a bud at the top. I chose my colors to imitate the glow of the daffodils in sunlight and their cast reflections in the shadows. I also wanted to create the appearance of a breeze blowing from the left.

I wanted the background to be natural but strong, a perfect tonal partner for the flowers. I used the complementary colors blue and purple along with a semi-abstract style to make the flowers really stand out.

my work process

- I drew the flowers and foliage on the canvas with a soft pencil.
- Then I stained the background with a wash of turps and Indigo, the flower area with turps and Yellow Ochre.
- The stain was dry after about an hour., I blocked in the design with approximate colors. I painted the background in crimson and mauve, using more Indigo between the foliage. I used Ultramarine Blue for the sky.
- After allowing the painting to dry for several days, I painted the flowers, capturing sunlight with shades of Cadmium Yellow and highlights with Lemon Yellow and white.
- I progressed to the shadows within the flowers, painting them with Yellow Ochre and touches of Alizarin Crimson and Cobalt Blue.
- I chose Sap Green and Indigo for the foliage in shadow, Viridian and white for the highlights.
- Finally, I spread Cobalt Blue and white between some flowers, leaves and the sky with a palette knife.

my advice to you

- Flowers illuminated by full sun look best set against a dark background, such as a wall, fence or conifers in shade.
- Select three to five flowers for your focal point, even when presented with masses of flowers. They may be beautiful, but they will lose impact in a painting.

John Stoa

ARTIST 90

the materials I used

support
board primed with acrylic gesso

brushes and tools
nos. 2, 5, 14 hog-bristle flats
palette knife

oil colors
Indigo
Ultramarine Blue
Cobalt Blue
Alizarin Crimson
Sap Green

Viridian
Yellow Ochre
Cadmium Yellow
Cadmium Lemon
Titanium White

John Stoa lives in Scotland, UK → www.johnstoa.com

I used silk-painting media and techniques to add texture and luminosity to these vining flowers.

Iced Gems, mixed media, 19 x 13" (48 x 34cm)

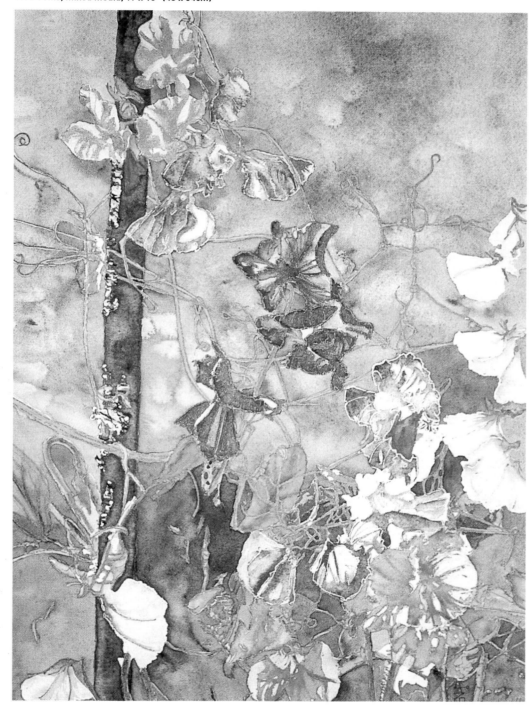

my inspiration

My inspiration came from the beauty of the translucent petals, the delicate tangle of tendrils and those sugar candy colors, all combined with dappled sunlight.

my design strategy

I used a triangular composition, placing the blossoms to lead your eye around the painting. I also placed complementary colors side-by-side: yellow-green was painted opposite red-violet, for instance.

my work process

- I began by making a detailed drawing with watercolor pens in the colors I planned for each flower and leaf. This eliminated the need to erase and created a wet-into-wet effect in the undergrowth later on.

- I masked all the flowers, tendrils and prominent leaves to allow a wet-into-wet background application. As the paper dried I dropped in splashes of green to represent the undergrowth and touches of Tiziano Red above as distant blooms.

- Because they "split" well with salt, I also painted with Ultramarine Blue Light and Permanent Violet Reddish. I applied salt when the paper was at the sheen stage of drying to get the best effect.

- When the paper was dry, I removed all the salt and masking fluid and glazed the foliage yellow-green. I worked upward to the petals using a mix of paint and pearlescent ink, following the curves and leaving white highlights.

- Proceeding to the foliage and cane, I worked wet-into-wet. I took special care to emphasize light against dark, using thin dark glazes and painting the negative spaces.

- To further highlight the petal edges and convey the delicate roundness and tangle of the tendrils, I outlined them using ink and a fine-nib dip pen.

- Finally, I outlined the tendrils and petal edges with metallic acrylic silk paint in an applicator bottle fitted with a fine nozzle.

the materials I used

brushes and tools
nos. 6, 14 sable rounds
nos. 0, 2 riggers
fine-nib dip pen
applicator bottle with fine nozzle

other materials
watercolor pens
masking fluid
silk-painting salt
pearlescent inks

watercolors
Permanent Green Yellowish
Green Gold
Manganese Blue (Light)
Cobalt Violet
Ultramarine Blue
Ultramarine Violet
Tiziano Red
Dragon's Blood
Sap Green
Antwerp Blue
Burnt Sienna
Permanent Violet Reddish

Lainee O'Donnell

Lainee O'Donnell lives in Lincolnshire, UK

Tonal contrast — glowing sunlight against deep shadow — enhances the vintage feel of this scene from my backyard.

Linen Line, oil, 18 x 14" (46 x 36cm)

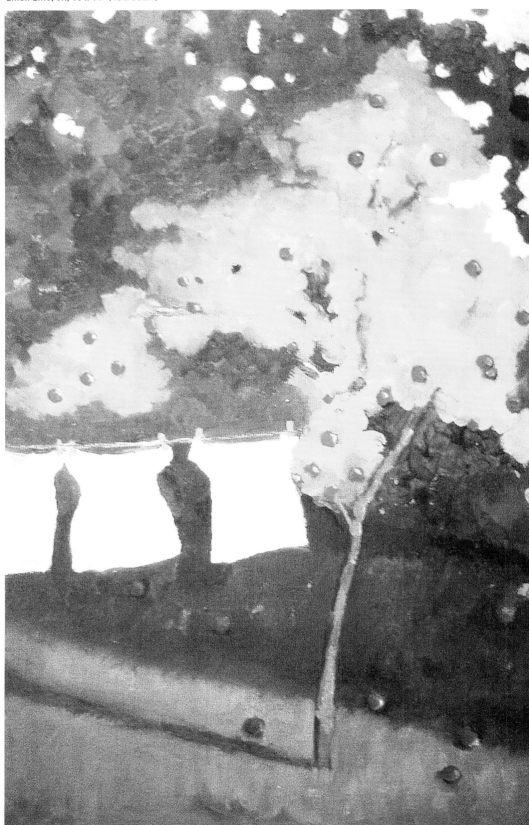

my inspiration

This old apple tree in my backyard has never grown to its proper size. Just after I resolved to chop it down, it produced abundant fruit for the first time — saving itself from the axe. The tree and the shirts glowing in the September sun looked like a vintage scene, a snapshot from another time.

my design strategy

The sunlit tree and bright T-shirts stood out from the darkness of the background hedge, which cast a strong shadow across the grass. This provided the all-important element of tonal contrast.

my work process

- I started by covering my canvas board with a bright orange wash. I mixed Cadmium Yellow and Cadmium Red with turpentine to allow the wash to dry quickly.

- The subject matter has many different shades of green. I chose to underpaint with orange as a contrast to help me decide how dark to make the shadows and how light to make the areas in full sunlight.

- When the background was dry, I sketched out the scene with willow charcoal.

- I mixed various different greens and applied the paint very quickly, building up layers of color to create a rich texture. I allowed some small areas of the underpainting to show through, which had the effect of pulling the scene together.

the materials I used

support
canvas board

brushes
nos. 8, 10, 12 flats
no. 4 round

oil colors

Cadmium Yellow	Prussian Blue
Chrome Yellow	Viridian
Yellow Ochre	Sap Green
Cadmium Red	Alizarin Crimson
Cerulean Blue	Burnt Sienna

John Atkinson

ARTIST
92

John Atkinson lives in Norfolk, UK → crown.studio@virgin.net

I used a simple, abstract painting style to recreate the random beauty of nature.

Wild Flowers, watercolor, 20 x 16" (51 x 41cm)

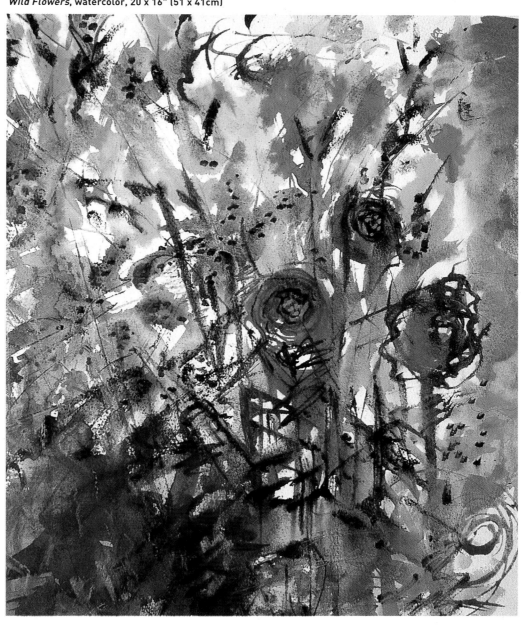

my inspiration

While visiting local gardens in the summertime, I noticed patches where flowers of different shapes and colors were growing wild together. Although each flower competed visually with those around it, the overall effect was vibrant and harmonious.

my design strategy

For this piece, I borrowed from the concept of Chinese and Japanese brush painting. This type of artwork is more about perception than realism and uses simple strokes to evoke the subject. I chose to paint abstractly to mimic this effect, creating the flowers and leaves with single strokes of Japanese and Chinese brushes. I left some areas of the paper untouched to represent the bright light you would typically see in a field of flowers. To contribute to the abstract feel of the painting, I used watercolor inks, pastels and powdered artist's pigments.

my working process

- I started with several photos of flowers in front of me.
- I used a medium-sized Chinese brush in a circular motion to paint the roses, then lightly sprayed water on some parts of the paper.
- Starting from the top and working wet-in-wet, I painted the pink lilies and yellow flowers and green foliage. Occasionally I painted with concentrated watercolor inks from a glass dropper, using the dropper to guide the flow of colors and even to draw lines and crosshatches.
- I painted the pink area on the right with a large Japanese brush loaded with watercolor, then added dry ground pigment for texture.
- Finally, I used touches of Rustic Gold ink and soft pastels to complete the bottom left corner of the painting.

the materials I used

support
140lb (300gsm) fine-grained cold-pressed paper

brushes and tools
large Japanese brush
no. 12 Chinese brush
spray bottle with water

powdered pigments
Alizarin Crimson

pastels
Permanent Rose
Turquoise

concentrated watercolor inks
Blue
Yellow
Grass Green
Rustic Gold

watercolors

KS Degon

ARTIST
93

KS Degon lives in Middlesex, UK → ksdegon@hotmail.com

The unblended areas of color in the foreground were inspired by needlework and tapestry designs.

The Blue Poppy, oil, 20 x 16" (51 x 41cm)

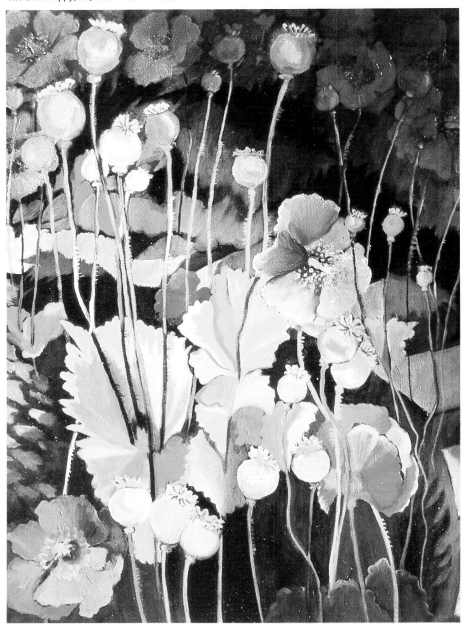

my inspiration

Poppy petals last only briefly, but the seed heads left behind are like magic wands, waving with every breeze. Most people think only of the color red when they think of poppies, but to me they are like little flames of all the hot colors. Yet their leaves seem frosted and cool. Poppies are flowers of other contradictions, one being the blue poppy, Meconopsis.

my painting philosophy

I don't want to paint exactly what a camera might see; I want to paint the spirit of my subject, the impression the subject has made on me.

my preparation process

Ideally, I sit for quite a while in my garden at ground level with my face close to my plants. I make a few sketches of any part of the plant that particularly catches my eye. I may also take a few photos, but the camera never sees things the way my eyes can.

To familiarize myself thoroughly with my subject, I often bring a sample to my studio, where I draw careful pencil or pen-and-ink studies. These help me learn the structure of the plant.

my design

- Gradual blending of color is very difficult in the needlework arts of tapestry and embroidery, yet the result is very appealing. I mapped the contrasts in this painting the same way.

- I carefully defined all the structures in the foreground, but forced the background to recede by filling it with random, semi-toned shapes of blue.

- Although I titled my picture *The Blue Poppy*, I did not want that flower to be the focal point. Instead, I wanted to preserve the feeling of natural growth. I introduced a bit more structure by adding hints of a curving path or border edge.

something you can try

Try working in thin layers of paint and blending wet-into-wet. You can create softer edges or new colors altogether.

the materials I used

support
stretched canvas

brushes
nos. 2, 4, 6 filberts and rounds

medium
linseed oil
turpentine

oil colors

CADMIUM YELLOW | PHTHALO LEMON | CADMIUM RED | ALIZARIN CRIMSON
COBALT BLUE | PHTHALO EMERALD | VIRIDIAN | INDIGO
SCARLET LAKE | TITANIUM WHITE

Joanna Crawford

ARTIST
94

Rather than *paint* detail, I *implied* detail with bright highlights.

Eye of Flora, watercolor/pencil, 41 x 48" (105 x 122cm)

my inspiration

Depth of tone and color drew me to the subject, as did the play of light across the dry, fragile flowers.

my work process

- I started with an accurate drawing. I applied masking fluid to preserve the white areas, especially the left window.
- If the tones of the painting work, you can almost paint the picture any color you want. In this case, I contrasted olive green with a warm orange glow.

- I applied thin washes until I achieved the correct tonal intensity and color value. I masked off the right wall and some of the leaf shapes and, after a few initial washes, spattered them to create a random texture.
- I used watercolor pencils over dark washes to develop the reflection and "bloom" on the glass in the nearest window. I occasionally spattered with white and Violet Grey, then worked over the top with pencil again. I finally "fixed" the area with a spray of clean water.

the materials I used

support
140lb (300gsm) cold-pressed paper, stretched onto board

brushes and tools
nos. 3/0–10 synthetics and sables, both new and worn

spray bottle with water

media
watercolor pencils

watercolors
Chinese Orange
Olive Green
Phthalo Green Light
Cobalt Turquoise Light
Emerald Green
Indian Yellow
Chromium Oxide Green
Cinnabar Light Extra
Venetian Red
Raw Sepia
Violet Grey
Bright Violet

Angus McEwan

ARTIST
95

Angus McEwan lives in Fife, Scotland → www.angusmcewan.com

The flowers were so exciting by themselves, I left the background as abstract washes of complementary color.

Cyclamen, watercolor, 26 x 18" (66 x 46cm)

my inspiration

I purchased this potted cyclamen from the local florist. The vibrancy of color, the shapes of the petals, and the patterns on the leaves fascinated me.

my design strategy

Because I wanted the emphasis on the plant itself, I made the background more abstract. I painted a light complementary background at the top and very dark tones underneath the bottom leaves.

my work process

- I quickly sketched the live plant, then applied masking fluid to the petals and leaves so I could paint the background liberally.

- When the masking fluid was dry, I wet the paper with water. Starting at the top, I used a very large brush to apply a loose wash of Phthalo Green, also dipping my brush in washes of Raw Sienna and Burnt Sienna. I intensified the tones toward the bottom. Under the bottom leaves I applied undiluted color, adding Sepia and Prussian Blue.

- When the background was dry, I removed the masking fluid and painted the flower petals. I let each petal dry before painting the adjacent petal to keep them from running together.

- I painted the lighter areas first, applying second washes to increase the intensity of the reds.

- I used the background colors in the leaves as well. Instead of applying masking fluid, I carefully preserved the veins as I was painting. I used washes to bring out the shadows.

the materials I used

support
140lb (300gsm) stretched paper

brushes
nos. 6, 10, 16 sables

watercolors

Raw Sienna	Thioindigo Violet
Burnt Sienna	Phthalo Green
Permanent Rose	Prussian Blue
Alizarin Crimson	Sepia

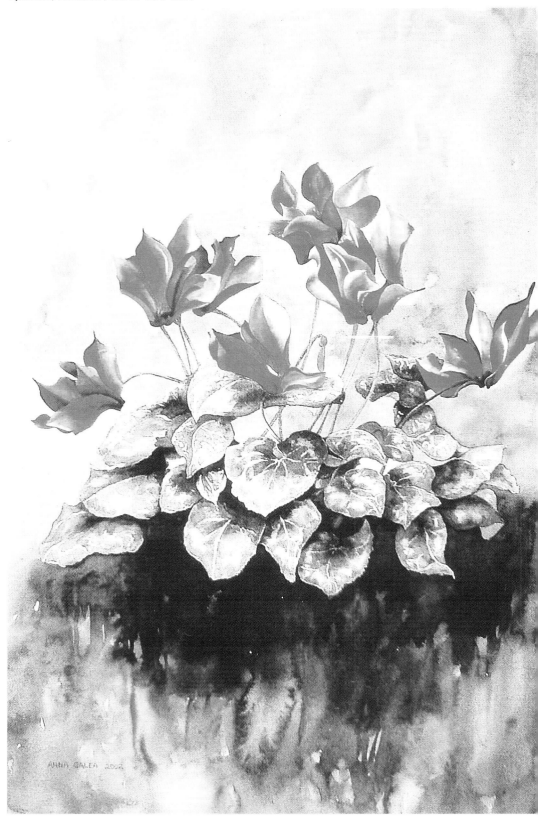

Anna Galea

I balanced my eye-catching focal point with accents of color.

Elizabeth's Garden, watercolor, 20 x 16" (50 x 40cm)

my inspiration

The autumn colors and the shadows in this corner of the garden called for the use of both warm and cool greens. Arranging these colors together in a pleasing and realistic way challenged me to reproduce what seemed like an infinite — but beautiful — array of greens.

follow my eye-path

This painting of a corner of my wife's garden composed itself. The strong diagonal lines from the bottom left corner to the top right corner would lead your eye out of the painting if the bright bench and table didn't call your attention back. The light flowers and reflections from leaves in the darker greens of the early autumn background help balance the large white shapes.

my painting routine

- Weather in Belgium is rarely constant for long, so it's very difficult to complete a painting on the spot. I take snapshots so I can preserve my memory of the light and color at that very moment. I can then finish the painting in my studio.

- I tape my paper to plywood so I can work with it on my lap or on an easel.

- I then mask out the areas I plan to leave white.

- I begin painting with the lightest colors and work toward the darker areas.

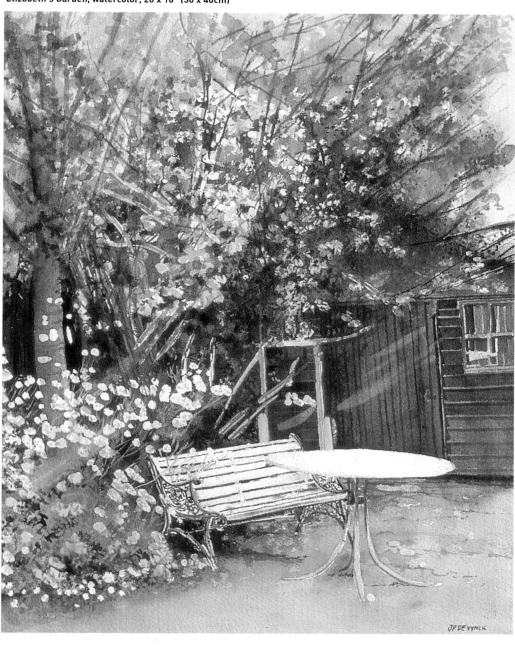

the materials I used

support
260lb (356gsm) fine-grained paper

brushes and pencils
³⁄₁₆" and ½" flats

nos. 2, 4, 6 pencils

watercolors

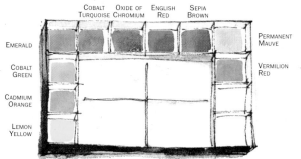

JP De Vynck

JP De Vynck lives in Belgium → jp.devynck@planetinternet.be

ARTIST
97

I made extra room in the composition for shadows because they were such a striking feature of this scene.

Ready for Bedding, watercolor, 12½ x 18½" (32 x 47cm)

Mary Rodgers

ARTIST
98

my inspiration

I took some geranium from the greenhouse, where they spent the winter, and put them in a sheltered spot outside to harden off. They just happened to create an eye-catching composition.

my design strategy

The organic shapes of the plants contrast with the structure of the boxes, bricks and pots. I moved some of the pots to create space in the composition and maximize the cast shadows. I think I was more inspired by the shadow shapes than by the subject itself.

my work process

• I began with a study drawing using 2B and 4B pencils, making color notes and plotting the changing shadows.

• I then drew the composition onto stretched watercolor paper

and masked out the flower shapes so I would be able to keep the sharp color later.

• I began painting with broad, flat washes in the light areas, then moved on to the darkest areas. This enabled me to compare the lightest and darkest tones with the midtones to keep the feeling of sunshine flooding onto the objects.

• I continued to build up layers of color using mostly wet-into-dry techniques, defining the flower and leaf shapes. I used wet-into-wet to add color to the leaves and for modeling the pots.

• I then removed the masking fluid to paint the sharp reds and pinks of the flowers and to add shadows to the whites.

• Finally, I painted the cast shadows with a mix of Alizarin Crimson, French Ultramarine and Raw Sienna.

the materials I used

support
140lb (300gsm) rough paper

brushes
nos. 6, 8 sable rounds

watercolors

other materials
masking fluid

Mary Rodgers lives in Leicestershire, UK → www.langtonstudios.com

I tried to emulate the still life compositions of 17th-century Old Masters.

Garden Apple Basket, oil, 20 x 24" (51 x 61cm)

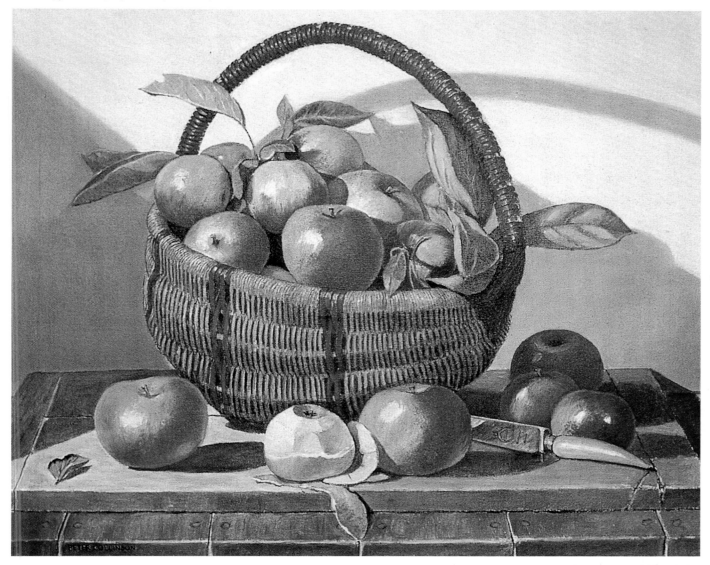

my inspiration

I have always been fascinated by still life paintings by the Dutch Masters. I am especially intrigued by their depictions of fruit flowing abundantly from dishes and baskets. Fruit has universal appeal and its enormous range of shapes, forms, textures and colors can yeild unending combinations of designs for the painter.

my design strategy

The basic composition of this painting is a series of interlocking triangles, which stabilizes the design. I was particularly intrigued by the visual contrasts between the smooth spherical shapes of

the fruit, the rigidity of the board and table and the complex weave of the basket.

my work process

- I transferred my photo to canvas using the grid method, spraying the canvas with fixative to seal it.
- I painted from top left to bottom right, allowing some color to bleed into adjacent areas to prevent hard edges and to unify the colors.
- I painted the objects from back to front.
- On completion I stood back to see if I need to fine-tune colors, values or edges.

Peter Collinson lives in Kent, UK

the materials I used

support
stretched canvas

brushes and tools
nos. 8, 10, 16 sable flats
nos. 3, 6 sable rounds
nos. 4/0 and 3/0 rounds
no. 2 bristle fan
palette knife

oil colors

TITANIUM WHITE · LEMON YELLOW · YELLOW OCHRE · LIGHT RED
CADMIUM RED · ALIZARIN CRIMSON · TERRE VERTE · CHROME GREEN
ULTRAMARINE BLUE · BURNT UMBER

After much experimentation, I found that only oil on silk would reproduce the vibrance and delicacy of this orchid.

Passion, oil, 59 x 47" (150 x 119cm)

my inspiration

I wanted to capture the power and fragility of the orchid by emphasizing its color and hard-edged, waxy, decadent form.

my design strategy

I used a dark background to sharpen the edges of the flower, and strong light to enhance the color and give the orchid depth. I wanted the viewer to be taken into the orchid as would a bee.

my painting preparation

- I first studied the orchid closely through the lens of a camera.
- I then made several thumbnail sketches and sample palettes.
- Keeping these materials around me along with the orchid itself, I began to paint.

painting on silk

After experimenting with many fabric supports, I ultimately chose silk to capture the delicacy of the orchid. The use of silk presented its own challenges, such as

- keeping the silk tight without damaging the edges of the fabric;
- the need to rotate painted areas while each section dried;
- keeping each layer within the previously painted area to prevent oil from bleeding off the edges of the image onto the silk.

I used very thin oils because I wanted to paint in transparent layers that would dry slowly, allowing changes to be made.

the materials I used

support
stretched silk

brushes
nos. 1, 2, 6 rounds
nos. 4, 7 flats

oil colors
Titanium White
Lemon Yellow
Cadmium Yellow
Yellow Ochre
Alizarin Crimson
Sap Green
Ultramarine Blue
Paynes Gray

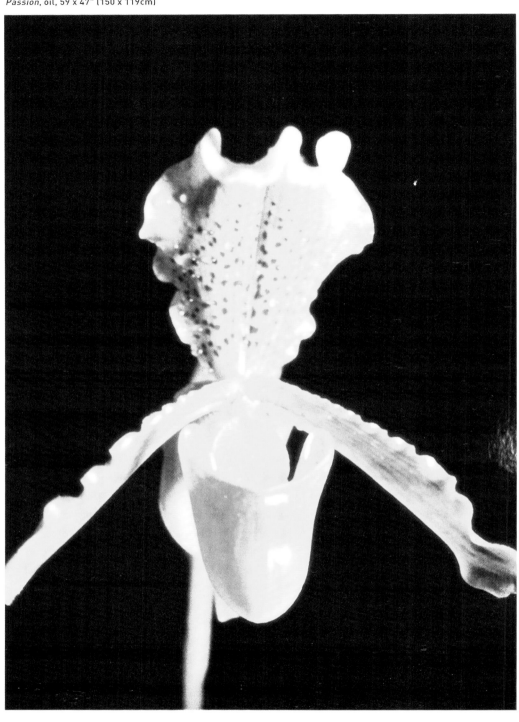

Valentina Bright

ARTIST
100

Valentina Bright lives in Derbyshire, UK → artprint56@hotmail.com

Terms you should know

abstracting Taking from reality, usually simplifying, to suggest a general idea. Not necessarily related to real forms or objects.

acid free For greater permanance, use an acid free paper with a pH content of less than 7.

acrylic Viewed historically, this is a fairly recent member of the color family. Waterbased, so can be diluted to create thin washes, or mixed with various mediums to make the paint thicker or textured.

aerial perspective Dust, water droplets and impurities in the atmosphere gray off color the further away it is from us. These impurities block light, filter reds and allow blues to dominate, so that in the distance we see objects as less distinct and bluer. This is an important point for landscape painters to grasp. Objects in the foreground will be sharp, more in focus and will have more color.

bleeding Applies mainly to watercolor where the pigment tends to crawl along the surface outside the area in which it was intended. Can be a good or a bad thing, depending on your intention.

blending Juxtaposing colors so that they intermix, with no sharp edges. Applies to pastel, where you blend colors by rubbing them with fingers or paper stumps, and to oil, where you would use a broad soft brush to blend colors.

body color Mainly gouache or opaque paint, as opposed to transparent paint. Can be used to create richness of color or to cover up errors. Chinese White (a zinc opaque watercolor) is often used to restore or create highlights. Many watercolor purists insist that a watercolor painting should only be created using transparent pigments, but countless leading artists use opaque paint in moderation. That is the key — only use opaque color on transparent watercolor paintings very sparingly.

brushes
Wash A wide, flat brush used for applying washes over large areas, or varnishing.
Bright A flat paintbrush with short filaments, often called a short flat.
Filbert Similar to a flat brush, with rounded edges.

Round A pointed brush used in all mediums.
Spotter A brush with a tiny, pointed head which is used for fine details.
Liner/Rigger A brush with a long brush head used for fine detailing.
Fan A crescent-shaped brush head for blending and texturing.

brush sizes The size of flat brushes can be expressed in inches and fractions of an inch measured across the width of the ferrule, or by a size number. A 1" brush is roughly equivalent to a no. 12 and a no. 6 brush will measure about ½".
 The size of a round brush is the diameter in millimeters of the brush head where it emerges from the ferrule. For instance no. 5 measures 5mm (¼ inch) in diameter.
 Be aware that sometimes brush sizes may vary slightly between brands, even though they may both be labelled say, no. 10 round. Instead of choosing numbers, choose a quality brush in the size you prefer.

canvas Mainly for oil painting. Canvas can be bought in rolls, prestretched or already stretched with support strips or mounted on a still backing.
Canvas is fabric which comes in cotton, linen and synthetic blends.
 Linen is considered better than cotton because of its strength and appealing textured surface. Newer synthetics do not rot and do not sag. You can buy canvas raw, (with no coating), or primed, (coated with gesso), which is flexible with obvious canvas texture. You can also buy canvas that has been coated twice — double-primed canvas — that is stiffer with less texture.
Canvas board is canvas glued to a rigid backing such as cardboard, hardboard or wood. Note that cardboard is not suitable for serious work because cardboard is not acid free, and will not last.
 Wood and hardboard must be prepared properly.

cast shadow A cast shadow is one thrown onto a surface by an object blocking the light. It is important to remember that the edges of a cast shadow are not sharp.

center of interest (focal point) This is the area in your painting that you want to emphasize. It is the main point. You can create a center of interest with color, light, tone, shape, contrast, edges, texture, or any of the major design elements. Any

center of interest must by supported and balanced by other objects. And do not simply place your center of interest smack in the center of your painting! Make it your mission to learn something about the elements of design.

chiaroscuro This is an Italian word meaning light and dark. In art is means using a range of light and dark shading to give the illusion of form.

collage A work that has other materials glued on, including rice paper, paper, card, cloth, wire, shells, leaves.

color temperature This term refers to the warmness or coolness of a paint. Warm colors are those in the red, orange, yellow, brown group. Cool colors are those in the blue and green group. However, there are warm yellows and there are yellows with a cooler feel to them.

composition and design Composition refers to the whole work, while design refers to the arrangement of the elements.

counterchange When you place contrasting elements — dark against light.

drybrush Mainly for watercolor. If you use stiff paint with very little water you can drag this across the paper and produce interesting textured effects.

frisket Frisket fluid (masking fluid) can be painted over an area to protect it from subsequent washes. When dry the frisket can be rubbed off. You can also use paper frisket that you cut to fit the area to be covered.

gesso A textured, porous, absorbent acrylic paint that is used mainly as a preparatory ground for other mediums such as oil or acrylic.

glaze A thin, transparent layer of darker paint applied over the top of a lighter wash. This richens, darkens, balances, covers up or adds luminosity.

high key/low key The overall lightness (high key) or darkness (low key) of a painting.

impasto Applying paint thickly for effect.

lifting Removing pigment with a brush, sponge or tissue.

Collect all these titles in the Series

100 ways to paint
STILL LIFE & FLORALS
VOLUME 1

ISBN: 1-929834-39-X
Published February 04
AVAILABLE NOW!

100 ways to paint
PEOPLE & FIGURES
VOLUME 1

ISBN: 1-929834-40-3
Published April 04
AVAILABLE NOW!

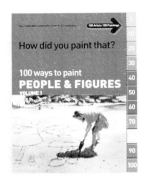

100 ways to paint
LANDSCAPES
VOLUME 1

ISBN: 1-929834-41-1
Published June 04
AVAILABLE NOW!

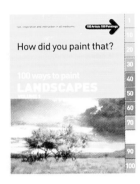

100 ways to paint
FLOWERS & GARDENS
VOLUME 1

ISBN: 1-929834-44-6
Publication date: August 04

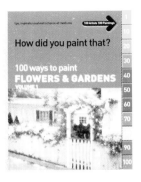

100 ways to paint
SEASCAPES, RIVERS & LAKES
VOLUME 1

ISBN: 1-929834-45-4
Publication date: October 04

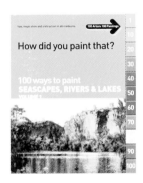

100 ways to paint
FAVORITE SUBJECTS
VOLUME 1

ISBN: 1-929834-46-2
Publication date: December 04

How to order these books

Available through major art stores and leading bookstores.

Distributed to the trade and art markets in North America by

F&W Publications, Inc.,
4700 East Galbraith Road
Cincinnati, Ohio, 45236
(800) 289-0963

Or visit: www.artinthemaking.com